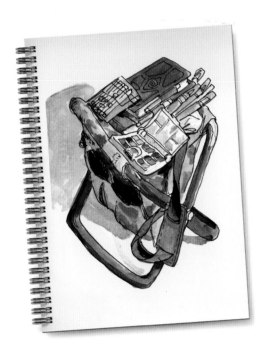

Urban Sketching

A Complete Guide

Sketches from Thor's daily blog,
Analog Artist Digital World

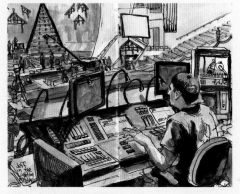

Jeff in the Lighting Booth

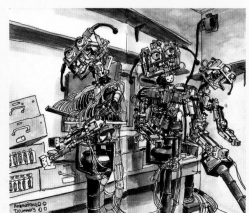

Animatronic Drummers

Mega Con

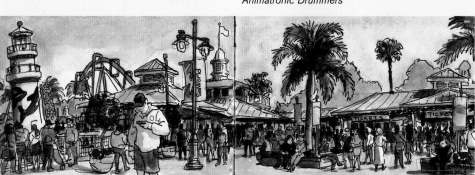

Sea World – Entrance

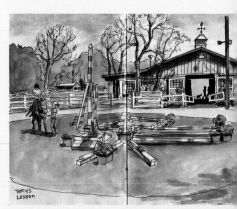

Terry's Lesson

Thomas Thorspecken

Urban Sketching

A Complete Guide

Search Press

The Social Chameleon

Adventures with Hal Studholme

Studio of Karen Russell – Painting Sirens

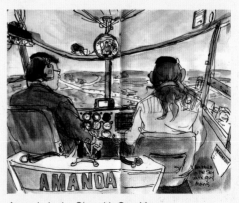

Amanda in the Sky with Guy Mans

URBAN SKETCHING

A Quarto Book

Published in 2014 by
Search Press Ltd
Wellwood
North Farm Road
Tunbridge Wells
Kent TN2 3DR
Reprinted 2014

ISBN: 978-1-78221-097-9

QUAR:DUA

Conceived, designed and produced by
Quarto Publishing plc
The Old Brewery
6 Blundell Street
London N7 9BH

Project editor: Lily de Gatacre
Designer: Karin Skånberg
Design assistant: Kate Bramley
Proofreader: Caroline West
Indexer: Helen Snaith
Picture Researcher: Sarah Bell

Creative director: Moira Clinch
Publisher: Paul Carslake

Colour separation in Singapore by Pica Digital
Pte Limited
Printed in China by Toppan Leefung

10 9 8 7 6 5 4 3 2

Unless otherwise stated in the caption,
all sketches in this book were created by
the author.

Contents

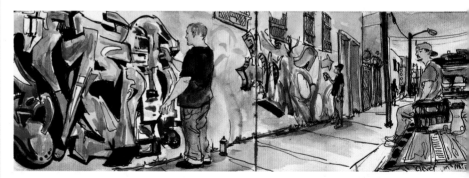

Clever in Miami

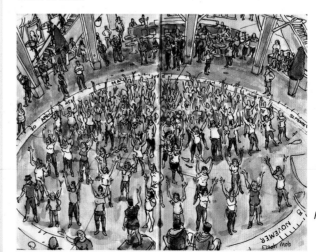

Pancho

Flash Mob

Snap Projections on the Kress Building

Flea Market Blues

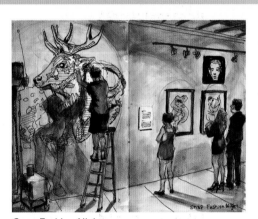

Snap Fashion Night

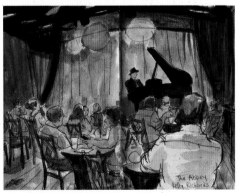

The Abbey, Kelly Richards on Piano

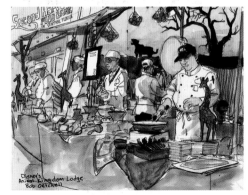

Disney's Animal Kingdom Lodge, Bob Getchell

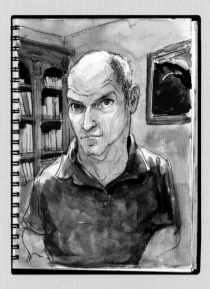

Foreword

Doing sketches on location has a universal appeal because the sketch doesn't have to involve complex, overwrought artistic theories or insights. Everything is in plain sight and the artist just needs to sketch what he or she sees. For the artist, tired of being isolated in the studio, sketching out in the community makes an exciting change. The more you get out to sketch events, the more you will become a citizen reporter. The tools needed are as simple as a pencil and paper, so it is easy for anyone to start. Artists around the world are documenting

Daily Blog

As a New Year's resolution I vowed to post one sketch a day. I have kept to that resolution for four solid years and it has changed my life. You can see some of the postings on the preceding pages and the pages that follow.

Starting a blog was incredibly easy. It simply involved filling out a short online form and picking a template, and then you can begin the adventure by writing your thoughts and pressing the 'Publish' button. I used Google blogspot and I have heard that Word Press is good as well. Most important of all, setting up a blog is free! Talk about freedom of expression!

Sharing your work every day online changes how you view your art. Knowing that a large audience can view everything you do makes you feel accountable, and you take your art and what you write more seriously. You can still enjoy the process of sketching and writing, but you soon realise you can inform and inspire the people who take the time to see what you are doing.

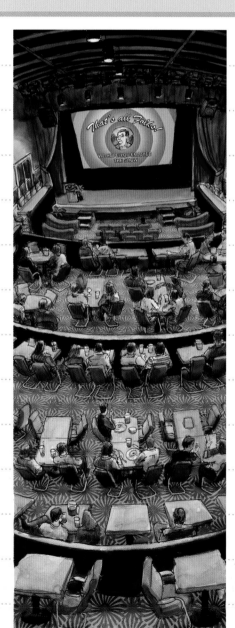

Enzian Theatre Restoration

Snap!

Rock-afire Explosion, on Loading Dock

their unique cultures and learning from one another as the Internet allows everyone to exchange ideas and learn from one another.

The fact is that everyone can draw. As an artist, I always admire children's drawings for their bold sincerity. Many people stop drawing because they feel their work isn't as good as someone else's. If you don't compare yourself to other artists and just strive to improve your work a little every day, then there is always some pleasure to be gained from sketching on location. Don't get me wrong, sketching is hard work, but what you need most is patience and the ability to slow down and truly see. TV and films have quick one- or two-second cuts, making it seem as if life is happening at a breakneck pace. Photographers shoot a photo and immediately move on. You need to learn how long it takes you to do a sketch, and be willing to put in that time every day. I take about one to two hours to do each of my sketches. I might be dissatisfied as the sketch progresses because the sketch is never perfect. It is important to accept the flaws and keep moving forwards. Days later, you might look back and realise that the sketch isn't half bad. As long as it isn't the worst sketch you have ever done, you need to accept it, share it and move on.

People react differently to a sketch of an event than to a photo of it. There is something more personal and direct about a sketch. People recognise the skill and patience needed to

Continued on page 8

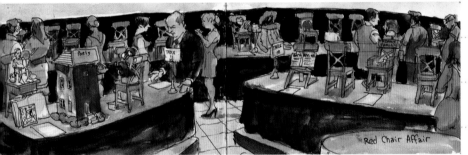

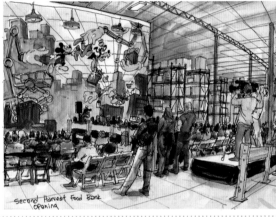

Red Chair Affair

Second Harvest Food Bank Opening

Marriage Equality Rally

Urban ReThink Mural Unveiling

Best B-Boy Competition

he Fashion Show

Valentine's Day

complete a sketch. Today, we are bombarded by photographic images constantly, and a sketch stands aside as being truly unique. People, children especially, see sketching as a magical process and they will stop to look over your shoulder. Once you answer a few questions or offer a joke, you can continue to work and they will eventually leave you to work in peace. These chance encounters often lead to other sketch opportunities and sometimes friendships. Once you start looking for sketch opportunities, you will suddenly discover things happening in your community that you were previously unaware of. If you remain open and curious, you will never run out of exciting stories that need to be told with a sketch and your insights.

Social media makes it possible for an artist to be aware of events as they happen, and you can share your work with people as quickly as the established media of newspapers and TV. Once you commit to sharing your sketches and reports online, then you are a reporter, and you deserve to gain access to events that you plan to cover. Part of your job becomes finding events and finding ways to gain access. The longer you

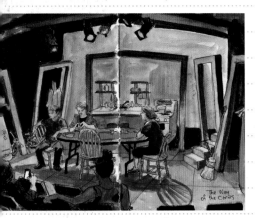

Mural at Hope Community Centre

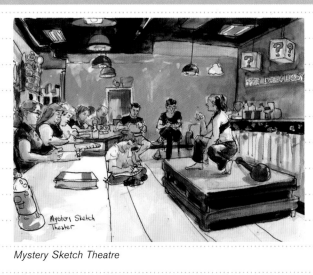

Mystery Sketch Theatre

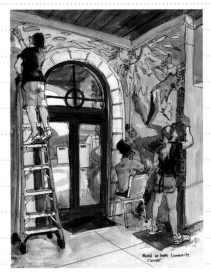

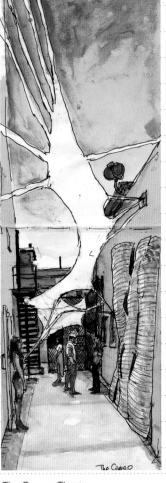

Bookstore

The Way of the Cards

The Cameo Theatre

Splicing Breakfast at Tiffany's

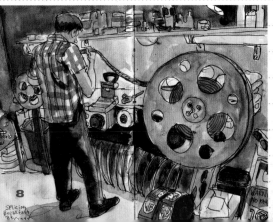

Monday Night Jazz at Taste

sketch and report on events daily, the easier it becomes to gain access. Once you get started, then every day becomes an adventure. This book offers insights into the artistic process. Learn what works best for you and get out every day to discover the world around you by sketching. Share your experiences online and keep drawing.

Thomas Thorspecken

Urban Sketchers' Manifesto

1 We draw on location, indoors or out, capturing what we see from direct observation.

2 Our drawings tell the story of our surroundings, the places we live and where we travel.

3 Our drawings are a record of time and place.

4 We are truthful to the scenes we witness.

5 We use any kind of media and cherish our individual styles.

6 We support each other and draw together.

7 We share our drawings online.

8 We show the world, one drawing at a time.

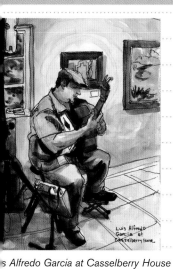

...s Alfredo Garcia at Casselberry House

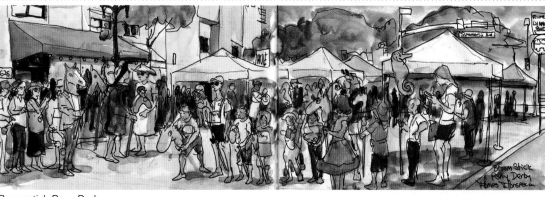

Broomstick Pony Derby

Earth Day

Santo Domingo

Red Chair Affair

Small label

Drip Art Night

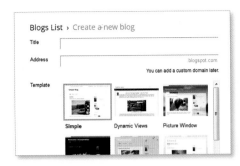

Get Blogging A simple interface you can use to begin blogging. The most important thing is to pick a catchy title that is easy for people to remember. At first I used my name, but later decided on 'AnalogArtistDigitalWorld.com'.

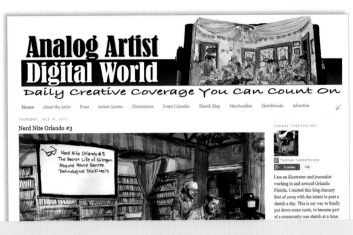

Blog Layout My blog uses a simple layout with a white background. Over time I figured out how to enlarge the photos to be 800 pixels wide. Some HTML code needed to be adjusted to widen the blog. All the information was found online.

Social Networks and Sketching

The Internet has made it possible for artists around the world to share their work and learn from the work of others. Exhibiting work on gallery walls isn't as important when anyone in the world can see your work virtually as it is created.

Blogging

In Paris cafés at the turn of the 20th century, artists like Monet, Degas, Gauguin, Van Gogh and Toulouse Lautrec could gather and talk about art. Artists inspired each other, thanks to ideas expressed and work shared. Today, artists don't have to be in the same city or on the same continent to inspire each other. I became obsessed by the online blogs of artists I admired – not only could I see their work, but I could read their thoughts about the process. I would literally read a year's worth of posts in one sitting.

I talked about starting a blog for at least a year before deciding on 1st January, 2009 to take the plunge. Every sketch published on my blog also gets uploaded onto flickr, which offers every user a solid terabyte of storage for free. The new interface showcases each sketch larger than before. I like the ability to show where each sketch was done on a map, which readers of the blog can link to. On flickr you can share your work with groups and communities, and get your sketches seen by a wider audience.

Social Media

By using social media like Facebook and Twitter you can be sure people see what you are sketching and posting on your blog. Social media is also a great way to seek out new sketching opportunities. Event invites and suggestions from friends can keep you up to date, sketching what is relevant in your community. Every time a blog post goes live, it is automatically shared on Facebook and Twitter, thanks to a program called Networked Blogs. I used to post to social media by hand and Networked Blogs has become a major time-saver. On Facebook, a separate Analog Artist Digital World fan page was set up and it functions as a place where Facebook readers can see the latest

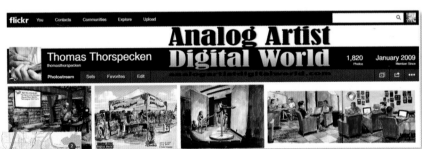

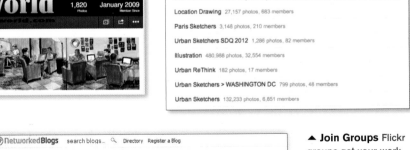

Plenty of Space A terabyte of free storage on flickr is incredibly large. I have used just 0.032% for 1,820 sketches. The people who interact with your work on flickr are often different than those who read the blog.

Pinpoint the Sketch This flickr map shows where I have sketched in and around my city. If you click on any dot, it will show the sketch done at that location. The maps are accurate and are another way for people to interact with your art.

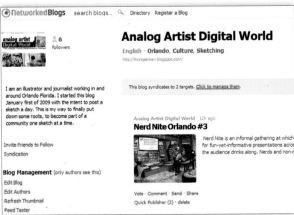

Join Groups Flickr groups get your work seen by more people. At present, I belong to nine groups but there are many more.

Link Up Networked Blogs makes it possible to automatically place links to your blog posts on Facebook and Twitter each day.

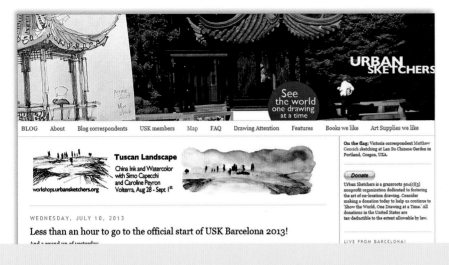

 Global Community The Urban Sketchers blog has more than one hundred correspondents. Sketches go online every day from artists around the world.

posts and link to the blog to read more. I also post quotes from artists and links to other artists' work on the Facebook page to generate interest. The insights section of the page allows you to track how many people have viewed each post. You can track which posts generated the most interest and discussion.

The Urban Sketching Community

Gabriel Campanario, a sketch newspaper journalist from Seattle, USA, founded a blog called 'Urban Sketchers'. More than one hundred urban artists from around the world contribute sketches to the site. There are artists from every continent and I am the Orlando, Florida, correspondent. Every day, artists contribute to the site, making it possible to tour the world with sketches at a glance. Every year there is an Urban Sketchers' Symposium held in a different city. At the Symposium, several hundred artists gather to sketch, and learn from one another. This organisation has promoted a strong community of artists from different cultures who all love to draw on location. Urban Sketchers can be found at www.urbansketchers.org.

SketchCrawl is a world-wide sketch marathon founded by Enrico Casarosa. Enrico is a Pixar storyboard artist and a director. A sketch crawl is modelled after a pub crawl but, instead of drinking, artists take a day to sketch everything they encounter. A site was set up online that helps artists gather together to sketch as a group, each in their respective cities. The next day everyone posts their sketches on the site. It becomes possible to see sketches from cities around the world that were all done on the same day. The site is www.sketchcrawl.com.

Sharing your work every day means you will have a sense of accountability and your work will mature more quickly. If I compare sketches done today to the sketches I did when I first started the blog, there is a world of difference. There is still progress to be made and, although change might seem glacial, you know the sketches will get better as long as you keep doing them and sharing them online. The key is to make sketching a daily habit.

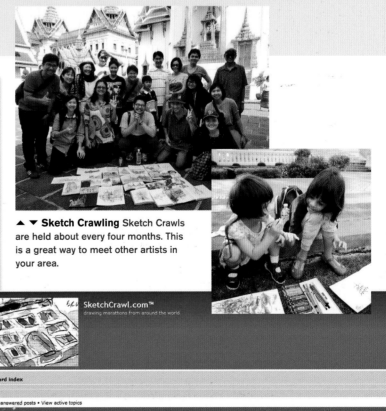

▲ ▼ **Sketch Crawling** Sketch Crawls are held about every four months. This is a great way to meet other artists in your area.

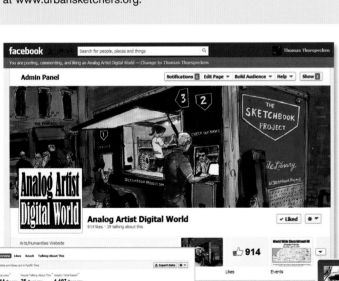

▲ **Facebook Fans** A Facebook fan page keeps people up to date with your blog posts.

▲ **Track Interest** Facebook insights help you see which posts generate interest.

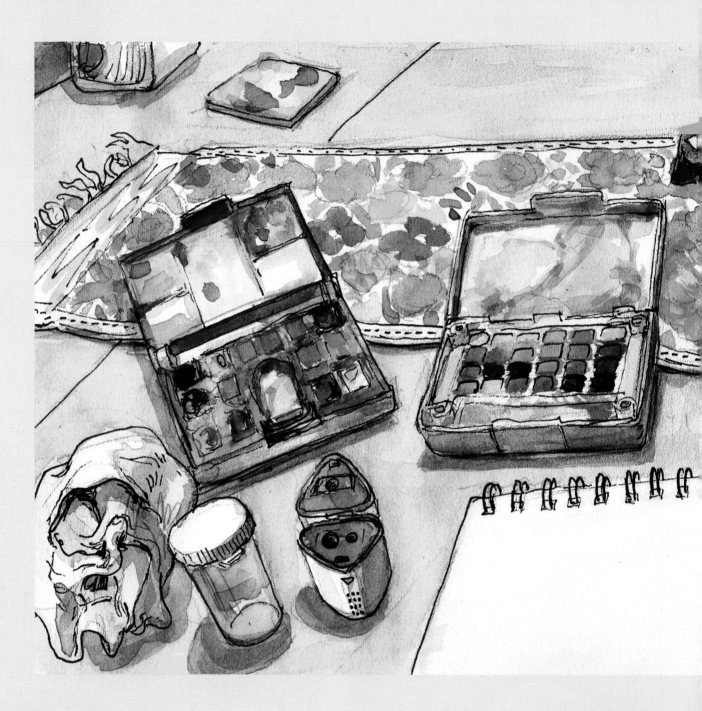

Chapter 1

Tools and Techniques

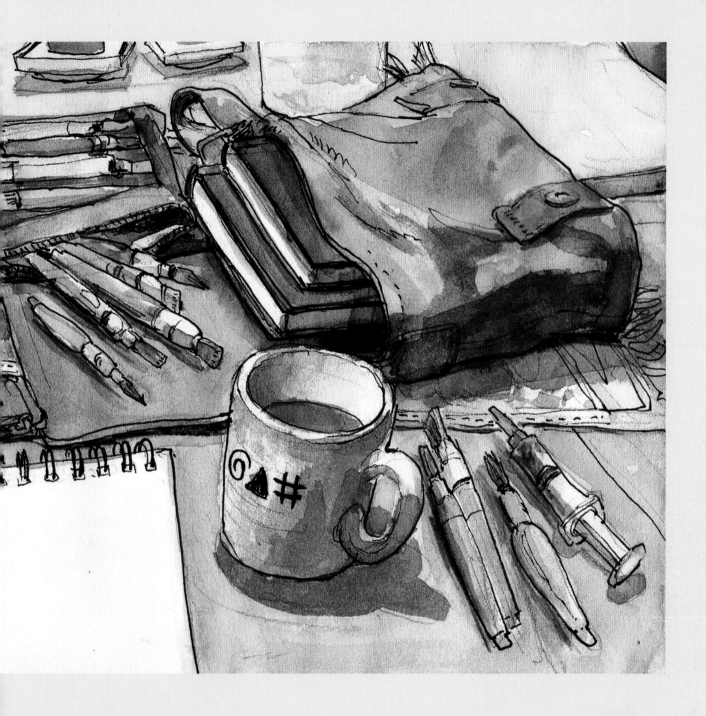

In this chapter you will find all the nuts and bolts of sketching. You will learn how to choose the right tools for line and colour work and pick out the right sketchbook for you from the huge range available. From making those first few gestural marks and studying the human form in a life-drawing class to mixing your bespoke colour palette, adding text to your work and enhancing your sketches with digital tweaks, this chapter will give you all the skills you need to get out there and sketch with confidence. It is not about learning to sketch in a certain style – but finding a way of sketching that feels easy and natural to you.

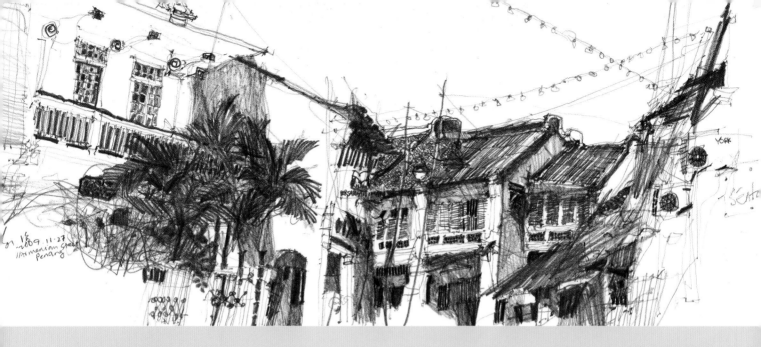

Line Tools

My sketches done on location tend to start with line. A line is simple and clean, and it is the easiest way to break up the page and create interesting shapes. Pencils and pens can be easily carried in your pocket or a light art supply bag.

Each of my sketches begins lightly in pencil. The reason for this is that it is important to be able to change your mind and refine shapes as you progress with the sketch. The pencil lines are used to quickly set up the bold shapes of the composition and decide where to place people. When placing people in the sketch, I work frantically in pencil until the person's gesture or pose has been found. I use Blackwing 602 Palomino pencils and can get a bold dark line by pressing hard or a light grey line with a light touch. I use the pencil with a light touch, knowing I will later add detail using a pen.

One of the most common comments you will hear while sketching on location is:

Blackwing 602 Palomino with heavy pressure

Blackwing 602 Palomino with light pressure (in a pencil extender)

Prismacolor Black Pencil PC935

◀ **Pencils** Used with or without a pencil grip, a favourite is the Blackwing 602 which gives a range of tones, depending on the pressure that is applied. The Prismacolor black pencil is used sometimes to make dark washes darker.

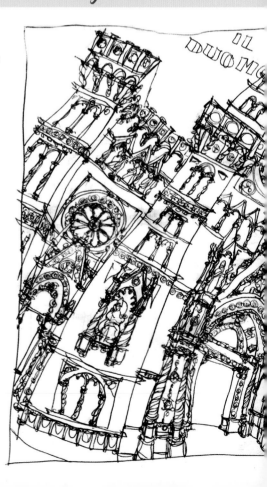

▼ **Important Extras** Along with my drawing tools, I always carry a Dahle pencil sharpener, which catches shavings, and an eraser.

▶ **Loose Lines** One of the most common comments you will hear while sketching on location is: I can't even draw a straight line. My response would be, why would you want to? Even quirky, off-kilter lines have appeal, as demonstrated in this sketch by Benedetta Dossi.

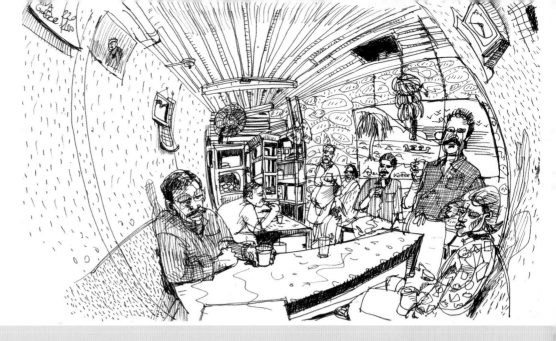

◀ The Right Touch This sketch by Kiah Kiean incorporates pencil line work of varying pressures, creating variety and a full range of values. Lines range from subtle greys to a deep, rich black.

▶ Rich Line Texture A variety of line work creates intricate patterns and values. In A. Rmyth's sketch, almost every surface has a pattern of short, staccato strokes. The variety of small, enclosed shapes and open spaces adds interest and variety.

Micron 05 and 08 Archival ink pens are used in most of my drawings. The advantage of this pen is that the lines are waterproof, meaning watercolour added afterwards will not make the ink bleed. Lately I have also been experimenting with fountain pens. Micron pens give a steady, mechanical line but a good fountain pen can produce a line that is thick or thin depending on how hard you press. I have been using a Noodler's Ahab Flex Nib fountain pen. Noodler's black ink is water resistant when dry but it isn't really waterproof. Ink from a fountain pen goes down on the page as a wet bead. It is important, therefore, to avoid smudging the line before it is completely dry, unless that is your intent.

I keep a few Prismacolor black pencils in my pockets as well. The Prismacolor is usually used after all the watercolour washes have been applied. It is simply used to make some dark areas darker. If the watercolour washes are dark enough, I tend to skip using the Prismacolor.

What works for me might not work for you; we all have different sensitivities when it comes to using line tools. I've found that pencil and pen can give decent results without too much mess. I have tried only using pencil, but it doesn't always scan well. This is why most sketches use ink. Bold ink lines act like the leading in stained glass windows, making the colours pop.

I can t even draw a straight line. My response would be, why would you want to?

▶ Micron Marks The pens I use most often are the Microns. They offer a very consistent mechanical line that is waterproof. I always carry the 05 and the 08. The 05 is for refined detail such as facial features and the 08 is good when a thicker line is needed.

▶ Pentel Brush Ink Pens The Pentel Brush Pen ink is water soluble, so I only use it after the watercolour washes are done. Pens come in different line weights.

▶ Fountain Pens The Noodler's Ahab Flex Nib is my first attempt at using fountain pens. I've heard that gold nib pens made back in the 1940s had much more flex in their nibs. Finding a truly flexible nib is the holy grail of sketching, and I'm still searching. In the meantime, I use what I have. Noodler's black ink has a tendency to bleed if there isn't enough drying time – since I'm always working fast, this is a drawback.

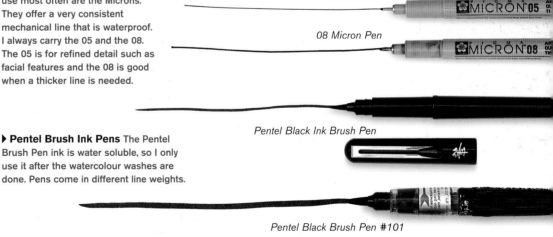

05 Micron Pen

08 Micron Pen

Pentel Black Ink Brush Pen

Pentel Black Brush Pen #101

Noodler's Ahab Flex Nib Fountain Pen

15

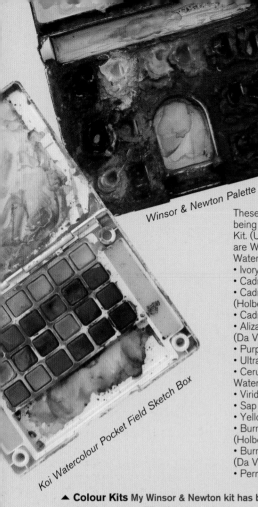

The Purple Lake pan needs to be refilled.

Winsor & Newton Palette

Koi Watercolour Pocket Field Sketch Box

These are the tube colours now being used in my Winsor & Newton Kit. (Unless otherwise stated, these are Winsor & Newton, Cotman Watercolours):
• Ivory Black
• Cadmium Yellow Pale Hue 109
• Cadmium Red Orange W216 (Holbein Artists' Watercolour)
• Cadmium Red Deep Hue 098
• Alizarin Crimson 202F (Da Vinci Watercolour)
• Purple Lake 544
• Ultramarine 660
• Cerulean Blue 535 (Van Gogh Watercolour)
• Viridian Hue 696
• Sap Green (Da Vinci Watercolour)
• Yellow Ochre 744
• Burnt Sienna W334 (Holbein Artists' Watercolour)
• Burnt Umber 206F (Da Vinci Watercolour)
• Permanent White

▲ **Colour Kits** My Winsor & Newton kit has been in daily use for the last four years. The Koi kit is a back-up for fun, bright colours. Neither kit is ever really clean. The Winsor & Newton colours are replaced as needed with tubes of watercolour squeezed in.

Colour Tools

The most compact colour tools to possess are a travel-sized watercolour kit and brushes that hold water in the handle. These water brushes make it possible to paint on a sketch anytime and anywhere.

The travel-sized palette I use most often is from Winsor & Newton. It is just 135 by 115mm (5¼ by 4½in) in size: small enough to fit into trouser pockets if needed. Most of the colours have stayed the same over the years. There are 14 colours in the half pans and I now refill the pans using tubes of watercolour.

Besides the Winsor & Newton Kit, I also carry a Koi Pocket Field Sketch Box. I tend to only use this for quirky colours like a bright pink, Quinacridone Rose or the rich oranges. The Koi kit is made of thin plastic and it breaks over time from repeated usage. I don't tend to have any brand loyalty in terms of watercolours: if one brand of watercolour has run out when I am picking up tubes of paint at the art shop, I will try another brand. I did find the Winsor & Newton Cerulean Blue to be too weak a colour; it never produced a blue that could make a believable sky. The Van Gogh Cerulean Blue is very saturated so that is what I use now. Viridian Green is seldom used and I plan to replace it with a Phthalo Yellow Green. The Viridian doesn't work well when painting foliage, whereas I'm always looking for light green hues. I found that I was spending too much time mixing Burnt Umber and

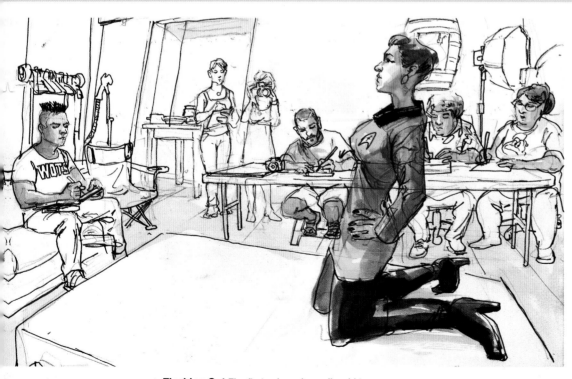

▲ **Fleshing Out** The first colours I usually add to a sketch are the flesh tones. Here, I mixed Cadmium Red and Yellow Ochre, and thinned that mixture down. The mid tones were applied in the shadow areas and gradually darkened with thicker paint.

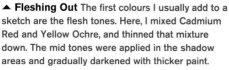

Ultramarine Blue to get something close to black, so one of the two yellows that came with the kit got replaced with an Ivory Black. I don't use white paint to lighten other colours. Water is added to colours to thin them out so more white paper shows through. In time, you will build your perfect, bespoke palette.

The palette is always changing and it is always dirty. Since pure, bright colour is seldom seen, I do some mixing of colours but, for the most part, colours are mixed on the sketch as washes are added. The second that a dirty brush is dipped into a colour pan, it becomes dirty. Every object in the sketch will have a medium value, a dark shadow and a highlight. The trick with a watercolour sketch is to avoid the temptation to paint the highlights. Always leave plenty of paper showing. Most of your attention will be spent thinning out the washes to create the mid values and then later adding darks with thicker pigment. If you leave the lights alone, you will have a fresher sketch.

There are plenty of other colour tools that could work on location – for example, coloured pencils can be great for things like signage that might have coloured lettering. I avoid dry media like pastels, simply because it would get all over my hands and clothes. Acrylic or oil paint could work, but it would need to be squeezed out of tubes for every session. When you are trying to complete a sketch fast, every second counts.

Quick Mix Tips

1. One of the first colours I put on every sketch is the flesh tones. I get these colours by mixing Yellow Ochre and Cadmium Red. These colours are mixed on the palette so I can see how it looks before it goes on the page.

2. Let's say you want to mix a light green. You would want to mix Cadmium Yellow with Sap Green. If you first get some Sap Green on the brush, you might be tempted to then dip the brush into the Cadmium Yellow. This would get the yellow pan dirty. A better strategy would be to place a yellow wash on the sketch and follow that with a green wash.

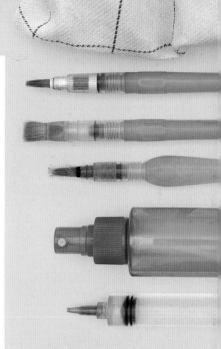

▲ **Vital Tools** These are the basic colour tools always in my art bag alongside my palette. A white rag is used to wipe pigment off brushes. I carry quite a few water brushes but only use one or two on each sketch. The spray bottle carries extra water and mists areas on the sketch that need a large wash. A syringe is used to refill water brushes.

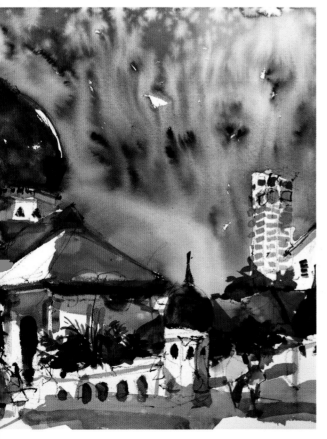

◀ **Paper Highlights** The white page is used to great effect in this sketch by Kiah Kiean, implying bright sunlight. Simple mid-value orange and grey washes define the shadowed areas, and dark browns define the domes. Dark greens were added for foliage. You can tell the colours were applied quickly since they bleed together.

▶ **Pencil Highlights** The grey paper creates a mid-value for the entire shadowed side of the building in this sketch by Don Low. White coloured pencil was used to show the lightest sunlit surfaces. The sky had to be lightened to define the building's shape. The warm dome and green foliage completed the sketch.

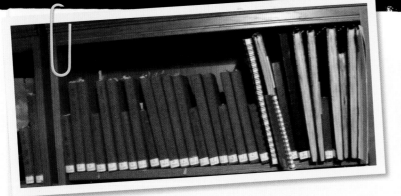

◀ **Sketchbook Library** These are the sketchbooks I have filled since 2009 when my daily sketch commitment began. To the left are the early Handbook artist journals and to the right are the more recent Stillman & Birn wire-bound books.

▶ **Personal Style** The open sketchbooks here show a definite personal viewpoint that has developed over the course of doing more than 1,500 sketches over five years. My work continues to change and evolve.

Sketchbooks

Sketchbooks come in a huge variety of sizes and shapes. The advantage of smaller sketchbooks is that you can complete a small sketch much faster than a large one. The advantage of a larger sketchbook is that you can capture a much larger scene. For this reason it is a good idea to carry several sketchbooks.

The first sketchbooks I began using when I started doing a sketch a day were called Handbook artist journals. Measuring just 215mm high by 135mm wide (8½ by 5¼in) when closed, these were used for everyday sketching. When open, each spread has slightly horizontal dimensions, and the paper has an ivory cast to it. The big advantage was that the paper was thick enough (130 GSM/87 Lb) that ink lines and watercolour did not bleed through the page, making it possible to sketch on both sides of each page. GSM stands for the mass per unit area of all types of paper and is expressed in terms of grams per square metre (g/m²). Each spread was treated as a single sketch and I filled up one of these sketchbooks every month. One feature I really liked was a clear plastic envelope glued to the inside back cover. That envelope was convenient for saving ticket stubs, business cards and other scraps – useful when I would later write about the events I had sketched.

I always carry a horizontal sketchbook as well for scenes that are undeniably horizontal. Another Handbook artist journal has a very horizontal format when open, perfect for creating panoramic sketches. However, lately I have switched to Stillman & Birn Alpha series horizontal hardbound sketchbooks that measure 230mm wide by 160mm high (9 by 6¼in) when closed. The paper in this sketchbook is heavier (150 GSM/100 Lb) than that in

the Handbook, and the pure white sheets make my watercolour sketches brighter.

In the last year I have begun using Stillman & Birn wire-bound sketchbooks. The Alpha sketchbook measures 280 by 355mm (11 by 14in). Each sheet is a bit larger than an open spread in the Handbooks. Rather than sketch on both sides of a sheet, I now only fill one side with a sketch. The backs of the sketches are used for compiling notes needed to write about the event. The big advantage of a wire-bound sketchbook is that a sketch can be ripped out of the book, put in a frame and sold.

I carry a third sketchbook which is also wire-bound and a bit smaller than the Alpha sketchbook. This Stillman & Birn Epsilon sketchbook measures 230 by 305mm (9 by 12in) and is almost identical in size to the Handbook spreads. The Epsilon paper is pure white, weighing in at 150 GSM (100 Lb). The paper is incredibly smooth, which I love, and the ink lines and watercolour flow easily onto the pages.

CARVOEIRO - LAGOA

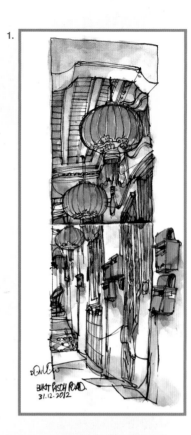

1.

▶ ▼ Find Your Style 1. Don Low's ink line work makes good use of a vertical landscape format across a hardbound book. 2. Lapin uses old lined account books as his sketchbook; the lined grid gives all his sketches a consistent and appealing background. 3. Kumi Matsukawa sketched across a wire-bound spread; since sketches are often personal observations by the artist, the wire binding can be ignored. 4. The accordion-bound sketchbook of Hélio Boto allows for an expansive panorama. 5. The warm brown paper in Sylvie Bargain's wire-bound sketchbook means only highlights and darks needed to be sketched. Your sketching style will evolve over time. Style isn't searched for – it develops from constant sketching.

2.

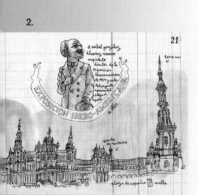

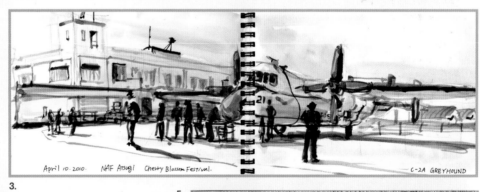

April 10. 2010. NAF Atsugi Cherry Blossom Festival.

C-2A GREYHOUND

3.

5.

4.

The Set Up

Sketching every day on location requires you to have a compact set of art supplies that you carry with you everywhere. Everything in my kit fits into a shoulder bag that is just big enough to fit an 280 by 1355-mm (11 by 14-in) spiral-bound sketchbook.

The bag I use today is bursting at the seams with all the supplies I use every day on location. I always carry three sketchbooks (see pages 18–19), several pens and pencils (see pages 14–15) and a travel-sized palette of watercolours (see pages 16–17). With a set up like this, you can sketch anywhere. The chair is always carried, even if the sketch will be in a venue with seats. Having a portable stool means that you can pick any vantage point from which to sketch, and you don't have to worry about arm rests restricting your arm movement.

I used to carry a separate notebook in which I wrote down names, dates and snippets of conversation. Every sketch has a story behind it and notes help you write about what happened; sometimes dramatic things happen that aren't in the sketch. I believe that writing helps to complete the picture. Now that I'm using larger sketchbooks, only one side of a page is used for the sketch, I use the back of the sketch for the notes. To me, finding interesting stories is the whole point of venturing out each day to sketch.

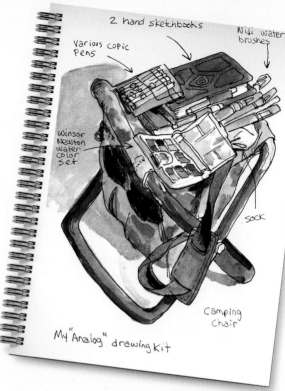

▲ **Early Kit** This was my early sketch kit. Everything fits into the pouches of the stool. A camera strap was used to sling the chair over my shoulder. Looking back, I'm amazed at how clean the watercolour palette looks.

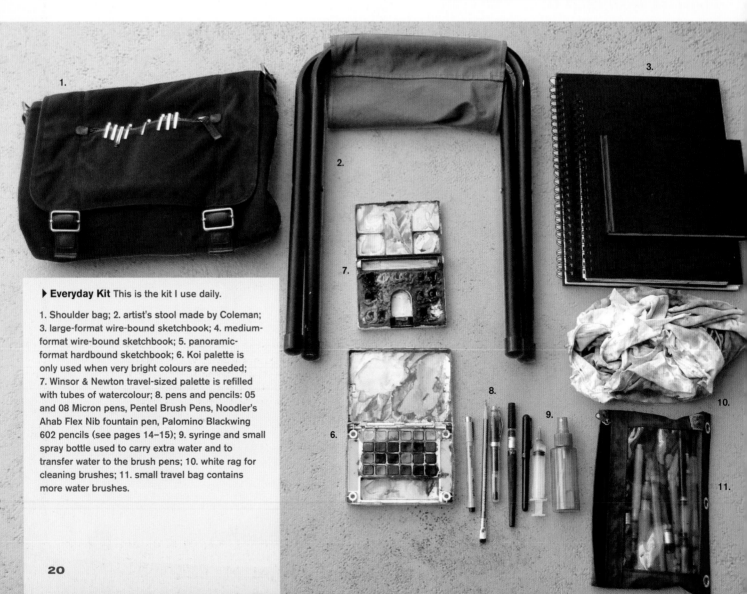

▶ **Everyday Kit** This is the kit I use daily.

1. Shoulder bag; 2. artist's stool made by Coleman; 3. large-format wire-bound sketchbook; 4. medium-format wire-bound sketchbook; 5. panoramic-format hardbound sketchbook; 6. Koi palette is only used when very bright colours are needed; 7. Winsor & Newton travel-sized palette is refilled with tubes of watercolour; 8. pens and pencils: 05 and 08 Micron pens, Pentel Brush Pens, Noodler's Ahab Flex Nib fountain pen, Palomino Blackwing 602 pencils (see pages 14–15); 9. syringe and small spray bottle used to carry extra water and to transfer water to the brush pens; 10. white rag for cleaning brushes; 11. small travel bag contains more water brushes.

Scheduling Time to Sketch

Your goal shouldn't be to just sketch things; you need to be searching for interesting human-interest stories. Each day that you set out to do a drawing, you should have a destination and a story in mind. Many artists who are starting out only sketch between moments of the daily routine, at bus stops or waiting for someone. To find places to sketch every day, scour the events' calendar of a local weekly paper. At each event sketched, you will meet people – take their cards and contact them using Facebook or Twitter. When these people become Facebook friends, they will keep you up to date on all the local events happening every day. It is work just keeping up with all the possibilities.

When you find events that interest you, contact the promoter to see if you can gain media access to document the occasion. A hand-drawn sketch is a very unique way to document events and many promoters recognise this. Every day there are at least five different sketch opportunities, the key is to find the one that will be the most exciting to draw and write about. With newspapers suffering from cutbacks, many people realise that promoting online is the new frontier. When you make a commitment to do a sketch every day and you plan ahead so you know what event or story you want to sketch, there is no excuse to not get out there.

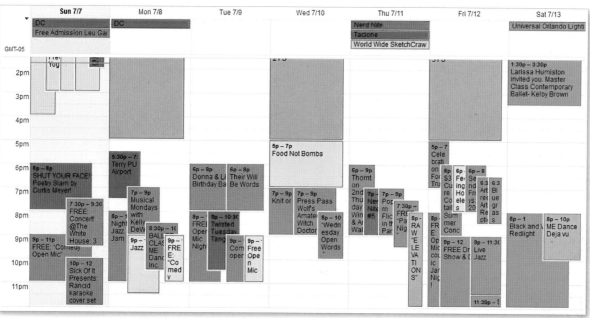

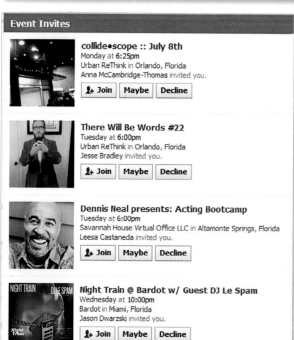

▲ **Create a Calendar** This is a typical week of possible events to sketch on Google Calendar. Blue items are work-related so no events are slated in those times. Purple events are ones I secured a press pass for or to which I was specifically invited. Red items are events that really interest me. Green items are family time. All the orange events are possibilities and grey events were covered in the past, so they are a fall-back if nothing else works.

◀ **Facebook Invites** Facebook offers notifications for events as they come up. I don't need to research in newspapers as much anymore since these event invitations come in every day. I tend to click that 'maybe' I'll attend every event and then turn off the notifications. Follow your instincts about what to attend. Create, share and repeat.

Life Model Class

Urban sketchers tend to come from two separate backgrounds: some sketchers come from an architecture background and like to sketch buildings and urban structures; the other camp comes from a fine art background whose foundation is figure drawing.

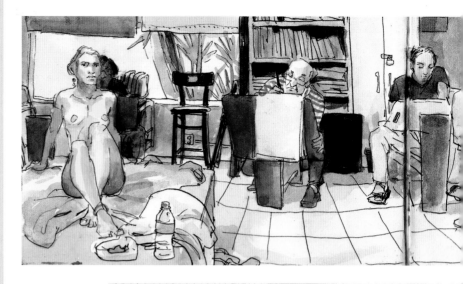

Sketching in a figure-drawing class is the perfect way to get a feel for proportions, rhythm, movement, line and volume. Usually a class will have a series of one-minute, five-minute and longer poses. The student can usually fit three standing poses on a 455 by 610mm (18 by 24 in) newsprint pad page. Although great training, these figure studies enforce the notion of placing isolated figures on a page, with no attention paid to the background or environment. Observing and sketching, a beginning student will feel rushed in the attempt to capture a moment. Life doesn't always happen at that breakneck pace. It is the artist's job to relax and slowly observe a scene.

Planning a Session

It is a good idea to attend a figure-drawing class with the goal of only finishing one or two drawings at most. Start the sketch, not with the model, but with the model stand and the room. Then go ahead and start drawing your fellow students. Pick one of the longer poses and draw the model's pose, and try and put colour and value on that pose before the break. The advantage to this approach is that you can utilise every moment in the session. During breaks, keep working on the sketch by observing details in the room; by widening your gaze you will be creating a scene with a story rather than just drawing the figure. Pay attention to fellow students' poses and their intense concentration. In this setting, the students are the audience and the model is the actor. If you sketch in a theatre or concert, the same principles apply.

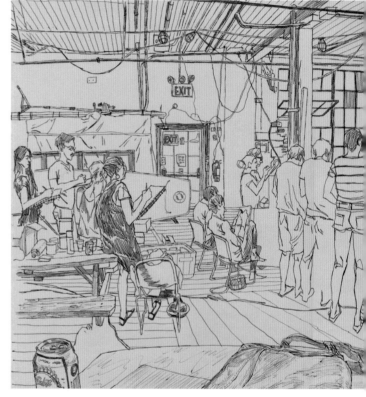

The goal is to leave the classroom and studio setting and start sketching out in your community. You may begin by sketching buildings, but in time you will want to capture the drama of human interaction and so you will sketch anywhere that people gather. Your classroom just got a whole lot larger. In any urban setting the sketch opportunities are limitless.

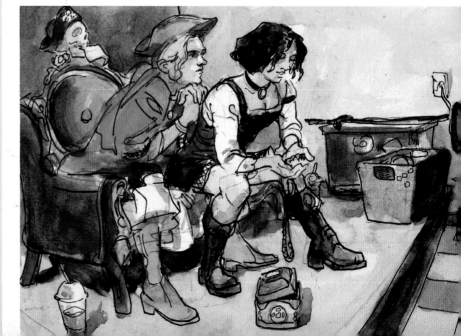

◀ **Classroom Setting** By placing the figure in a panoramic format, she becomes part of a much bigger picture. The students, classroom and the view outside the studio window give a bigger sense of place and time.

▼ **Multiple Models** Having more than one model is a good first step towards what you might want to catch when working on location, as demonstrated in this sketch by Guno Park. The best subjects can usually be found where people gather and interact.

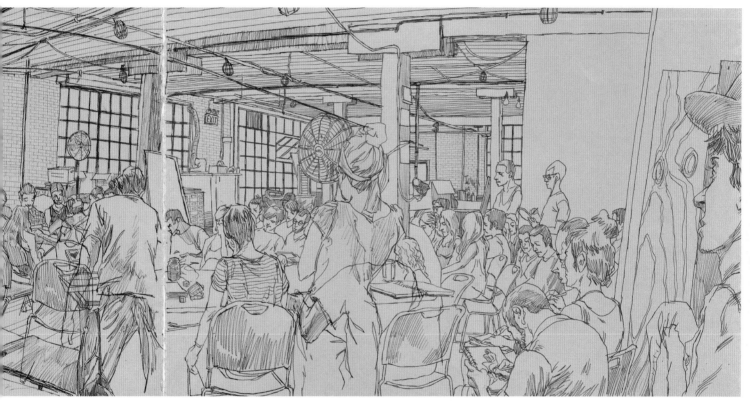

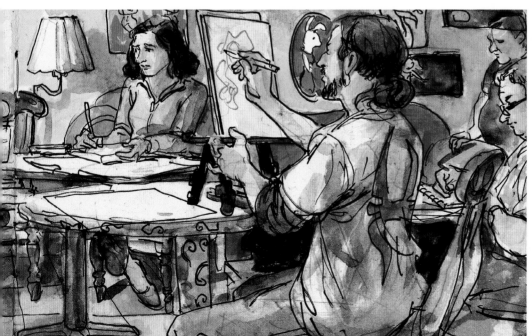

◀ **Stage Setting** The models are on a stage with artists as the audience. As Shakespeare said, 'All the world's a stage'. The modelling session is a microcosm of what you can discover on location. Sketching clothed models gets you closer to the experience of sketching on location. Companies such as Sketchy Broads, Mystery Sketch Theatre and Dr. Sketchy's offer classes with clothed and costumed models, so check for similar sessions near you.

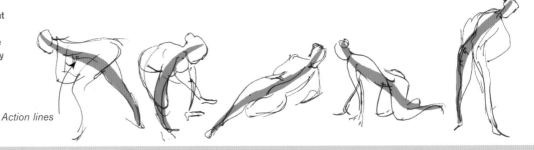

▶ **Action Lines** The most important thing to capture in a quick pose is the action line or main thrust of the pose. The action line isn't about any one shape or form, but about the overall flow of the pose.

Action lines

Figure Drawing

Of course, figure drawing is a subject large enough for a whole book. Here, I will outline the aspects of figure drawing that I use day to day when drawing on location. You will learn the most by returning to figure-drawing classes and repeatedly sketching from live models for years.

In the corner of my studio is a mountain of newsprint pads that are full of figure studies. Animator and director Chuck Jones, recalled a teacher telling a class he was in, 'All of you here have one hundred thousand bad drawings in you. The sooner you get rid of them, the better it will be for everyone.' So, start filling those sketchbooks. No artist is ever satisfied with every sketch as it is done. What is important is to share the sketch and move on to the next one.

As previously outlined, figure-drawing classes often have one-minute, five-minute and longer poses. In terms of figure drawing, the most important thing to capture in such a short amount of

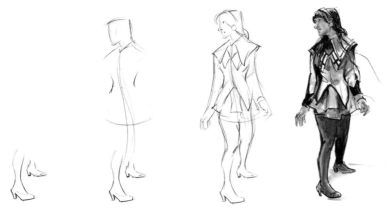

◀ **Chiselling Basic Shapes** Sketching on location, I almost invariably sketch the feet first to anchor the pose to the ground plane. Next, I sketch a simple cube shape for the head to judge the height and to decide which way the head should be oriented. I might change my mind several times, so I don't linger here. I figure out the orientation of the ribcage and the hips to each other as I place a couple of lines at the hips. Since the hips are oriented ¾ right and the ribcage is straight on, there is a curve to the torso that needs to be found. In this case, detailing of the face and costuming was done with a brush pen and then watercolour.

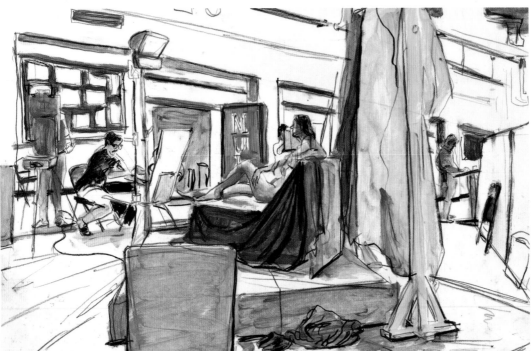

◀ **The Bigger Picture** As soon as you treat the figure as part of a much larger scene, you are on the road to becoming an urban sketcher.

▶ **Costumed Models** Several models formed their own sketch group where they could pose each month in different costumes. Challenge yourself to place as many people as you can into the scene.

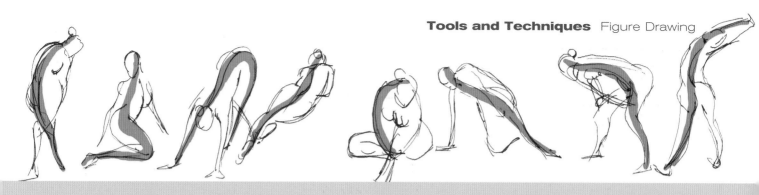

time is the line of action. The line of action is usually related to the curve of the spine and it can flow from the feet all the way through to the hands. Lines should communicate flow and movement. The key is to draw the action, not just the individual shapes. The entire pose should be kept in mind with one action line throughout.

When drawing on location, people will move and even walk away. It is possible to catch the line of action and then complete the figure study by following that person with your eyes and building in details and proportions, even though the person is no longer in the pose. Quick studies require long, fluid lines thrown down on the page with abandon. When doing a drawing on

location, it is a good idea to do these quick gestural studies in pencil, since that leaves you the option to erase the figure if it doesn't work in the overall composition.

A figure's proportions are the first thing that must be established when drawing on location. A simple approach is to block in the feet, waist and head with chiselled pencil marks. By chiselled, I mean straight lines that define planes. This block figure is used to define where the figure stands in the composition. A second pass with pen and ink adds detail and a sinuous flow to the figure. For more on successfully adding figures to your scenes, see pages 80–85.

▼ **New Orleans Sketching** Figure-drawing classes offer a chance to play and experiment with different media without worrying about composition or getting a finished look. Here, oil paint was thinned down with Liquin and washes added to the page prior to putting down lines. Bold shadows can be defined quickly with the pencil lines, adding detail. By placing a rough perspective grid below the figures, they begin to populate the same space.

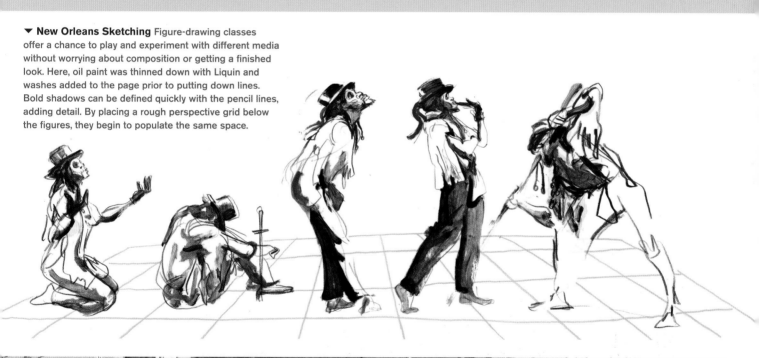

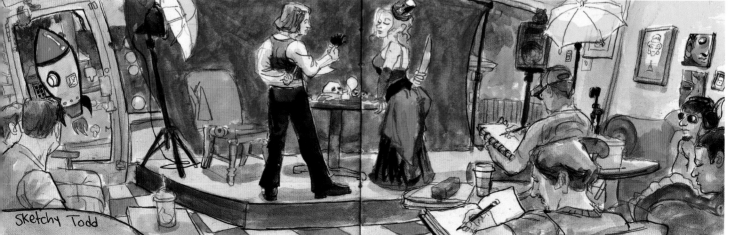

Sketchy Todd

Drawing Strokes

A figure-drawing classroom is a perfect place to get used to the simple act of putting marks on a page. Sometimes, fast, fluid marks are needed, while at other times slow, deliberate marks are required. Repeated observation of the model will help you experiment and find your personal arsenal of marks.

It is important that your figure drawing feels grounded to the model stand. One way to do this is by sketching the feet in position first and then finding the thrust of the gesture through the whole pose. The trouble with starting a figure drawing by sketching the head first is that many students feel the need to get the facial features nailed down before the whole pose has been established. Always focus on the large shapes first and then go back for secondary features like the face. Fast poses will go down quickly if you use long, fluid lines. I also like to do sketches that are executed strictly using straight lines. These straight, chiselled drawings are more about structure. After doing soft and

fluid drawings followed by hard, angular drawings, I combine the two approaches in one sketch. Lines are either soft and fluid or hard and straight, with no middle ground.

In the classroom, it is good to experiment and play with ways to make marks. Take a twig and dip it in a bottle of ink; the twig becomes a simple pen. This exercise will make you realise that there is no magic in finding just the right tool – even a twig can produce great drawings. I don't use a bottle of ink on location, since I dread the possibility of it spilling. But in a classroom it is fun to play. Soft sticks of charcoal can produce bold, dark masses, but again I tend to only play with this in the studio.

I use large washes of colour when working on location as it is the perfect way to quickly define shadow masses.

The most important thing you will discover by repeatedly taking figure-drawing classes is how long it takes you to get a figure down on the page. It is possible to get a loose gesture done in a minute, but five minutes might be needed if you want to include costuming and facial features. On location, you are always trying to guess how long you have to capture someone in the scene. You instinctively have to decide how quickly to work. Even if the person walks away, you will be able to complete the pose thanks to your experiences in the classroom.

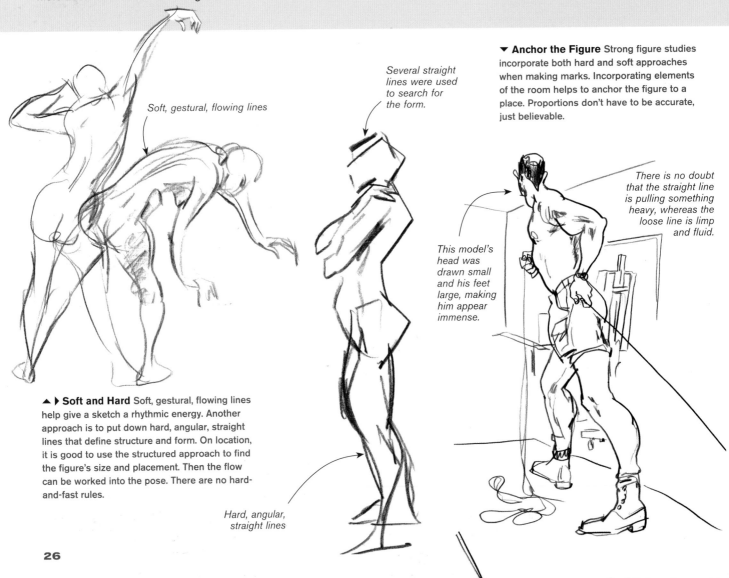

Soft, gestural, flowing lines

Several straight lines were used to search for the form.

▼ **Anchor the Figure** Strong figure studies incorporate both hard and soft approaches when making marks. Incorporating elements of the room helps to anchor the figure to a place. Proportions don't have to be accurate, just believable.

There is no doubt that the straight line is pulling something heavy, whereas the loose line is limp and fluid.

This model's head was drawn small and his feet large, making him appear immense.

▲ ▶ **Soft and Hard** Soft, gestural, flowing lines help give a sketch a rhythmic energy. Another approach is to put down hard, angular, straight lines that define structure and form. On location, it is good to use the structured approach to find the figure's size and placement. Then the flow can be worked into the pose. There are no hard-and-fast rules.

Hard, angular, straight lines

26-9-2012

▲ **Silhouettes** These quick figures sketched by Juan M. Josa use bold black washes to help solidify the forms. If you can tell what a figure is doing just by the silhouette, then you know you have an easy-to-read sketch.

▼ **Value and Form** With additional time, values and forms are added to the figure drawings using hatched lines. When working on location, I seldom use hatched lines, preferring to put down a wash of colour to add darks. However, this is a method well worth learning.

Hatched lines are used to show shadows.

These hatched lines follow the form.

▼ **Wash then Line** These sketches of children on the beach by Patrizia Torres use a simple ochre wash with lines only adding necessary detail. Leaving some lines out allows the viewer to complete the picture. Each pose has a clear line of action.

▼ **Twig and Ink** This figure drawing was done with a twig dipped into ink. By using this most rudimentary pen, you will realise there is no single tool that makes perfect marks. Even a twig can give decent results. Playing with new tools is a good way to keep growing as an artist.

▼ **Using Colour** Bold washes of colour are a quick way to block in mass. Line is then used to define detail and delineate muscle forms. This is a great principle to remember when working on location. By blocking in bold masses, you are less likely to get lost in secondary detail.

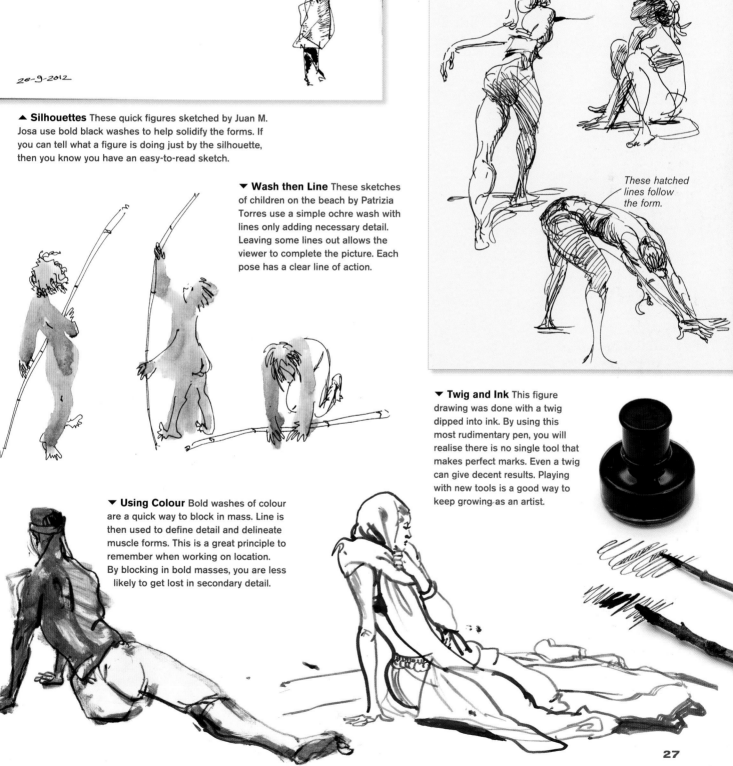

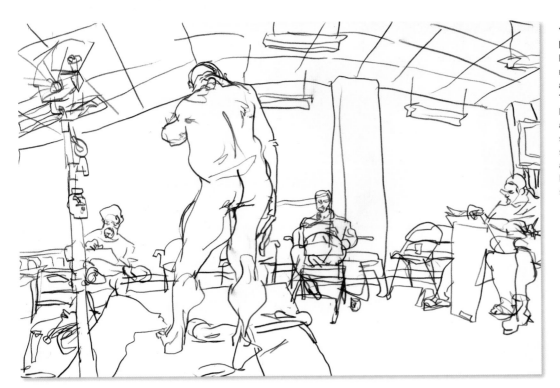

◀ Keep Your Eyes on the Model This sketch was done by contour drawing, where more time was spent looking at the model than at the page. The pencil was repositioned by looking at the page and then another line was drawn while staring at the model. Forms swell and flow expressively and proportions might be off, but that is what makes the sketch interesting.

Contour Drawing

While gesture drawings are done with quick, fluid line work, it is also necessary to slow down the eye by doing slow, deliberate contour drawings. A contour drawing is done by moving your eye and hand with slow deliberation.

▼ **Careful Observation** Since the subject is napping, Anthony Zierhut had time to carefully observe the contours for this sketch. Lines defining folds in cloth have a quirky, directly observed feel. Drawing details like the wires hanging from the walls might require you to look at the page more often. Being brave enough to let the lines flow develops with maturity.

Put the point of your pencil on the paper and then look at the model or object you are drawing. Imagine you are touching the model with the pencil, then, without looking at the page, let your line move as you follow the contour of the model with your eyes. Don't just draw the outside edge, but let the line flow inside the form as well. The line should be slow and deliberate. To retain some control over the sketch, while maintaining the expressive quality of a carefully observed contour, you can put a line on the page while staring at the model and then reposition the pencil point by looking at the page. Then, stare at the model again and repeat.

A blind contour drawing would be a drawing done without ever looking at the page. These drawings can be quirky, with shapes not lining up and things being off kilter. Being able to let go and not worry about how 'correct' a drawing is can result in more expressive work.

By doing a contour drawing, you are forcing your eye and hand to slow down

and observe subtle details. By focusing on a small area it is possible to tackle a scene one small detail at a time. In this way you will not be overwhelmed by any given scene. When sketching people on location, it is good practice to catch them quickly with a gesture drawing and then slow down and add details of the face and costume using a slower contour line. If the

person moves, follow them with your gaze and wait to catch the details you need.

Contour drawing is the best way to sharpen your focus. Pick some object in the scene that you can return to at any time to add loving detail. Since things are always changing, it is good to return and then strike out again to tackle some new challenge.

▼ **Self-Portrait** You are your own best model. To get used to doing contour portraits, sketch yourself in a mirror. Place each contour line with slow deliberateness. Each line is put down without looking at the page. Adding background elements creates a sense of place.

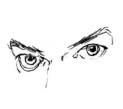

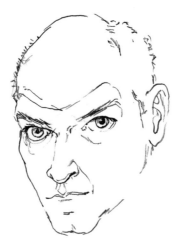

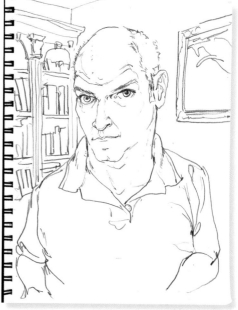

1 Begin with the eyes. If you catch the expression in the eyes, you'll find the rest of the sketch will easily fall into place.

2 As each line is put on the page, stare at the detail being sketched and move your eye at the same speed you move your hand. Don't look at the sketch until you need to start a new line.

3 Focus on each feature being drawn intently one at a time. You only look at the sketch to be sure the features relate well to each other. If something is a bit off, just accept it and move on. No sketch is perfect.

4 Add details of the environment. This step adds the specifics of time and place. If you're sketching somebody else and they lose patience, then work on these details as they relax.

5 Loosely and quickly add watercolour washes (see pages 34–35).

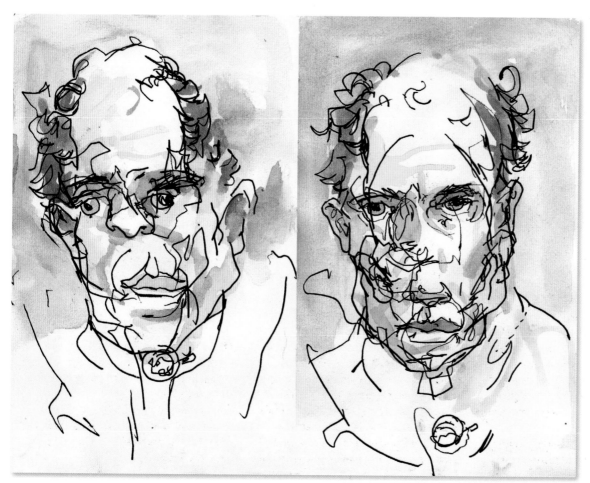

◀ **Don't Look Down** These sketches were done during a staring contest. All the contour lines were put down without looking at the page. Although facial features do not always line up, the expressive, pure observation is what makes the drawings work. Colour washes were applied afterwards.

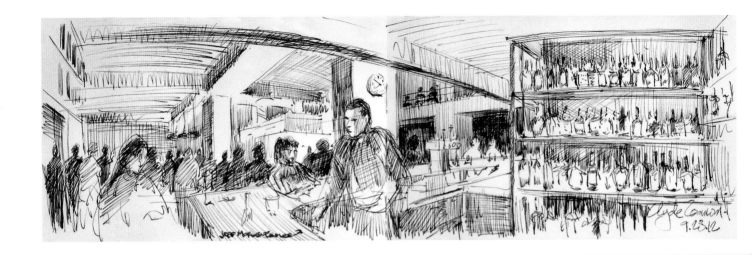

▲ **Hatched Values** In this bar scene by Matthew Brehm, hatch marks imply the shape, form and mid-range value of objects. Cross-hatching creates darker values all the way to black.

Creating Value in Black and White

Any scene will have a full range of values, ranging from pure white through mid-range greys, all the way to black. You could define values using hatching, or use a simple wash to establish mid-range values.

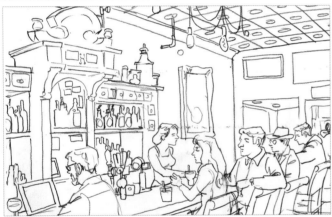

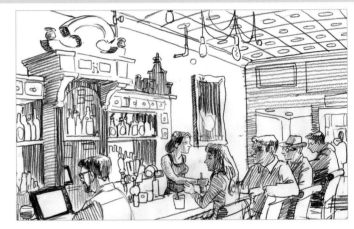

Hatching and Cross-hatching

By placing hatch marks in the shadows, you can build up darks gradually. The only drawback is that this is a slow method of applying value to a sketch.

1 Block in the sketch using contour lines to define shapes. Consider the light source – in this case the windows.

2 Hatch the shadows on the figures, imagining the plane breaks. Press down harder in the darker areas.

3 Hit shadowed areas a second time with cross-hatch marks. Keep working into the darkest areas.

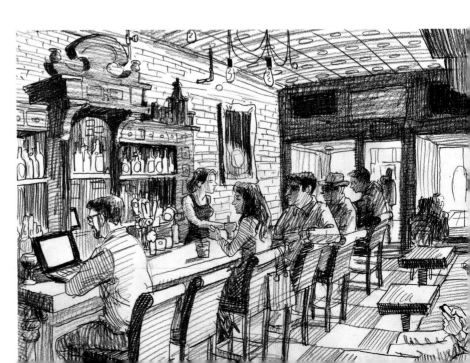

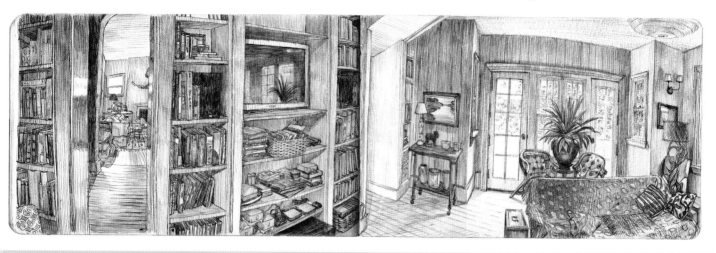

By using line to form the outside shape of an object, you begin to describe shapes in your sketch. By adding value to the sketch you are creating form. When light hits any object it creates at least three distinct values: a grey mid-value, dark shadows and a highlight. You can spend hours refining the myriad of values or you can settle for the basic three for a quick sketch.

Hatching is simply a method of defining value by using a series of pencil or pen lines placed side by side that become a grey tone. If you add more lines across the first hatch marks, you are creating a darker tone; this is cross-hatching. It is always best if the lines follow the form.

▲ **Room With a View** This panoramic sketch by Guno Park uses pencil cross-hatching to great effect to create a range of values, and to add depth and space to the sketch.

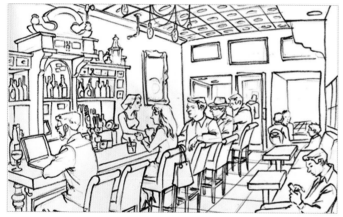

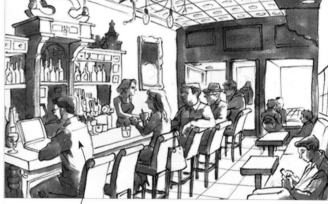

The white page is left alone as the highlights.

Creating Tones with Black Ink

By applying a broad wash of medium value to the shadowed areas of objects, you can get a value study quickly.

1 The Pentel Brush Pen puts down a bold line with plenty of thick and thin to establish the composition.

2 A medium grey wash is applied to the dark side of all objects, creating two values: light and medium.

3 Darks up to complete black are added along with very light washes to complete the scene.

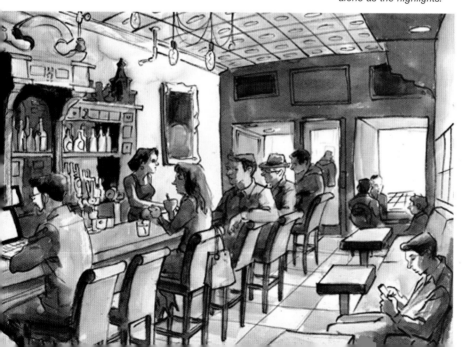

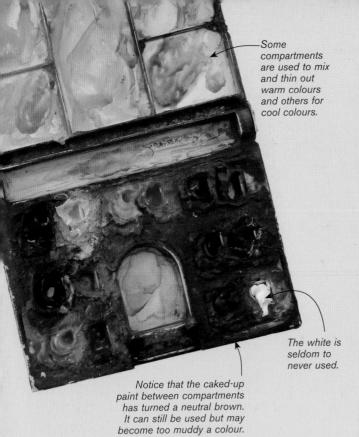

Some compartments are used to mix and thin out warm colours and others for cool colours.

The white is seldom to never used.

Notice that the caked-up paint between compartments has turned a neutral brown. It can still be used but may become too muddy a colour.

▲ **Winsor & Newton Palette** This palette has been in daily use for almost five years. There are a variety of travel-sized watercolour kits, so find one that works for you and start experimenting.

Colour Palette

Anytime you mix two colours, you are reducing the colours' intensity. Working on location, it is important to work quickly. Rather than mix colours on the palette, it is faster to apply pure colour washes on the sketch. To get light colours, add plenty of water to the pigment. To darken the colour, use less water and more paint.

In an ideal world you could mix any colour needed using just the primary colours: red, blue and yellow, by mixing them together in various combinations. Having pre-mixed secondary colours: orange, green and purple (which are formed by mixing two primary colours) in your palette simply saves you from having to mix those colours yourself. Mixing complementary colours that are directly opposite each other on the colour wheel will create various versions of brown (see below).

Generally, it is not a good idea to use black but Burnt Umber mixed with Ultramarine Blue makes a good bluish-black. However, I have found myself struggling to mix large enough batches of it. Sometimes, it just feels good to throw down a pure black once in a while, so you know you are using a full range of values from white to black. Never mix the black with other colours to darken them – it is better to layer pure colour washes on top of each other on the sketch to darken the colour. This is called glazing and is an advantage of using watercolour, as its transparent nature allows layers of colour to show through while gradually darkening

▼ **Colour Wheel** These are the colours used in my watercolour palette. When you mix opposite colours on the wheel you tone down the colours' intensity. Yellow Ochre, Burnt Sienna and Burnt Umber are essentially colours that would result from mixing such opposites. Never use black to darken a colour. I only use black when an object is an undeniable deep black. Too many colours mixed together will make mud.

The spokes of this wheel show complementary colours. Mixing complementary colours produces various browns.

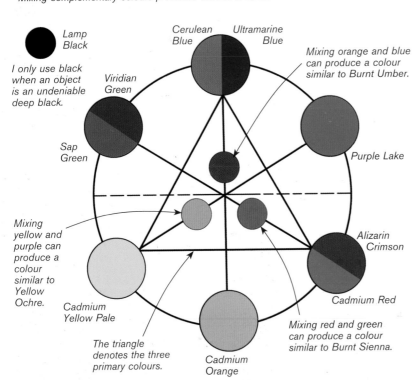

Lamp Black

I only use black when an object is an undeniable deep black.

Cerulean Blue

Ultramarine Blue

Viridian Green

Mixing orange and blue can produce a colour similar to Burnt Umber.

Purple Lake

Sap Green

Mixing yellow and purple can produce a colour similar to Yellow Ochre.

Alizarin Crimson

Cadmium Yellow Pale

Cadmium Red

The triangle denotes the three primary colours.

Mixing red and green can produce a colour similar to Burnt Sienna.

Cadmium Orange

▼ **Useful Mixes** These are some of the mixes that I use a lot. For the first stages of flesh tones, I mix Yellow Ochre and red. When painting foliage, Yellow Ochre is often mixed with Sap Green to warm up the colours. Cerulean Blue and Purple Lake mixed together create great shadows.

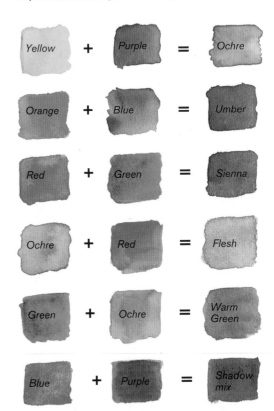

Yellow	+	Purple	=	Ochre
Orange	+	Blue	=	Umber
Red	+	Green	=	Sienna
Ochre	+	Red	=	Flesh
Green	+	Ochre	=	Warm Green
Blue	+	Purple	=	Shadow mix

An artist is in her studio using pure primary colours to create an abstract painting. I applied paint to still-wet areas in my piece to reproduce the pure, poured colours that mix organically at the edge of her work. However, working on location, a wash usually dries before it is touched again.

The primary painting stands out from the dark, neutral floor and the shadowed areas of the room.

Purple is used throughout to indicate shadows. Even the green shirt has purple glazed over it in the shadows.

as you build up layers. Take care not to mix too many colours or layers, as with every mix you lose intensity of colour and gradually a dull, muddy, unattractive colour will develop. Instead, just use the complementary colours, which are opposite each other on the colour wheel. For example, if you want to darken a yellow area, then add a purple wash on top of it.

Pay close attention to the warm and cool colours in your scene. For example, sunlight creates warm highlights with cool shadows. Fill the page with colour. With less time you might get a tinted drawing but, if you have enough time, each sketch will be a step closer to being a solid painting.

Local Colour and Coloured Light

Local colour is the natural colour of an object – unaltered by light or shadow. When sketching a band playing, or in a theatre, the lighting tech will often illuminate large areas of the stage with a bold swath of colour, covering everything in the vicinity and masking the local colour of objects. By painting these large patches of colour, you get to ignore the subtle colours of costuming and hair colour, and apply colour without considering local colour.

Once you realise how liberating coloured light can be, you can make similar bold decisions when applying colour to any location sketch. If you are drawing outside at the golden hour before sunset, you will probably apply plenty of orange and yellow to the sketch; a figure in the shadows will appear bluish purple. When you are adding figures, you get to decide what colours work – what colour shirt, trousers and hair they had. Ignore local colour and fulfill the sketch's needs.

When sketching, if you feel yourself getting caught up in too many patches of local colour, then get out a bigger brush and imagine a spotlight illuminating a large area of the scene. When that dries, add darker areas of that colour to create shadow and form.

▶ **Cool and Warm Spots of Colour** Being outside, the night sky turned these two figures blue, while the indoor light appeared warm yellow, orange and red. Painting the figures blue meant ignoring the local skin colours to find an expressive colour that worked in the world of the sketch.

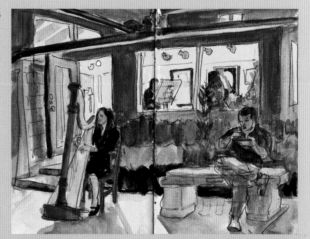

▶ **Spotlights** Stage lighting offers bold areas of primary colour. The performer might be wearing a brown hat, grey shirt and blue jeans. The red stage light, however, made the performer appear deep red. Such bold spots of colour can help any sketch done on location.

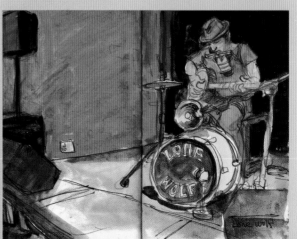

Value and Colour

Value and colour go hand in hand. When working in watercolour, the lightest values are achieved by mixing plenty of water into the pigment. The palette's main function becomes a place to thin out pools of paint.

The fastest way to add values to a sketch drawn on location is with bold watercolour washes. With a small, travel-sized palette and handy Aqua wash brushes (which have water in the handle), it is possible to do loose watercolour sketches anywhere. The brushes make it possible to paint without a cup of water, which always has a habit of spilling. Most objects can be quickly defined with just three values. The local colour of the object would be the mid-value. Highlights are simply achieved by letting the white of the paper shine through. The shadows are the last wash added. This dark colour can be applied right on top of the initial objects' colours.

Working on location, there is seldom time for a careful value study. Rather than try to catch ten different values in a sketch, just focus on capturing three values: black,

white and grey. All watercolour paints have a medium value range straight out of the tube. When you mix any two colours, the value always gets darker. To keep the sketch light and spontaneous, spend less time mixing colours and more time working with the medium values, keeping the highlights white. Add a bold, dark complementary colour in the deepest shadows and you are done.

Working quickly is important and large washes of colour can quickly define the mid-values, darks and highlights. When painting with colour, still focus on the three simple values. Just thin the paint down until you find a good mid-value of the colour. Leave paper for the highlights and come back on a second pass with pure, dark shadows. No matter what colour the object is, try and simplify it to three values.

Rather than applying light colours first, alternatively you can add the darkest value first and then thin that colour down with water and drag this lighter wash across the page to create the mid-tones. Don't follow any set rules about how a painting should be done. Instead, do whatever it takes to get the result needed quickly. If you want an object to appear light, then you might need to darken up the surrounding area. By using a heavyweight watercolour paper, you can also lift out some colour if a value becomes too dark. If you are sketching an urban event, then you are usually limited to about two hours to get a decent sketch. In time, you will learn how to pace yourself and get the colours and values in place before the event is done.

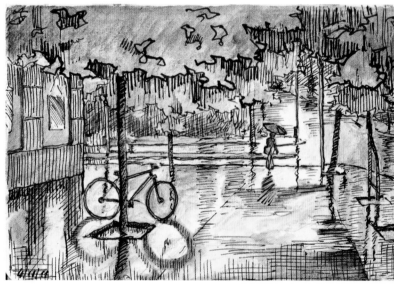

◄ **Three Values** The simplest form of a value study should have black or dark grey, medium grey and white. With these three values you can sketch any scene.

▲ **Ink and Coloured Pencils** This street scene by Ana Rojo consists of largely grey mid-values. The lightest area is right next to the person holding the umbrella. Desaturated colours hint at a wet pavement. Hatching further darkens the scene.

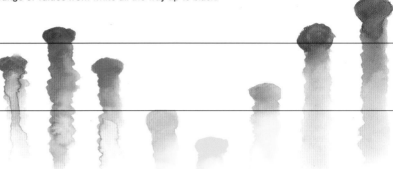

Value and Colour Chart

Each colour has a different value when it comes straight out of the tube. Thinning the pigment with water will bring the value down closer to the white page. A strong image will have a full range of values from white all the way up to black.

| Lamp Black | Sap Green | Viridian Green | Cerulean Blue | Ultramarine Blue | Purple Lake | Alzarin Crimson | Cadmium Red | Cadmium Orange | Cadmium Yellow Pale | Yellow Ochre | Burnt Sienna | Burnt Umber |

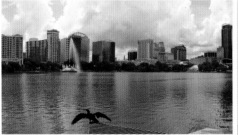

▼ **Contrast and Affinity** This sketch of Lake Eola shows how few values are needed to create a scene, whether you are creating your sketch in colour or in black and white. The cormorant airing his wet wings is the centre of interest. The bird is a pure black silhouetted against white. The high contrast is guaranteed to catch the eye. The buildings are all essentially middle values with darker shadows added, making them appear as a unified mass.

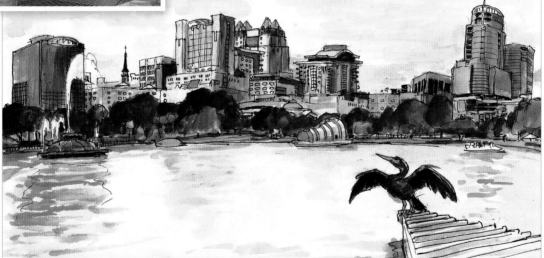

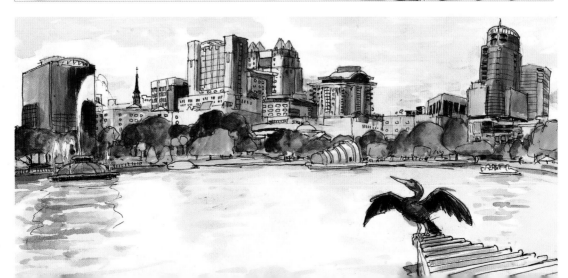

▲ **Inside Notes** The clear envelope in the back of the sketchbook is ideal for saving cards, invitations and flyers which are all useful when writing an article.

Reading the Sketch

Every sketchbook can also function as a notebook. On the insides of the front and back cover, every surface can be a place to take notes. As my sketchbooks get larger, the backs of every sketch get covered with notes.

At times I've thought ahead and purchased small reporter's notebooks. But if someone introduces themselves and offers information, I find it easier to jot notes in the sketchbook I'm using rather than rummage through my bag to find a notebook. If I'm using a fountain pen, a test sheet often gets covered with strokes as I test out the flex on the nib. Notes are imperative to keep track of names, places, dates and snippets of dialogue that all come

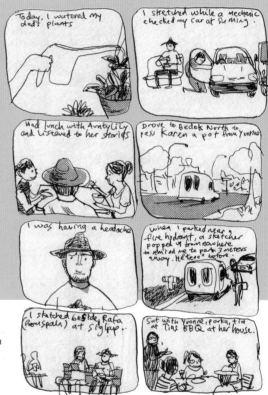

▼ **Journaling** Liz Steel writes her thoughts right on the sketch, creating a personal journal that documents the moments of her life. Entire paragraphs are written and organised into neat layouts.

▶ **Story Panels** Andrew Tan created simple storyboard panels that function to recreate the day. Organising the page into a grid of panels is a long-established format for graphic novels. Find the style that works best for you to tell the story.

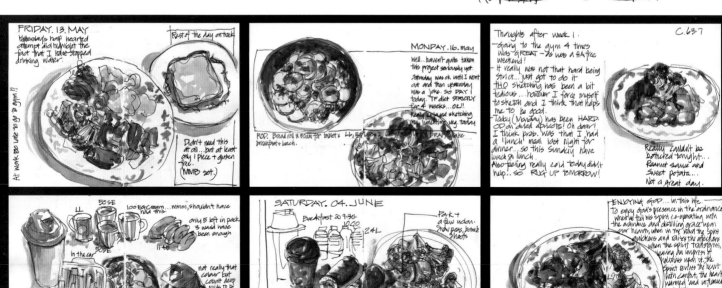

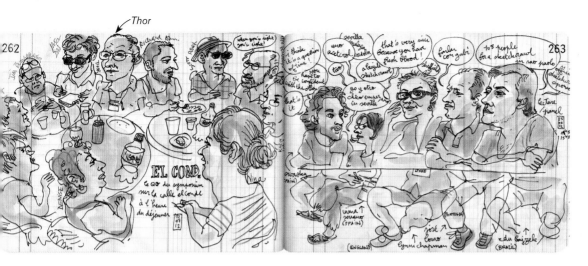

◀ **Santo Domingo**
Lapin sketches constantly, even during lunch. Both these sketches were done in Santo Domingo during the Urban Sketching Symposium. The sketch on the left was done during a quick lunch break. I know this since I was seated diagonally across from him and he managed to catch me in the sketch.

together when reflecting back on the event. When I walk through a museum today, I realise that every painting had some drama associated with it that isn't recorded on the name plates. By writing about your experiences, you get to complete the picture by mentioning the myriad of other senses and happenings that didn't make it into the sketch. A sketch by definition is incomplete, but by writing you can help fill out the scene. With my own work, the sketch stands on its own and becomes complete once it is united with my thoughts written into a blog post. My sketches always have the event name written in a corner and this functions as the title for the sketch.

Some artists will write notes right onto the sketch. These notes help the viewer slow down as they read, thus spending more time examining the sketch. Notes can include small maps, ticket stubs and diary entries. These sketch journals become multi-layered collages with hand-drawn elements and writing all working together. Street names might be written right on the street, or conversation added comic-book-style in bubbles. The possibilities are endless.

Since you might be seated for one or two hours as you work on a sketch, you will often overhear conversations, witness arguments or see many incidents that don't fit into the scene you have established. Writing can bring all these disparate events to light. Some sketchbooks have clear envelopes in the back which are awesome for holding cards, invitations and flyers, which all help to jog the memory. The main thing to remember is: if writing on the sketch will clarify a point, jog the memory or otherwise add to the picture, then write on the sketch!

◀ **Le Cité** Benedetta Dossi lets her fluid writing flow within the sketch, acting as labels. Elements from different scenes mix and collide together in interesting ways.

▼ **Text Block** Black cars are grouped together and form a visual block which is matched by a similar-sized text block on the opposite page in this sketch by Miguel Herranz. The sketch and text are equals that add up to a greater whole.

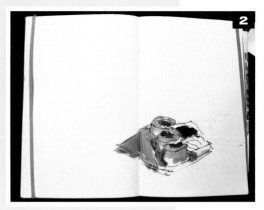

Liz Steel

Sketchbook Journaling: The Closure of a Café

For me, sketching is all about capturing the moment and documenting your life in a unique way. Recording your life through sketches is a rich and exciting way to remember important events – but, in many cases, it also creates events.

Visiting my local café (an amazing teahouse) has become a big event in my life over the last five years, as I like to go and record each cup of tea in my sketchbook. So, imagine my shock to be told that it was closing. This page records the visit there when I was told the sad news – I even had tears in my eyes when I worked on it!

I like to include text and a collection of different images in my sketchbook pages, and mostly spend time during the sketch spontaneously composing the page and looking at different alternatives. On this occasion I started with the scones (which I like to eat warm) and worked outwards from there. After adding the tea cup and pot, I then explored a few alternative layouts before deciding on a vertical grid representing a lattice screen and the horizontal red lounge chair that was nearby. Shadows added towards the end of the sketch tied the various elements together and I made sure that the text was added in a way that balanced the page.

I spent some time on thumbnails to explore layout and composition options.

1 When journaling, it is fun to allow the page to evolve spontaneously after making a few quick decisions at the start. Unlike an overall scene, where all the line work is completed before painting, when journaling, some elements on the page are completed before other parts.

2 Decide on the focus of the sketch and start from there – if it is likely to move (or be eaten), add local colour before starting on objects that will not change.

3 Arrange supporting items that surround the area of focus, paint and then add the shadows to tie them together.

4 When looking for additional graphic elements to complete the page, think about how they will balance each other, how verticals and horizontals will work together and how to connect all objects into a harmonious composition. Do a few quick thumbnails to explore options.

5 Try to preserve areas of clearly defined white space – make it look like you have carefully designed the negative as well as the positive space on the page.

6 When adding text, make sure that it will not destroy the integrity of the sketches on the page – keep it together in a block and use a variety of type or add headings for interest.

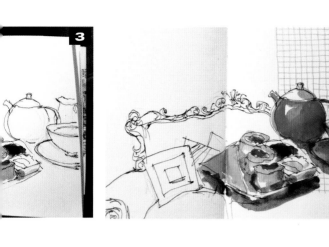

3

4

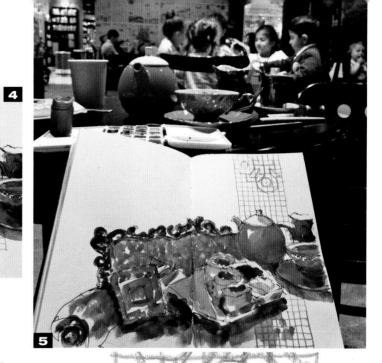

5

It is a great idea to engage other people in your sketchbook by getting them to sign your page.

6 VERY VERY SAD NEWS! T2 is closing down (the teahouse that is the BEST in the world.) I love this place – the STAFF!!, the atmosphere, the tea + cups, + pots + scones! LOVE IT ALL!

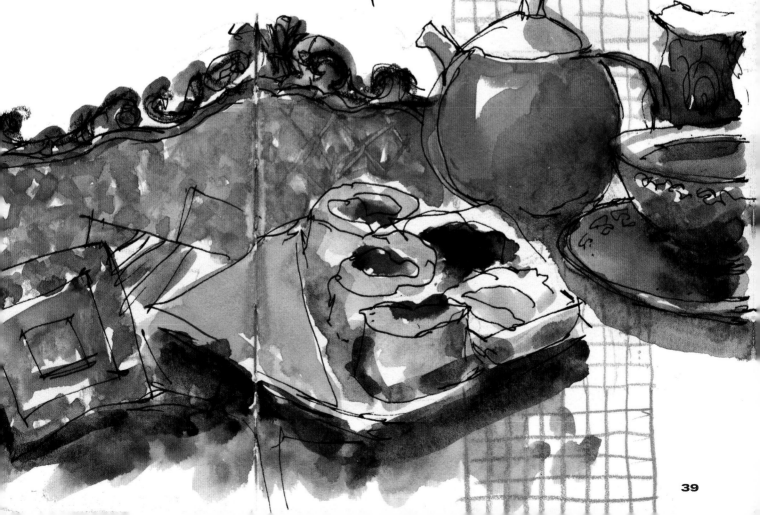

Basic Adjustments

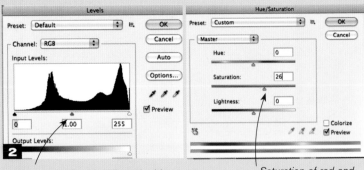

Crop tool was used to crop out unwanted wire binding and excess scanned area.

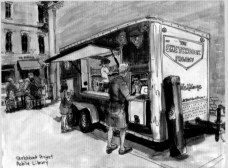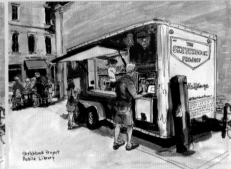

The Levels slider is adjusted a bit to the right to 'punch up' the colours.

Saturation of red and yellow were adjusted.

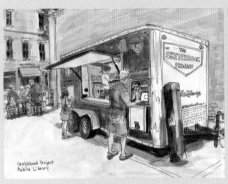

On the left is the original, cropped scan of the sketch, the centre shows Levels adjusted and right has red and yellow Hue/Saturation adjustments. In most cases, this is what is posted online.

Further Adjustments

Background copy layer created and set to Multiply.

Use the Paint Bucket tool to create a white layer behind the background layer. Now you can paint behind the background copy.

Polygonal Lasso tool

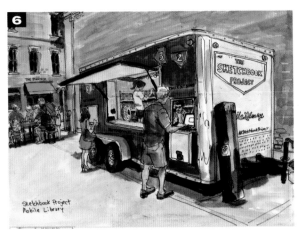

Paint Brush tool was used to paint cool blue colours of dusk. The left image shows the blues painted and the right image is what is seen as the paint was applied behind the Background copy. The Background itself can be turned off, since it isn't seen, by tapping the eye icon to the left of the layer.

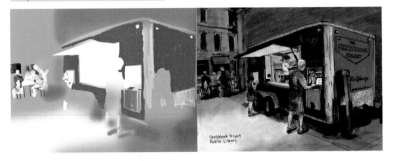

Everything but the yellow/orange windows had the red de-saturated. The red building across the street turned grey as all the warm colour was removed.

8

Warm layer painted and then the opacity of the warm layer was reduced to let warm colours and cool colours mix.

9

The white type was drawn in on its own layer above the Background copy. Some of the black line work was hidden with a layer of paint. A soft brush was used to add a white glow to the two spotlights in the truck.

The final image

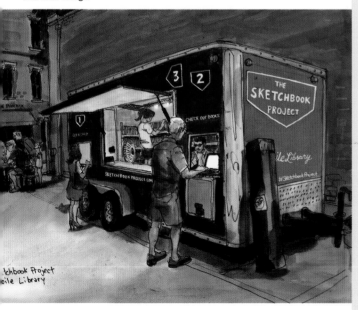

Digital Tweaks

Every sketch posted online requires some fine tuning in Photoshop. The tweaks can be small or the painted aspect of the sketch can be pushed further.

Basic Adjustments

Every time I scan a drawing using a flat-bed scanner, I load the image into Adobe Photoshop, where adjustments are made. Below we look at the steps involved in tweaking one of my sketches ready to be posted on my blog.

1 Use the *Crop* tool to get rid of the sketchbook wire binding.

2 I use *Image > Adjustments > Levels* to darken and enrich the colours, and I always need to use *Image > Adjustments > Hue/Saturation* to dial up the reds and dial down the yellows a bit. This brings the digital image closer to what the original looks like – perhaps only the artist would notice these adjustments. In most cases, that is all that is needed before the sketch goes online.

Further Adjustments

In the case of this sketch, dark storm clouds rolled in and the only warm light came from inside the truck. If all the colours outside the truck were cooled down and darkened, then the truck's open windows would become more dramatic. The orange wall behind the truck and the red building across the street worked against this warm/cool contrast idea. The truck was black with white lettering, which would be difficult to achieve with watercolour, so I decided to do the lettering later in Photoshop.

3 I duplicate the Background layer and set it to *Multiply*. The multiply setting turns everything white on the image transparent.

4 The image now seemed twice as dark, so to get it back to the right levels, I created a *New Layer* behind the Background copy, and filled the layer with white paint using the *Paint Bucket* tool.

5 The *Polygonal Lasso* tool was used to select the warm areas of the truck windows. An animated white dotted line surrounded the selected area.

6 *Select > Inverse* was used to select everything except the truck windows. I wanted to reduce the warmth of these colours. To do this, the *Image > Adjustments > Hue/Saturation* window was opened and the reds were dialed down.

7 A 'Cool' layer was created and the *Paint Brush* tool used to paint cool blue colours behind the sketch layer.

8 Some of the warmth of the alley wall and distant building were needed. A new 'Warm' layer was created and painting continued. Warm colours were painted at 100% opacity and then the opacity of the warm layer was dialed back until it looked right.

9 The final layers were added. I seldom have time to do this much digital work, but since the original sketch was done on location, the spontaneity wasn't lost. Any sketch can be pushed further, but usually it is best to live with what was done and move on to the next sketch.

Chapter 2

Going Urban

Discover how to get outside and start to work on some of the classic subjects that fill up the sketchbooks of urban sketchers across the world. We start with the practicalities of getting out of the studio and sketching on location, and the challenges and rewards this can bring. Some essential perspective rules follow, which will govern everything you draw, from a balcony view of a cityscape to an interior sketch of your favourite café.

Learning to consider composition, explore space indoors and out, and find your sketch anchor will open the doors to a whole world of sketching opportunities right on your doorstep.

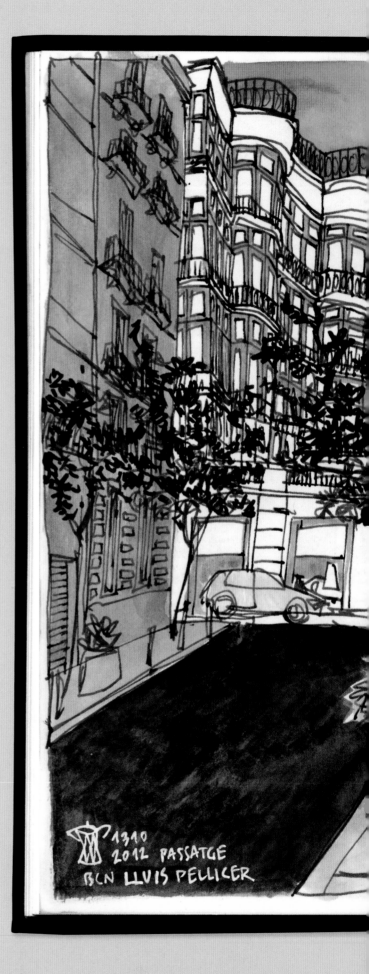

Passatge Lluis Pellicer (left)
Of Sketches and Flirts (right)

Miguel Herranz

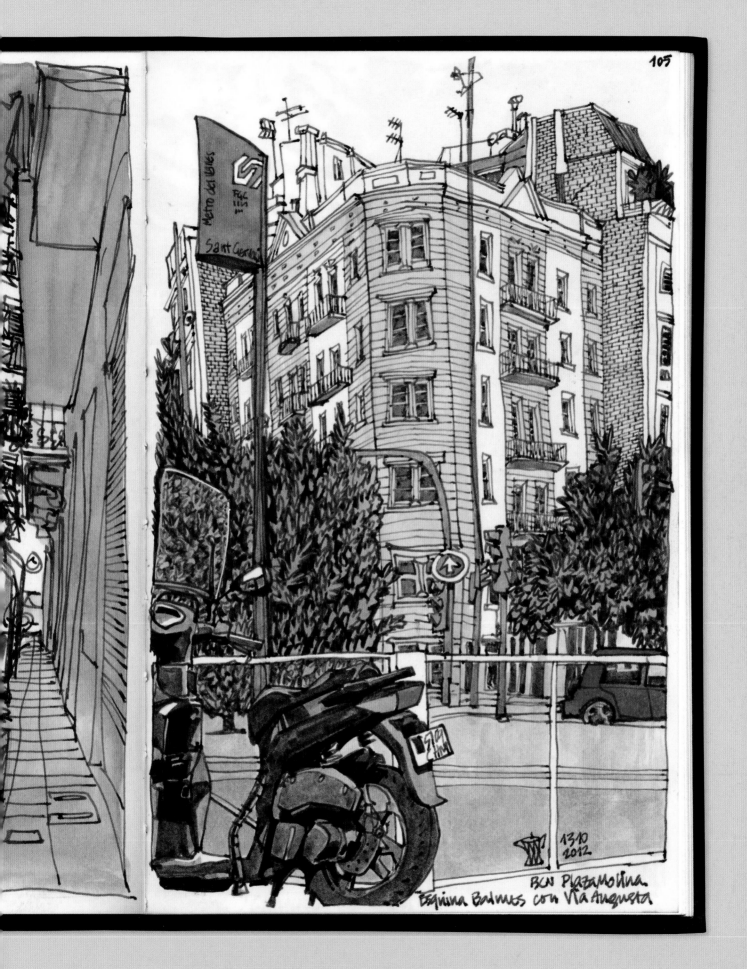

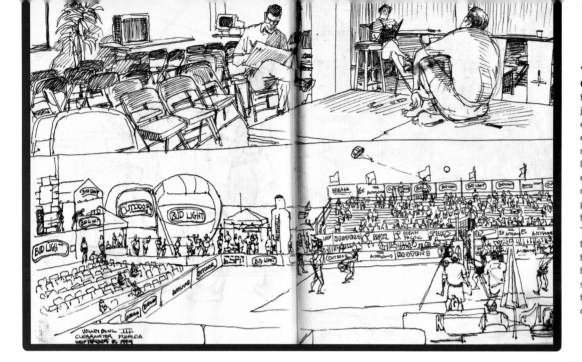

VOLLEY BOWL III
CLEARWATER FLORIDA
SEPTEMBER 8, 1999

Getting Out of the Studio

The figure-drawing classroom is a small microcosm of what it will be like to draw on location. You need to truly study not just the model, but the space and all the participants. The centre of interest isn't always the model posing. The studio is a great place to experiment and build your drawing chops, but getting out and sketching your community has so much more to offer.

A university lecturer teaching history of art gave a test to his students on the final day. Rather than have the students write a long essay about art history, he asked them to draw or describe the door to the classroom. It is only now, after years of sketching at events, that I realise the importance of that lesson. For many people, everyday scenes are boring and are largely ignored for other concerns in the mad rush of life. As an artist, you have to take the time to slow down and truly observe everyday life. There is drama in every scene you encounter. You might not see the drama until you have been sitting and drawing for an hour. There is beauty in the mundane as well as the spectacular.

Once you take enough figure-drawing classes, you will reach a point where you capture a pose with time to spare. Turn your attention to your fellow students and capture the essence of the room. This type of sketch is much like what you would sketch at any event on location. If you carry a sketchbook everywhere you go, you can create sketches in the quiet moments of your day. At some point you might find that you can't resist sketching in event programmes or on napkins if you don't have a sketchbook on hand.

The next step is to set aside time each day to go out and find a sketch opportunity in your community. Each time you sketch, you will discover leads to new sketch opportunities. If you share every sketch you do online, then slowly your confidence will build. You might be concerned that people will not like your sketch, but in time you will realise that very few people even notice you at work. Once you catch someone's gaze, they will become curious about what you are doing. The simple trick is to not catch their gaze as you sketch. I used to experience 'stage fright' every time I went out to sketch – I would walk around the block several times until I built up the nerve to start the sketch. Over time, the nervousness disappeared to be replaced with the excitement of going to sketch something new.

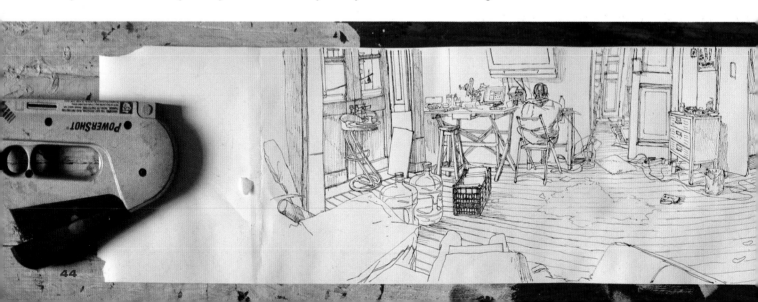

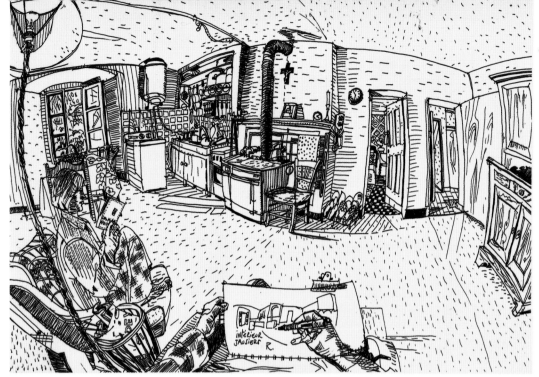

◀ Close to Home Like A. Rmyth, start by sketching your everyday environment. No aspect of your everyday life is too small to be sketched. Every room is a setting for the drama of life. While others read or watch TV, you could be sketching.

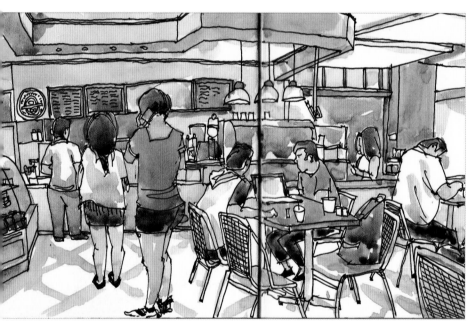

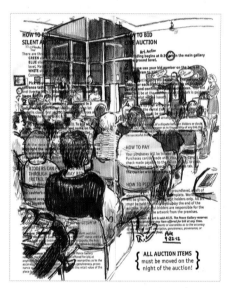

▲ Never Waste a Moment Coffee shops or restaurants are perfect places to people-watch and sketch. Teoh Yi Chie's sketch of a Coffee Bean in a shopping centre incorporates people in a queue and animated conversations at a table into a complete scene.

▲ Any Opportunity When you find yourself sketching in the margins of event programmes, then you know it is time to start carrying a sketchbook everywhere you go. Here, Pete Scully makes use of an auction programme which would otherwise be thrown out.

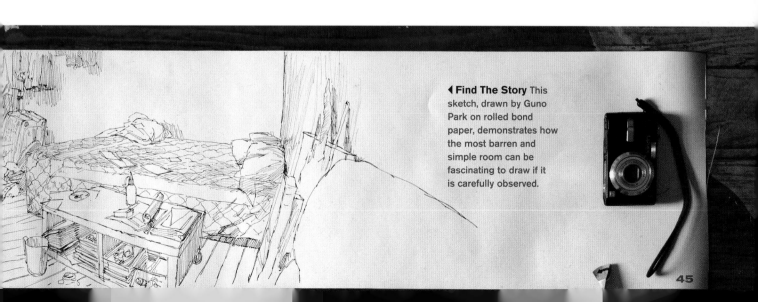

◀ Find The Story This sketch, drawn by Guno Park on rolled bond paper, demonstrates how the most barren and simple room can be fascinating to draw if it is carefully observed.

1. The quick pencil composition

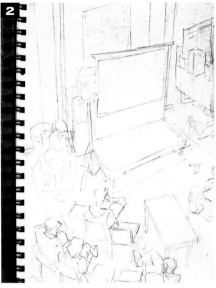

2. Sketched-in figures

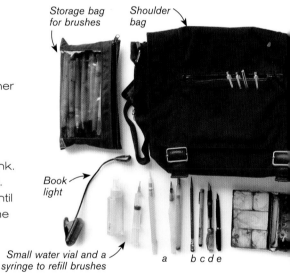

3. Inked-in audience

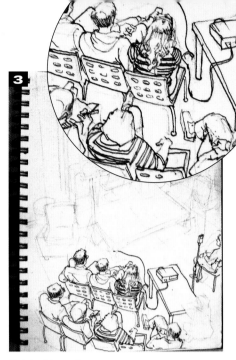

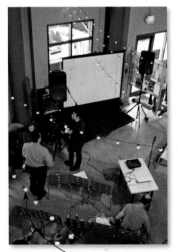

Hanging strings of lights were ignored.

Sketching on Location

My sketches always tend to focus on the creative process and the reasons people gather together in public forums. Authors, poets, musicians, actors and visual artists all inspire my work. This is a typical daily sketch assignment on location. My assignment is to report on a flash Fiction Slam at Urban Rethink. The sketch is my way to document the event. For me, the report isn't complete, however, until I also write about the event. On the back of the sketch, authors' names are noted and the winners of each round are highlighted.

Storage bag for brushes

Shoulder bag

Book light

Small water vial and a syringe to refill brushes

a b c d e

Arriving at the venue a little early allowed me to pencil in the seating and staging before people arrived. As people milled around and chatted, the composition was established in pencil. It is always important to use every available moment to sketch – if I am approached, I've learnt to keep sketching as I speak. At the start of the evening there was daylight, but I knew that the colours when added would reflect a darker evening scene. Hanging lights were ignored for simplicity.

1 Using pencil allows for erasing or repositioning things if needed. By lightly sketching in the chairs, it was possible to later quickly sketch people into the seats as they arrived. Most of the focus at this point was on establishing the perspective in the room.

2 As the audience arrived I frantically sketched them into their seats, all the time paying attention to their posture and gestures. I might change a figure several times until I'm sure that their signature pose has been found. A girl sat in a lounge chair next to the stage. I considered blocking her in but realised she would probably move since she wasn't facing the stage. She did move and she was erased.

3 Fountain pens were used to ink in the audience. I knew that the reader on stage would be the last person sketched. I considered blocking in a figure standing on the right but decide against it. The film screen turned out not to be an important element, so it was erased.

4 After sketching the figures using the fountain pens, I switched to a Micron pen for simple architectural details. The author that I suspected would win was sketched on the stage. If this author won the first round, I would get a second chance to catch details in the final rounds.

5 The first watercolour washes were applied thinly with plenty of water. In this case, thin primary washes of red, Yellow Ochre and blue were applied. The lightest values were left as the white page. At this stage the focus was on covering as much of the sketch as possible with light washes.

6 Smaller areas of colour were blocked in and attention paid to the local colour of people's outfits. Each figure has three values: light, medium and dark. The same

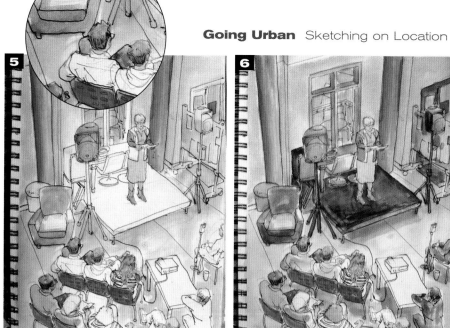

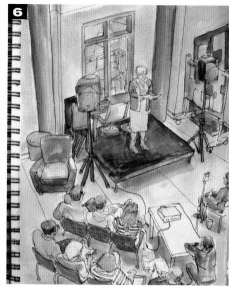

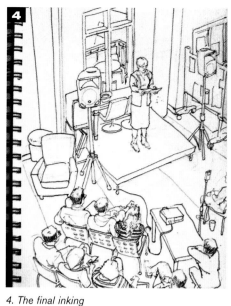

4

4. The final inking

5

5. First washes

6

6. Further blocking in the darks

Stillman & Birn sketchbooks

Rag

a. Aqua Wash Brush pens of various sizes

b. Blackwing 602 Palomino pencil

c. 05 Micron Pen

d. Noodler's Ahab Flex Nib Fountain Pen

e. Noodler's Crawler Fountain Pen

f. Winsor & Newton travel palette. For colours, see page 16.

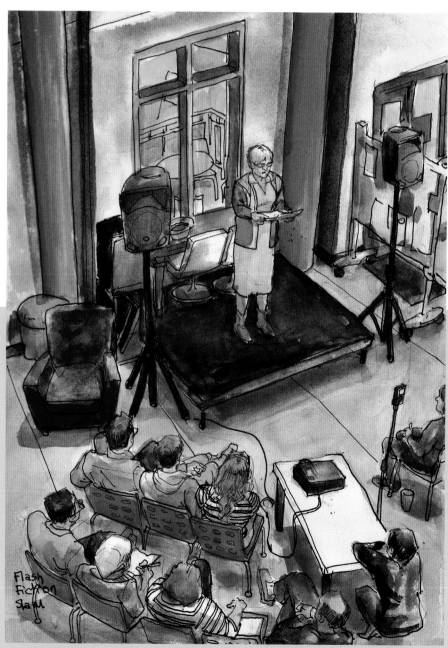

three-value treatment was given to the room. Shadows were added and the image slowly darkened. Shadows were hit with thick juicy paint and, in this final 10%, the image truly came together. The richer the darks, the more the scene will jump off the page. When the event is over, the sketch must be complete. I was still working as people put away the chairs.

▶ **The Finished Sketch** With this spoken word subject matter, I knew that I would have limited time to draw any given reader. I focused on the audience as well as the reader. Much of the fun was trying to decide which author was likely to win the slam. In this instance I chose correctly. At no point do I ever feel satisfied with how the sketch is progressing. It is only later when I look through the sketchbook that I realise it isn't the worst sketch I ever did.

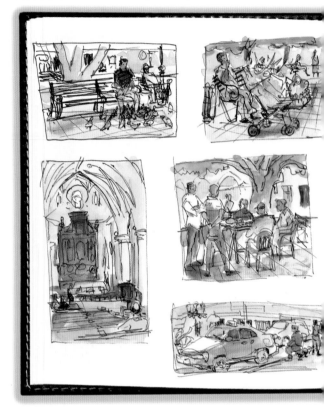

▼ **Thumbnail Page** These thumbnails were done in Santo Domingo as part of the Urban Sketching Symposium. First, each picture outline was drawn and then each thumbnail sketch took about 15 minutes. Notice that no lines are drawn entirely straight. Accuracy is considered after spontaneity.

▲ ▶ **Thumbnail Variety**
Virginia Hein makes good use of Cretacolor Aqua Monolith indigo watercolour pencil and water brush in the blue-grey value study thumbnails of an ice rink (above). She then creates quick value studies of Descanso Gardens using a fountain pen with Noodler's black ink (right), hatching since the studies are small (each less than 75mm/ 3in in size).

Gazebo

Japanese Garden

Thumbnails

For some artists, jumping in and immediately starting a large sketch on location can be a daunting task. A good way to warm up and ultimately decide what story needs to be told is to do a series of thumbnail sketches.

Thumbnail sketches, as the name implies, don't need to be much larger than your thumb. Thumbnails can be put down in a matter of minutes, whereas a finished sketch can take several hours. It is much easier to experiment with composition ideas on a small scale. I use a second, smaller sketchbook, just 210mm wide by 135mm high (8¼ by 5¼in) for thumbnail studies. I'll use this book when I know time is limited. Artists tend to cherish sketches done in larger sketchbooks, while smaller sketches can be liberating since they are done quickly.

▼ **Multiple Thumbnails** Four thumbnail sketches were done in the time it might usually take to do two 280 by 355mm (11 by 14in) sketches. By working fast and working small, you get to experience and explore more locations.

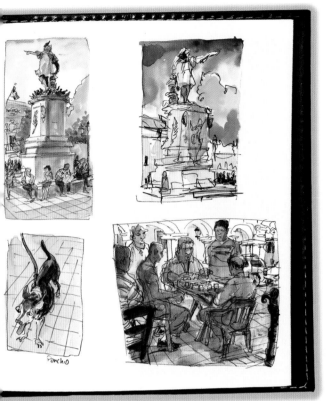

▼ **Disney Thumbnails** Orling Dominguez created these ink thumbnails at Disney's Animal Kingdom in Florida. Her bold use of ink creates patterns and shapes quickly. Foliage, architecture and people are all incorporated on a small scale.

◀ **Limited Lines** These small pencil studies were done quickly to create compositions with as few lines as possible. This is essentially my approach to each large-scale sketch as well. Look for simple shapes in the scene, without detail.

A loose page of thumbnails will help you as you consider the composition, staging and important large shapes that are needed in a sketch. You are less likely to become caught up in every little detail of a scene if the sketch is small. These small sketches can later be used as inspiration for a much larger sketch done on location. Thumbnails don't need to be in colour – you will work faster if you just do quick pencil or pen studies. Thumbnails are a great place to experiment and let loose.

In an animated feature film, thumbnails are used by storyboard artists and animators to find great storytelling moments. Thumbnails serve the same purpose for a sketch journalist working on location. Any artist is trying to convey just the right moment that needs to be caught in the sketch; sometimes that moment is obvious, but other times unexpected events transpire that weren't considered but need to be caught. A thumbnail sketch can be incorporated into an article as a secondary visual note to add detail. The goal is to capture the overall ambience of an event, and sometimes a few quick thumbnail sketches can tell the story better than a larger, detailed sketch.

Composition

For any artist sketching on location, a composition is simply an interesting arrangement of shapes on a page. The space around objects is as important as the objects themselves. Drawing to the edge of the page helps the viewer feel that the world of the sketch continues beyond the picture plane.

A sign above my desk reads: 'Don't draw things, draw ideas.' A sketchbook isn't just a place to visually catalogue the world around you; it is a tool to learn about the community in which you live.

The first concern when starting a sketch is to find how much of the scene you can fit on a page. If it is a tall building, then mark the top-most point and the lowest point to be sure you can fit the whole structure on the page. If you are sketching a wide panorama, then find the furthest left object and furthest right object. The information that lies in-between can often be adjusted to compensate.

When I was working as a graphic designer back in the 80s, there were no computers and photos on a page had to be positioned so the printer knew how to crop the photos. A slide projector was used to position the image on the layout and the image was traced with as few lines as possible. This is what you need to consider every time you start a sketch. Use a pencil to indicate the large forms of the composition before using an ink pen to add the details.

Composition Tips

- Avoid lines that follow the flat picture-plane grid.
- Don't let lines run parallel to the edge of the picture, particularly near the edge of the picture plane.
- Rather than squares and rectangles, search for interesting trapezoids and wedge shapes.
- Balance out the objects of the composition on either side of the centrefold, like balancing weights on a seesaw.
- Curved lines in a composition are an elegant way to help guide a viewer's gaze. That is why I will often curve even structurally straight elements, such as walls.
- Leave out anything that blocks a story element. If a tree is blocking a view, then erase it. If a person blocks your view, then sketch another element until they move.

▶ **Avoid Even Spacing** Nothing is more boring than a picture with the centre of interest right in the centre of the sketch. A stronger composition is found once you position things a bit off centre. See page 52.

▶ **The Rule of Thirds** This convention proposes that an image should be imagined as divided into nine equal parts by two equally spaced horizontal lines and two equally spaced vertical lines, and that the centre of interest should be placed along these lines or their intersections. Aligning a subject with these points creates more tension, energy and interest in the composition than simply centring the subject.

Decide if you want the horizon ⅓ up or ⅔ up the page.

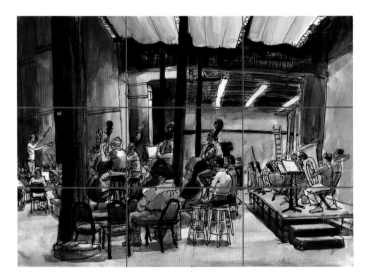

▲ **Considering Thirds** When sketching on location, it isn't necessary to be mathematically accurate when considering thirds. In this sketch, the floor plane meets the far wall ⅓ of the way up the sketch. Keep things off centre and let the location dictate the composition organically. This composition began with the decision to include the conductor on the left and the tuba player on the far right.

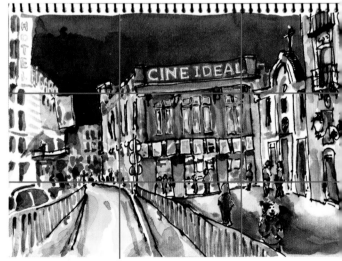

▲ **Two-thirds Left** Ana Rojo divided this nocturne into thirds. It is important that the road doesn't converge with the horizon directly in the centre of the page, but rather ⅔ to the left.

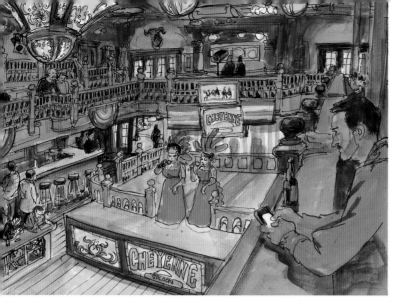

◀ **Find the Big Shapes First**
Even complex scenes like the Cheyenne Saloon and Opera House begin by breaking up the composition into about four simple shapes. In this sketch, the skylight was drawn first. It was drawn bigger than real life since the detail was worth capturing. The second shape found was the opening created by the balcony. Note that no lines run parallel to the edge of the page. The audience member in the foreground showed up late in the performance and I used him to frame the picture on the right.

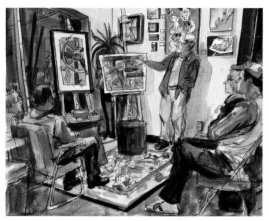

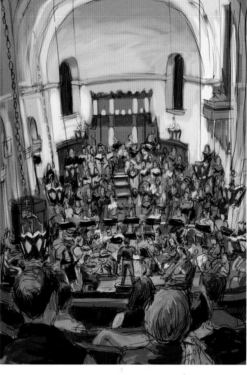

▲ **Create a Visual Aisle** You can 'bookend' a scene by placing figures at the far left and far right of the sketch. This invites the viewer to travel inside the composition between the figures. The centre of interest is kept off centre. Of course, having someone pointing at the centre of interest further stresses its importance. There is nothing wrong with being obvious.

◀ **Breaking the Rules**
This digital sketch is a rare case where a symmetrical composition seemed to work. A triangle is the largest image implied by the composition. The side walls angle down towards the floor, creating wedge shapes.

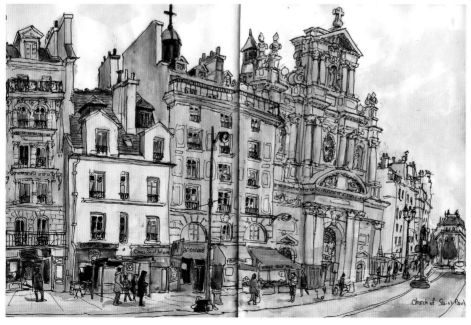

◀ **Avoid the Centre** The horizon in this sketch is very low on the page, suggesting that the viewer is looking up. The centre of the church façade is drawn ⅔ of the way to the right, thus avoiding the centre where the sketchbook gutter lies. All details in the window arches and doorways were added after these compositional decisions were made.

51

Perspective: Single Point

The most difficult thing to face every time the sketchbook is opened is a blank page. It is important to strike, to make a mark, any mark, and to start the process of the sketch. I often start with the humblest of marks, a dot or point. Many sketches revolve around establishing a single-point perspective, so it's a good place to start.

Imagine standing in a square room. Each time you face a wall, a vanishing point exists and can be imagined. Each wall you directly face will have its own single-point perspective. The position of the point is based on your height and position in the room. From that point, you can radiate all the lines of the room as well as a grid pattern on the floor. Everything in the room, furniture, fixtures, even people, is then positioned based on the one-point perspective.

Keep in mind that you probably don't want the centre of interest or the horizon to be exactly in the centre of the page. How many boring family photos have you seen where the face is exactly in the centre of the image? Offsetting the centre of interest to the left or right creates a more interesting negative shape around it. Working across two-page spreads in a hardbound sketchbook is a great way to avoid that habit of centring things.

Begin your sketch by playing a game of 'Where is the vanishing point?'. When you enter any venue to sketch, the vanishing point is the first thing you should consider. If the point is above the halfway point on the page, that indicates you are looking down on the scene; below the halfway point implies that you are looking up towards the ceiling. It can help to actually draw the point on the page; with experience you'll be able to place your index finger on the page and aim the construction lines towards it.

 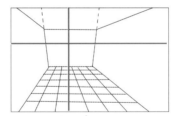 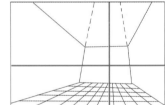

Centre of interest in the centre Horizon on centre of page Offsetting the centre of interest and avoiding a central horizon will add interest.

▲ **Centre or Off-Centre** Avoid placing the centre of interest directly in the centre of the sketch. Placing the vanishing point and horizon ⅓ or ⅔ the way up the page is a good starting point. It is also a good idea to place the vanishing point left or right of centre as well. See page 50 for more on the Rule of Thirds. Notice how I tilted the outer edges of the far wall. If the vanishing point is low on the wall, then you are seated or close to the floor looking up. Notice how the wall edges are tilted the opposite way. The floor tiles can be added loosely with all the lines radiating from the vanishing point.

Mirror

▶ **Using a Reflection** When sketching in a room with mirrored walls, the vanishing point becomes obvious, since it is located right between your eyes in the reflection. If you can imagine your reflection in any wall you face, then you can place the vanishing point in the scene.

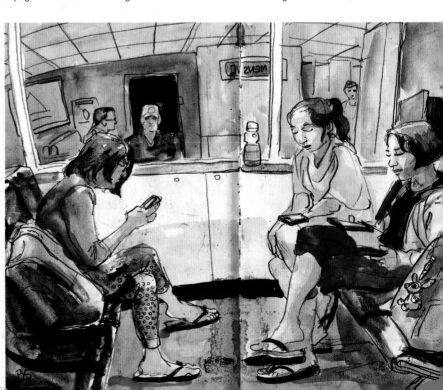

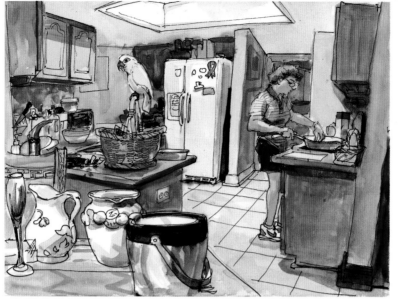

▶ **Find the Perspective** Here, we look at the construction of a single-point perspective sketch. Notice that the vanishing point isn't in the centre of the page, nor is the implied horizon midway down the page. You will also see that tiles closer to the foreground are bigger than tiles that recede into the distance. As you sketch, imagine the room and the objects in it like transparent boxes. This will allow you to imagine not only the planes of the object facing you, but the planes of the objects that cannot be seen.

Vanishing point

1 The right-hand cabinets offered the best clue to the vanishing point. The horizon and vanishing point are ⅔ up the page and eye level is about halfway up the far wall.

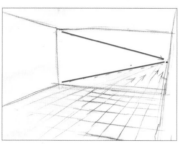

2 Sketch in the back wall and then aim the side wall construction lines towards the vanishing point. Adding a grid pattern on the floor will help to further solidify the perspective of the room.

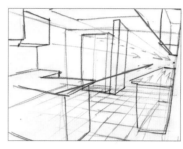

3 Sketch in the cabinetry and fridge, thinking of them as transparent boxes in space. Single-point perspective is most obvious when you look straight back into a room, or straight down a road to a vanishing point on the horizon.

▲ **Spatial Boxes**
Even the person added to the scene was thought of as occupying a simple box-shaped form. The box isn't drawn, it is only implied. The person placed in the scene will relate to the vanishing point, much like a chess piece on a chess board. The figure is built from the floor up, considering the cross-sections as they relate to the vanishing point. The waist is below the vanishing point, and thus it arcs downwards.

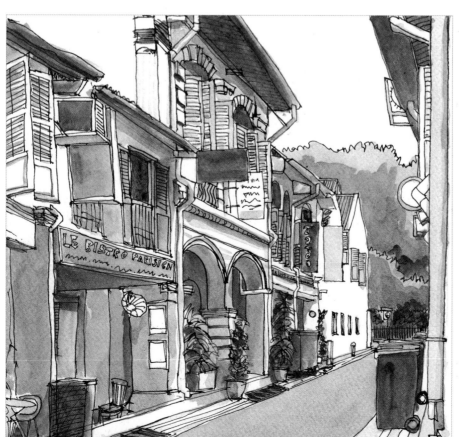

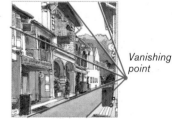

Vanishing point

◀ **Lead the Eye** This street scene by Teoh Yi Chie makes good use of single-point perspective. You just have to follow the road to the horizon.

Perspective:
Two and Three Point

Two-point perspective is most obvious when looking at large buildings or viewing an interior from a corner of the room. Three-point perspective can be used to give size to extra-large objects and buildings.

With two-point perspective, the second vanishing point is often outside the picture plane. If you are sketching on location and you see a road that trails straight off into the distance, then you have found a very obvious vanishing point where the road hits the horizon. If that road is heading due North, then you can be sure that, due East, there is another vanishing point. I never use rulers or actually draw lines all the way to the vanishing points; I just need to have a general idea of where they are so I can use them as guides. Sketching is about interpretation and art, not technical

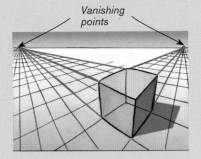

Vanishing points

◀ **Two Points** The two vanishing points are on the horizon, each used to distinguish the planes on the side of a cube-shaped object. Notice that the two vanishing points are located 90 degrees apart from the centre of the cube.

accuracy. As long as the scene is believable and tells a clear story, then the sketch is successful.

The most dynamic vantage points can be found when you look up at tall buildings, or look down from a high elevation. Such views incorporate a third vanishing point, since lines of the large object converge as they fall away from the viewer. Three-point perspective works well to imply large spaces. A very tall object will appear to grow smaller as it rises up and away from the viewer. A giant's head might appear small, whereas his feet would

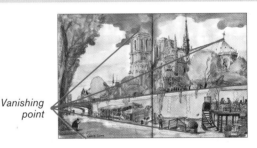

Vanishing point

▼ **Massive Architecture** The story point in this sketch of Notre Dame isn't just the magnificent historic architecture, but the man looking at his mobile phone and the tourist taking a photo with his digital camera.

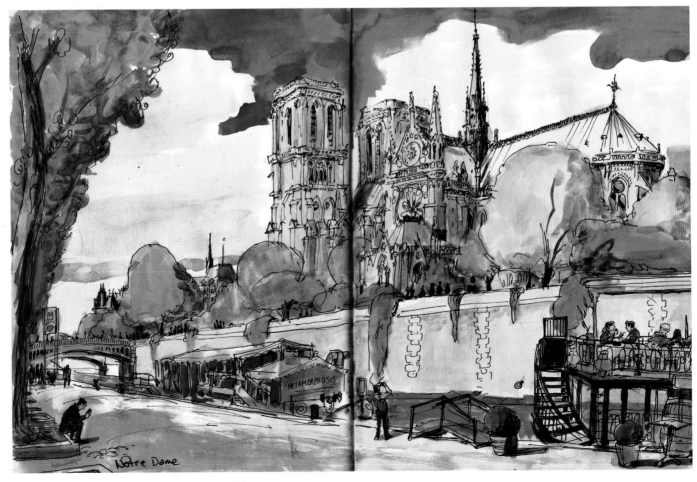

Notre Dame

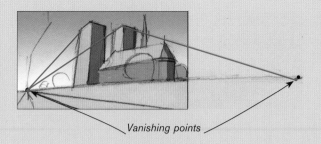

Vanishing points

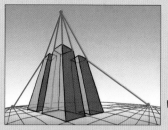

Vanishing point 3

Vanishing point 1

Vanishing point 2

◀ Second Point off the Page
Often, the second vanishing point
will be off the sketchbook page.
Having a general idea of where it is
will help you as you sketch in the
angles of the structure. You don't
need rulers or protractors, just
some instinct and common sense.

▲ Third Point Above Imagine drawing
tall buildings on a city street corner. When
you look up at skyscrapers, there would
be a third vanishing point high up in the
clouds, as the buildings' floors and
windows grew smaller. It isn't important to
define exactly where, you can just consider
the base of the building to appear bigger
in the sketch than the top.

be huge as you stood looking up at him. In some theme parks, the
upper stories on buildings are actually constructed with smaller
windows and forced angles, thus creating the illusion of a larger
scale than actually exists. As artists, this is our goal: to use
perspective as another tool to create dynamic images that convey
a story. It is a way to fit more of the scene onto the pages of
the sketchbook.

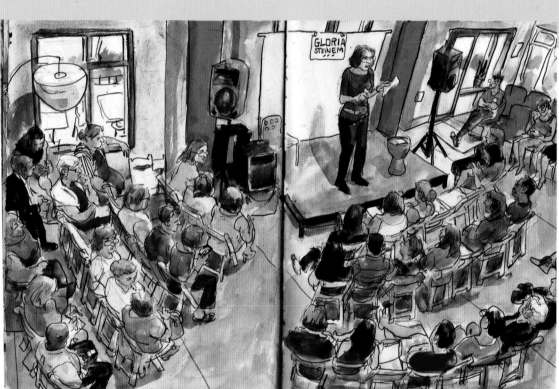

▲ Third Point Below This sketch was done
from a second-floor balcony looking down on
the talk below. A third vanishing point exists
directly below the floor. The people seated in
the room occupy imaginary cubes of space
that aim down at the third vanishing point
below the floor. The other two vanishing
points are high on the page. Since two of the
vanishing points were off the sketch, I implied
them instead of physically drawing them.
Once you understand the principle, you can
use it to help mould the space to suit the
needs of the sketch.

Vanishing point 1

*Vanishing
point 2*

Vanishing point 3

Perspective: Three-Point Curves

Sometimes straight lines aren't enough to fit everything you want into a sketch. Three-point curves allow you to fit a full 180-degree vista onto a sketchbook page. If you consider any floor as a stage, then three-point curves allow you to push the stage out towards the viewer.

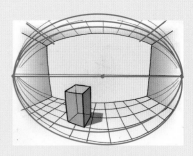

▲ **180-Degree View** The centre vanishing point acts as the one-point perspective vanishing point, while the two outside vanishing points work to create a fish-eye distortion.

Three-point curves use three vanishing points, with curved lines between the two outer vanishing points. The curved lines imply a 'fish-eye' lens effect and the objects are warped and pushed out towards the viewer. This effect can add drama to an otherwise straight-on view, making the space feel more expansive. The effect is very much like what you would see if you looked through one of those front-door peepholes. Once you start to mould and warp the scene to suit the needs of the sketch, then anything is possible. Sometimes you might find yourself wishing that you could incorporate an object in the far left corner of a room as well as an object in the far right corner of the room; three-point curves can make that possible.

Our eyes are round, so in many ways this is how we perceive the world through our peripheral vision. If you were to stand inside an expansive hall or cathedral, you would see with your peripheral vision so much more than could be captured with a single picture. This is why so many amateur photographers find themselves backing up when they want to take a photo – they wish they could fit more of the scene into their small viewfinder. Any artist feels the same way; we use any trick we can to fit more of the world on the page. Some sketches just require an expansive stage.

▼ **Fish Eye** A room packed full of people could present a challenge to an artist. By using three-point curves, you can fit more people onto the page. Knowing what details are important to include on the left and right of the scene will help you to decide how much curved distortion is needed.

Vanishing point

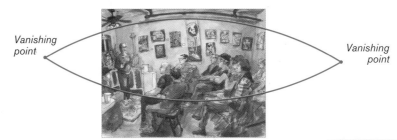

Vanishing point

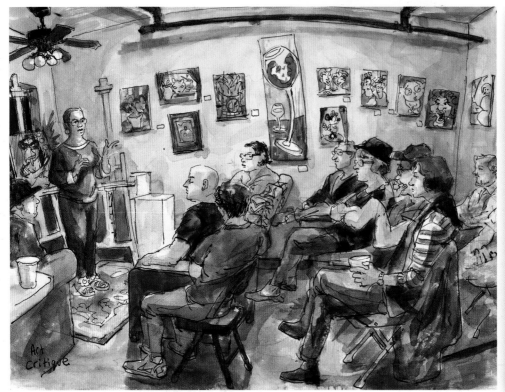

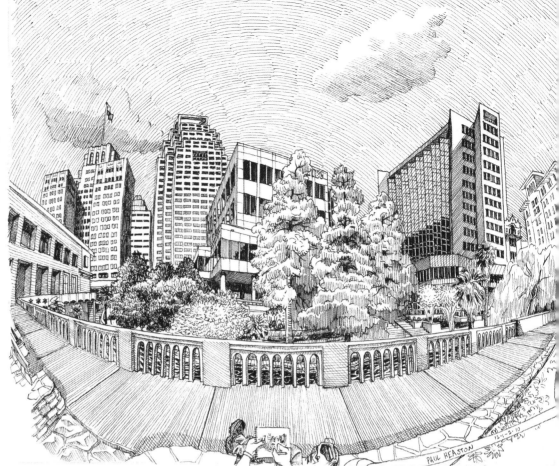

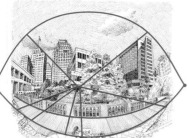

▶ **Spiraling Scenes** This city scene by Paul Heaston feels massive because the line work spirals around the distant vanishing point. The human element adds a spark to the sketch, since the artist's hands and the sketchbook are included at the bottom of the page.

▼ **The Whole Block** By using three-point curves, Paul Heaston is able to fit an entire city block into his panoramic sketch. Hatch lines in the sky and street all radiate from the central vanishing point. Try to sketch an entire city block or large building using three-point curves. Try to fit more of your peripheral view onto the sketch and open your mind to the expansiveness of the scene.

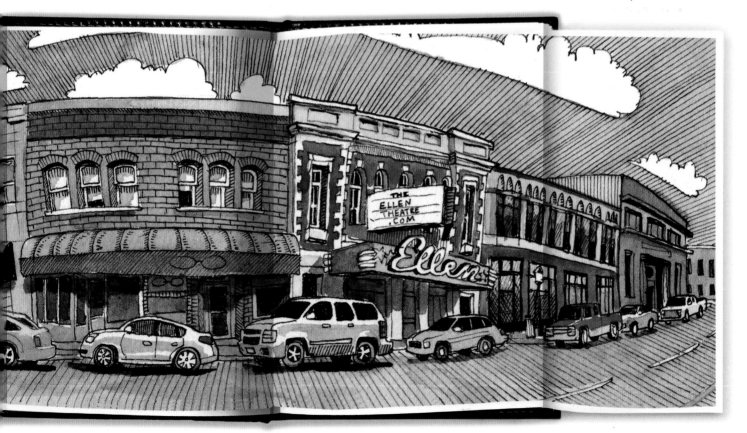

Perspective: **Seeing It**

A good way to learn to see perspective is to study how other artists apply it in their sketches.

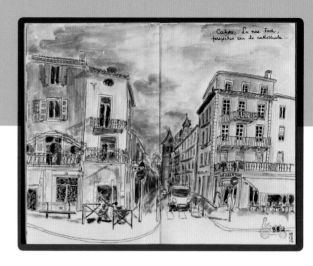

▶ **Low Horizon** In Sylvie Bargain's sketch, a road leads off straight towards the horizon, creating a very distinct vanishing point.

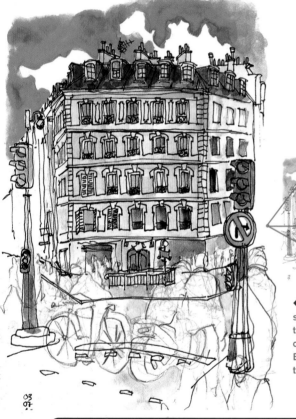

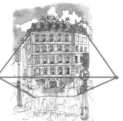

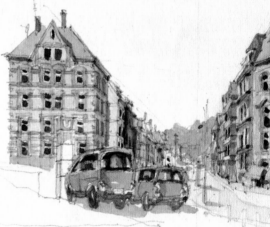

◀ **Two Points** There are two streets leading off the page in this sketch by Cristina Curto, creating two vanishing points. Both vanishing points are off the page.

▲ **One Point Each** Florian Afflerbach uses one-point perspective for the buildings in this sketch. Several cars are drawn at an angle, so they have their own vanishing point.

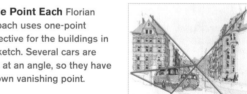

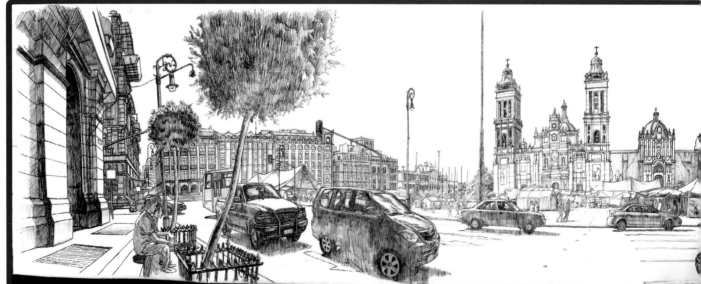

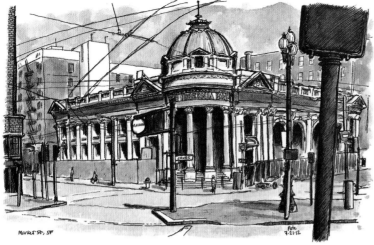

Market St, SF
Pete
7-21-12

◀ **Judge Angles** In this sketch, Pete Scully depicts a building in two-point perspective with both vanishing points well off the sketchbook page. When vanishing points are so far off the page, you need to judge the angles carefully.

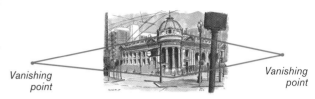

Vanishing point *Vanishing point*

▶ **Multiple Points** Ana Rojo depicts two distinct vanishing points in this sketch, as city boulevards push back the horizon.

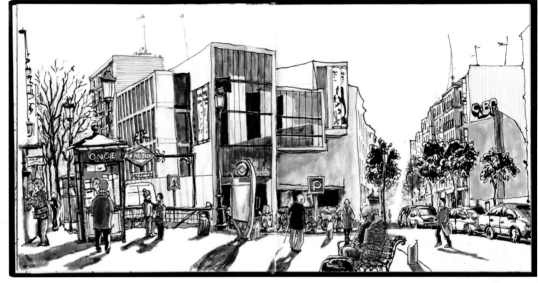

▼ **Angling Vanishing Points** One distinct vanishing point is depicted at the end of the street in this sketch by Guno Park. Since the road curves, other vanishing points help to define the cars. Vanishing points are usually found at 90-degree angles to each other.

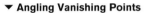

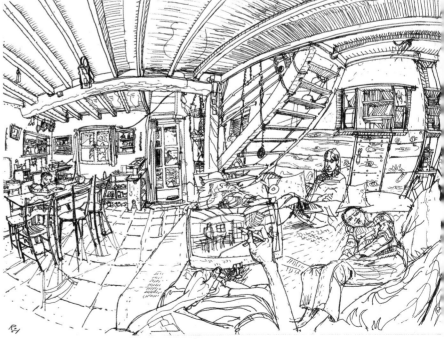

▲ **Three-Point Curves** A. Rmyth uses three-point curves to capture the entirety of the room he is sketching.

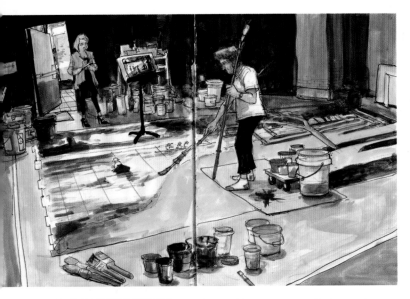

▲ **Floor Plane** In this sketch of a scenic artist working on a large set painting, a light pencil grid on the canvas helped draw the eye back to the reporter writing in her notebook and the open doorway to the hall beyond. My eye is always drawn to an open door or window. I moved brushes and buckets around on the sketch until their placement made sense, drawing the viewer's gaze into the scene.

▲ **Overlapping Shapes** The giant balloons create simple overlapping shapes that imply depth. If you assumed the balloons were just flat discs, then the space wouldn't feel as deep. Incorporating part of the ceiling and floor helps the room feel massive and cavernous.

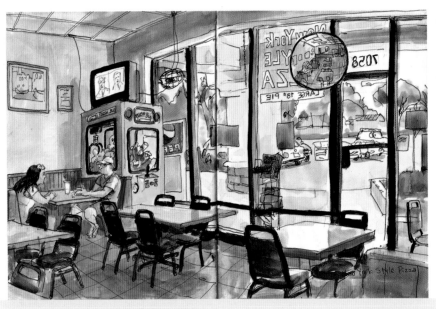

The round mirror distorts the room, offering a tantalising hint of what remains unseen.

◀ **Look Beyond the Subject** Incorporating elements beyond the interior helps this scene feel spacious. Distant parked cars, rooftops and trees pull the viewer's gaze deep into the distance. The isolated couple seem dwarfed by their surroundings.

Space and Distance Indoors

When sketching, it is important to find ways to push the viewer's gaze deep into the sketch. The image should contain a foreground, middle ground and background. Often, just like on a stage, set pieces, furniture and walls will help in creating a sense of deep space. The key is to know what visual clues to look for.

Perspective that is implied by the grid of the floor plane can be used as a foundation on which to build depth in a sketch. When there is no obvious tile or wooden floor, search for other cues. Use objects in the foreground to guide the viewer's eyes into the scene – foreground objects invite the viewer to look beyond them.

Overlapping shapes help in creating depth. In general, it is good to have large open shapes in the foreground and then more cluttered, intricate forms as they get deeper into the scene. Objects will appear smaller as they move away from the viewer. Including an open door or passageway is a good way to imply a space beyond.

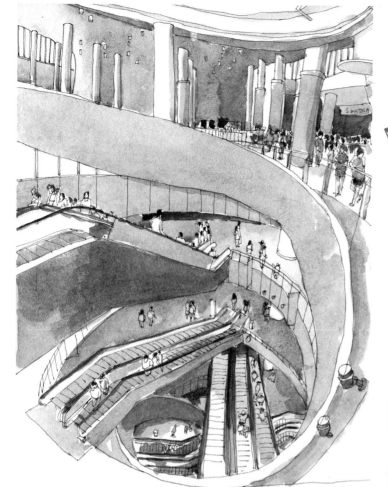

◀ **Receding Spirals** In this sketch, Teoh Yi Chie depicts an architectural spiral that follows a cylinder shape relating to the vanishing point below the artist. The horizon line is straight ahead on the floor that the artist is standing on. The escalators that line up are in a cube-shaped form, which relates to the vanishing point.

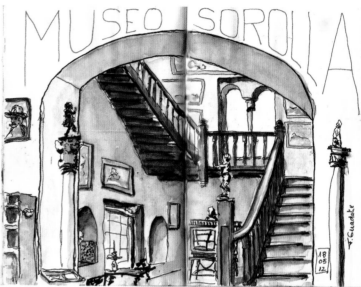

▲ **Arch Frame** An arch is used to show the separation between rooms in this sketch by Felipe Gaudalix. The far room has a cool, blue tint, which pushes it back in space. The staircase helps to define the room's cube shape. A single line hints at the floor plane.

◀ **Silhouette** Matthew Brehm silhouetted this figure in shadow against the bright window. The cool, grey interior is in contrast to the warm, sunlit exterior.

Colour helps in adding atmospheric depth to a sketch. Objects that are far away in a landscape appear bluer and less saturated; whereas objects in the foreground will look closer if they are warmer in colour. Values can also imply depth in a scene. For instance, characters in the foreground of a scene might be in shadow, thus separating them from a brightly illuminated middle ground. When paint is applied to a sketch, these value shifts are the first thing searched for. Value and colour should both be considered as watercolour is applied to a sketch. Value is often a matter of how much water is used to thin the paint – light values are mostly water, while the darkest values have the most pigment.

Diminishing detail is used on people and buildings in a sketch. If a person is drawn close to the foreground, then they will have the most detail, right down to buttons and eyelashes. If the person is further away, then less detail is needed. If they are part of a crowd in the background, then they might not even need faces. Detail is added in a sketch only where it is most needed to tell a story.

Space and Distance Outdoors

When you are working outdoors, the scene will often have much more depth than an indoor scene. Remember that sunlight and weather conditions affect every aspect of the sketch.

In an urban environment, outdoor sketches are often done at gatherings, such as outdoor concerts or festivals. Space and distance are always accentuated when you add people to your sketch. People follow the same rules of perspective as any other object in the scene and it is important that they are well grounded. Placing one person in the foreground and another in the distance instantly creates space, since we instinctively know how large people tend to be. The size and scale of architecture will often help in establishing the size, scale and depth of a scene. Roadways will lead the viewer's eye all the way to the horizon, with cars, signage and buildings acting as overlapping shapes that push the viewer's gaze deep into the scene.

I always carry a second sketchbook which is horizontal in format. This sketchbook is often used when sketching outdoors, since the panoramic format is a good way to capture the wide expanse of an outdoor setting. By showing more of the horizon and using a wide format, you are implying an endless expanse.

Atmospheric perspective is when water particles in the air gradually make objects that recede into the distance turn blue. This can even apply to an urban street scene, where distant buildings pick up a bluish tint. It is a good idea to exaggerate this principle. Even if distant trees or objects don't appear blue to you, I would suggest you add blue to push them into the distance.

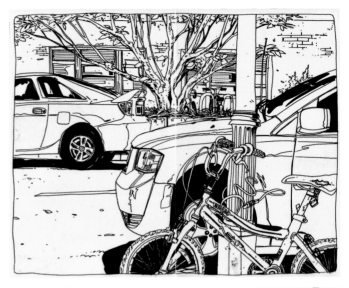

▲ **Overlap** Tin Salamunic overlapped the foreground bike in front of a lamp post, which is in front of a car, which is in front of a distant car, tree and wall. Every overlap implies how deep the space is.

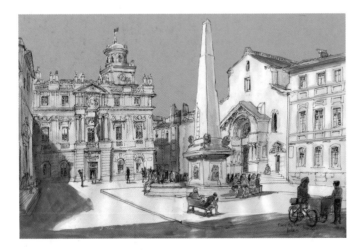

▲ **Values** I removed the colour from this sketch of Arles so you can clearly see that basically the scene has just three values, a dark foreground shadow (1), a bright middle ground (2) and a middle value for the secondary planes on the monument and buildings (3). The square feels expansive because the dark figures in the foreground are so much bigger than the distant figures, yet they are sill dwarfed by the architecture.

▲ **Receding Blues** In this sketch, trees in the foreground are a dark, rich green (1), while trees in the middle ground are a less saturated, light blue-green (2). The rocks in the foreground are warm in tone (3).

▲ **People in Perspective** People added to a scene follow the rules of single-point perspective. It is important that they seem to be standing on the same ground plane. See pages 52–59 for more on perspective.

Receding Figures Joao Catarino features a large figure in the foreground and the hints of several figures in the middle ground of this sketch. The blue buildings further recede into the distance.

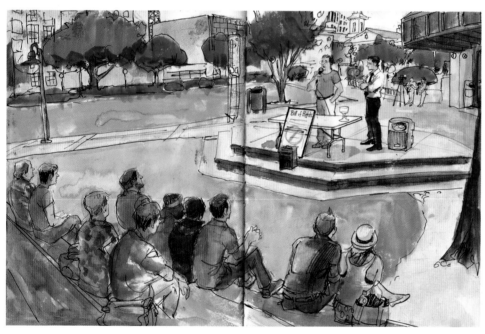

◀ **Details Add Depth** Paying close attention to details in the distance is one way to draw the eye deep into the scene. Having people in the foreground, middle ground and background also helps to add depth.

A church steeple in the distance pulls the viewer's gaze even deeper into the cityscape.

▼ **The Panorama** A panoramic view is a good way to capture space and distance in a scene. The vanishing point becomes obvious as you look down a roadway which points into the distance.

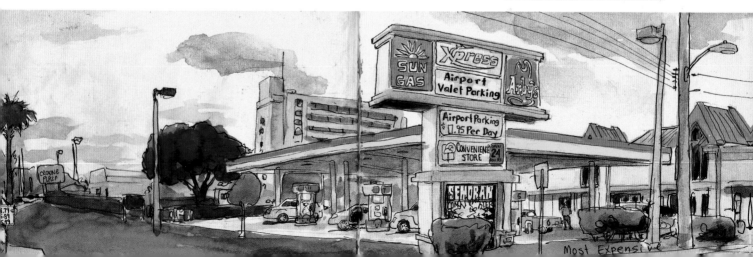

Recording the Changing City

When I first started doing a sketch every day, I began by taking a daily trip into town to sketch buildings. Nothing is more fascinating than watching a new building's skeletal structure take form.

Building sites offer endless sketching opportunities: slender, intricate cranes cut the sky and a building's inner anatomy is exposed, ready to be captured by any artist. Buildings used in a composition are very much like actors on a stage; every building has its own personality. Buildings need to be firmly anchored to the grid of the ground plane and positioned in such a way that they are easy to identify.

Remember that no city scene is complete without the human element, so keep an eye open whenever you are sketching buildings to catch people on the street, too.

Urban sketching is all about recording the changing face of a city. Buildings come and go and it is the artist's job to document that change. As you sketch on city streets, people will stop and tell you their story. A seated

Continued on page 66

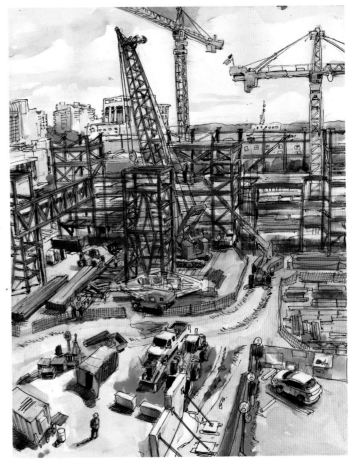

▲ The Building's Inner Structure This sketch of a building being constructed didn't feel complete until a workman standing in the foreground was added. Instantly, the scene is active and alive with possibilities.

▼ In Plain Sight Even mundane, everyday buildings can tell you something about a city's people and culture. These everyday places often offer the most personality for a sketch.

▲ Great Heights The building depicted in Pete Scully's sketch appears incredibly tall because the unfinished upper floors are drawn so much smaller than the floors at the base of the building.

ROME, Je t'aime

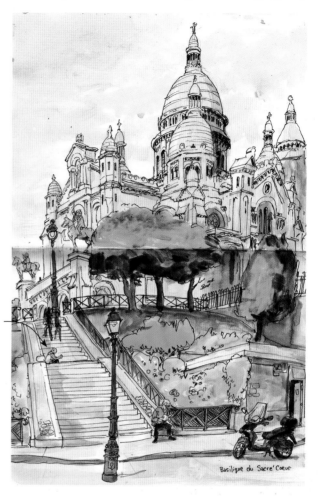

Basilique du Sacré Coeur

▲ **Organic Architecture** Benedetta Dossi seldom relies on straight lines. Forms bulge and pinch, giving a lively, organic feel to the sketch. Cars become exaggerated bubbles.

Similarly to Juan M. Josa's sketch, this figure, begging for change in Paris, draws the viewer into the sketch.

◀ **Human Interest** In this sketch, Juan M. Josa treats bricks and arches with care, but the person sitting holding out a cup invites the viewer to complete the story themselves.

The figure holding out a cup catches the eye.

▲ **Old and New Collide** Historic architecture might have been sketched hundreds of times by different artists through the ages. The key as a contemporary urban artist is to find modern touches, like the moped or a beggar on the steps, to make the sketch feel modern.

▼ **Crowded City Block** Ana Rojo does a great job of depicting the buildings surrounding the Cines Callao. She has populated the public space wonderfully, with people in the foreground, middle ground and background.

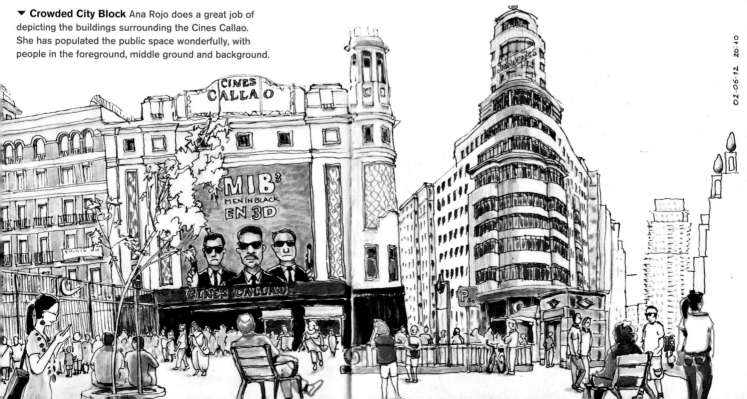

02·06·12 20:40

artist is a captive audience and meeting people daily becomes second nature. Keep your eyes and ears open for interesting stories – artists are sponges and often, as you work, some drama will unfold. Take notes. The sketch might record only a fraction of the drama, and writing about your experiences later can be just as important as the completed sketch. Together, the writing and the sketch tell a much broader story.

Buildings are interesting because they house so many human stories. You will find yourself drawn inside looking for places where people congregate. Bars, music halls, theatres and churches are all places that have endless variety and interest for an artist searching for sketch opportunities. I live in a city that is insanely hot nine months of the year, so a cool drink and air conditioning are welcome perks for me when planning a sketch outing. Be sure to consider the quirks of your own city.

Buildings are sketched most often when travelling. When you go to a city with a rich and vibrant history, the architecture offers clues to the city's past. Sketching is a great way to uncover that history, and new and old living side by side adds multiple levels of meaning to any sketch. Find the city's story and share it.

Paul Heaston

Architecture Study: Denver City Cable Railway Building

My sketching affliction began in 2007 during a semester in Italy, and I have been sketching ever since in San Antonio, Bozeman, Montana and now Denver, Colorado, where I work as a commercial illustrator. Amongst my other urban sketching projects, I spent six months between 2008 and 2009 drawing every building in downtown Bozeman in a pocket-sized sketchbook, and another three months completing a 3.4-metre-long (11-foot-long) panoramic drawing of San Antonio in a folding sketchbook from 2010 to 2011. I maintain my own sketch blog, Three Letter Word for Art.

The Denver City Cable Railway Company building is immense and yet for this sketch, I worked in a small wire-bound sketchbook. I used three-point curves to warp the building's shape and fit it on the page.

1 Begin by lightly sketching the general shape and arc of the area in 2B pencil. This helps determine where the composition will begin and end and roughly what will be included within.

2 Break down the larger shapes into smaller ones and start to think about proportion and the future location of details. At this point the locations of doors and windows are starting to emerge. They can be adjusted later, but for now there is a rough framework with which to work.

3 More specifics start to emerge, including finer details of the masonry, background buildings and cars parked along the curb. These foreground elements are added last as they overlap the building, but they will be tackled first when the sketch is inked.

4 The cars are inked, as they have the potential to drive off at any time. Remember to completely finish one car before moving on to another, in case any of the other cars leave. During this sketch, the minivan on the far right drove away and was replaced by an SUV. Fortunately, this car wasn't yet inked and the penciled Minivan was converted into an inked SUV.

5 Once the cars are finished, move on to the background details at a more deliberate, relaxed pace. You can be fairly confident the building won't be leaving anytime soon.

6 More foreground elements are added, like parking metres and street lamps. Then, the most basic masonry elements are inked. Pay close attention to those lines that pass all the way up or across a building without interruption, especially ones that separate important architectural elements like window bays and individual floors.

7 Once the basic structure has been addressed and the contour line drawing is finished, begin to think about smaller details like window frames, bricks and 'dental work' – the small, saw-tooth architectural elements that are found along the bottoms of cornices and ledges on the building's façade.

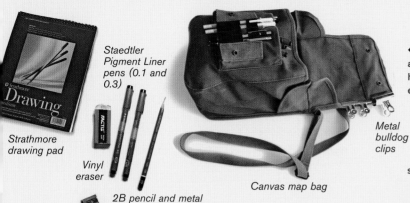

◀ **Equipment** I prefer metal pencil sharpeners for their durability and compact size. A good 2B pencil is vital as the lead is relatively hard and stays sharp, but it still makes dark marks that are easy to erase with a white vinyl eraser. Staedtler makes very good, inexpensive waterproof technical pens in many different line widths. A sturdy, weatherproof canvas bag is important, especially one with several small compartments and one large one for sketchpads. I found this military-style map bag at an army surplus shop. Strathmore makes good, inexpensive spiral-bound sketchpads with perforated edges.

Strathmore drawing pad

Staedtler Pigment Liner pens (0.1 and 0.3)

Vinyl eraser

2B pencil and metal pencil sharpener

Canvas map bag

Metal bulldog clips

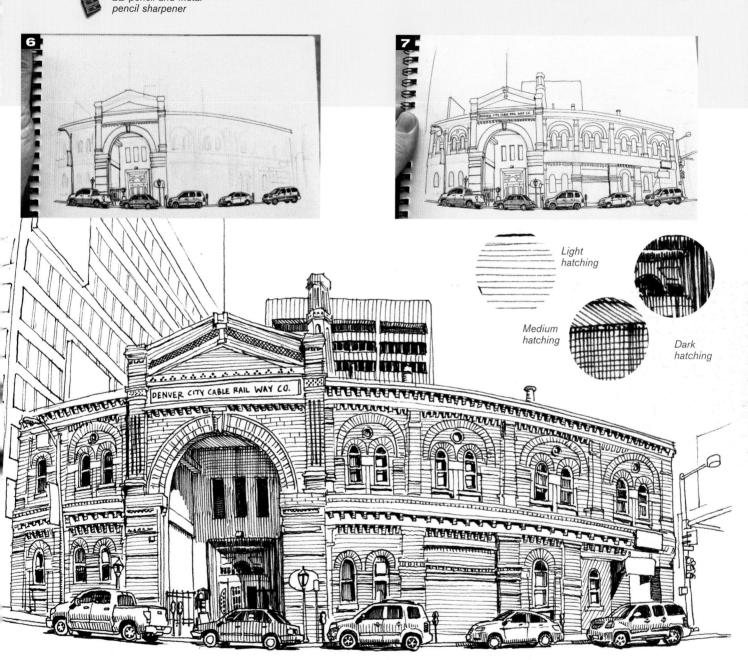

Light hatching

Medium hatching

Dark hatching

▲ **Denver City Cable Railway Building** The very last thing to consider is value. Light on the building changes during the course of a sketch, so it is a good idea to save values for last, so the shadows in the sketch are consistent. Here, hatch marks are used to show the locations of shadows inside the arched entryway, and the underside of ledges and window niches are darkened to add dimension and volume. The effective use of value can turn a flat-looking line drawing into a solid, three-dimensional-feeling building that pops off the page.

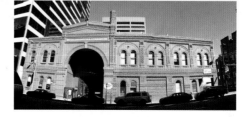

A Sketch Anchor

Working on location is a hectic, ever-changing challenge. No one is posing, so it is easy for any artist to become frustrated at first. There is a certain peace of mind that washes over you when you know the sketch will work. The key to this security comes in knowing there are certain objects that you can return to if everything else changes. That object is your sketch anchor.

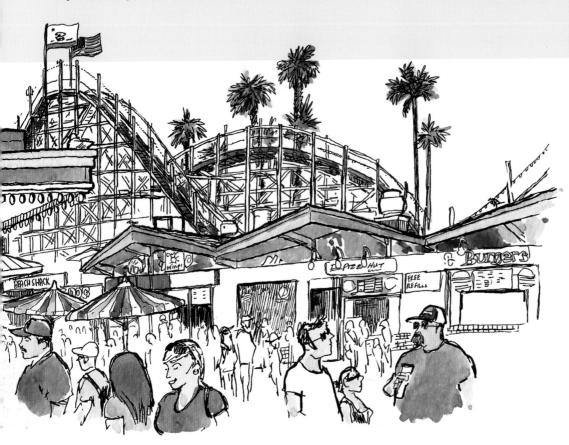

◀ **Park Anchor** The intricate wooden structure of the rollercoaster acted as an anchor for Pete Scully in this sketch. Individuals in the foreground could be captured individually, and the crowd in the distance could be quickly added as simple gestures. If someone walked away, the rollercoaster could always be returned to.

▶ **Theatre Anchor** While creating this sketch, Ana Rojo could always return to the audience as an anchor. Action on the stage would be a fleeting moment that would have to be sketched quickly, while the audience would be in one place for the duration.

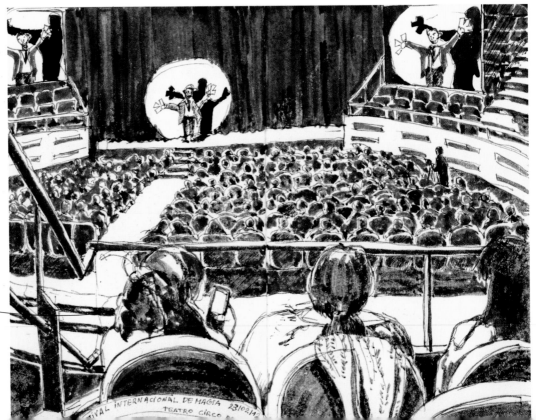

Catching an audience member looking at their phone is a case of a quick gestural catch.

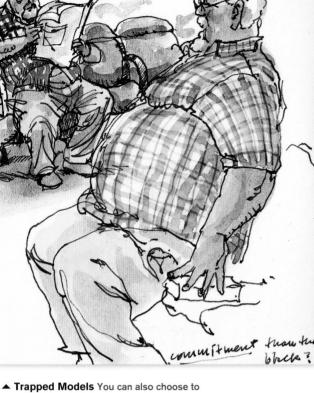

In a classroom-based figure-drawing class, the model holds a pose for five, ten or even twenty minutes at a time. Sometimes, as the pose progresses, the model relaxes a bit and the pose changes. I'm always surprised that some artists get annoyed and frustrated with these subtle shifts. On location, you get used to the fact that some people will turn on their heels and immediately walk away the second you start to sketch them. The human eye is

Continued on page 70

▲ **Trapped Models** You can also choose to sketch in locations where people tend to sit still for some time. As you sketch, you will discover each person's 'signature pose' – they will move but they will often return to that pose. If the person moves, you can focus on the room as a whole. Details, such as the shirt pattern in this sketch by Anthony Zierhut, can be added later.

▲ **Sculptural Anchor** Kumi Matsukawa used the sculpted Guardian Lion and Red Torii as an anchor in this sketch. People could be sketched in quickly after the composition had been established. Whether in a theatre or not, my general approach is to sketch the 'stage', then the 'actors'. If an actor leaves the stage, then return to sketching the stage, which is the sketch anchor.

◀ **Ceiling Anchor** In this crowded room, people were moving constantly and dancing. To find a stable place to start, the fish and submarines suspended from the ceiling were sketched. Once the far walls and dance floor were established, people were added one at a time to the scene. You get to decide how populated you want the sketch to be.

attracted to motion, so it is no wonder that you might draw someone who is about to leave. I have trained myself to look for still, quiet moments that stand apart from all the motion. A person's proportions and placement in the scene are first put down in pencil. If the pose and placement work, then I can follow the person as they walk around with my eyes. I add costume and facial features to the sketch even though the person is no longer in the spot in which I first saw them.

If someone blocks your view, then return to the sketch anchor and add detail to it. The anchor can be anything that doesn't move. Once that object has been established, you can feel secure, knowing the sketch will be completed. This also allows you to make the most out of every moment you are sketching on location. You will constantly find a way to keep the sketch progressing. Since a good sketch can take two hours or more to complete, it is important never to waste any time; otherwise, the sketch might not

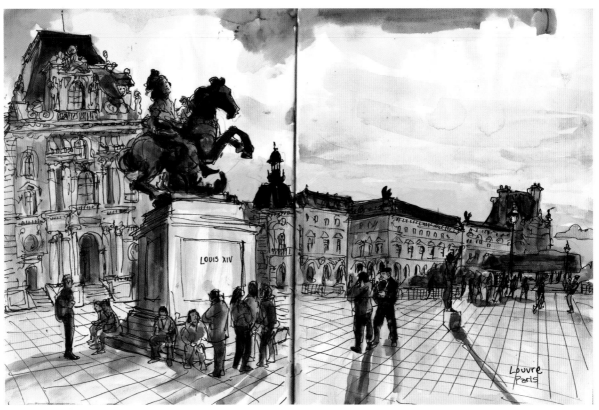

▲ **Statue Anchor** The statue of Louis XIV in front of the Louvre in Paris could be counted on to not move. Much of the open square, however, was full of tourists coming and going. If the crowd became overwhelming, the statue and building architecture acted as a place to focus. Both the activity and the stillness are important to any sketch.

▶ **Before the Musicians Arrive** The film screen, speakers and stage lights all acted as anchors in this sketch of a concert. All of this was sketched during the sound check before the musicians got on stage. Once the musicians were in place, they could be quickly blocked into the composition.

1 First, I established how much of the stage could fit on the page by sketching the top, bottom, left and right extremes.

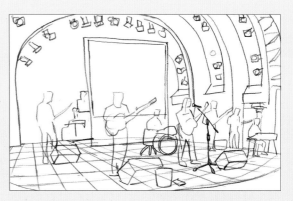

2 The rest of the time was spent placing objects and singers on the grid of the stage floor. If a performer moved, I could shift my attention back to the details of the stage.

be complete before the event is over or the moment passed. Sketching on location is all about time management and never being distracted – the key is deciding where best to spend the time adding detail for the story to become obvious.

A great way to start is to go to a concert and arrive about an hour early. In that hour, pencil in the elements on stage that aren't likely to move. If you are sketching audience members, sketch the empty seats lightly in pencil and then use a pen to sketch people in the seats as they arrive. Use every available moment during the event to sketch the gestures and attitudes of the performers or the audience. If you sit in the audience, you might end up sketching the backs of people's heads. Carry a portable artist's stool, as having one opens up so many more possibilities to sketch the performers and audience. Musicians often take a break before the sketch is complete. Use the break to return to the detail in the anchor or to add detail in the room.

▼ **Gallery Anchors** While completing this sketch, Cristina Curto could always fall back on the intricate detail in the paintings and their frames if someone walked out of view. The perspective of the gallery walls would have been established first, before the scene was populated with people and paintings.

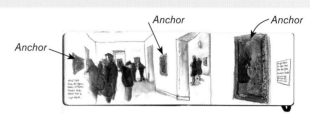

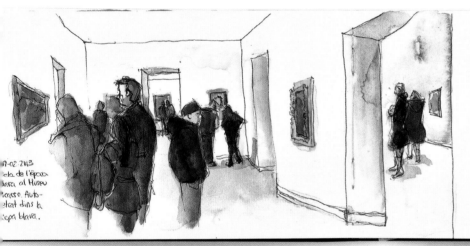

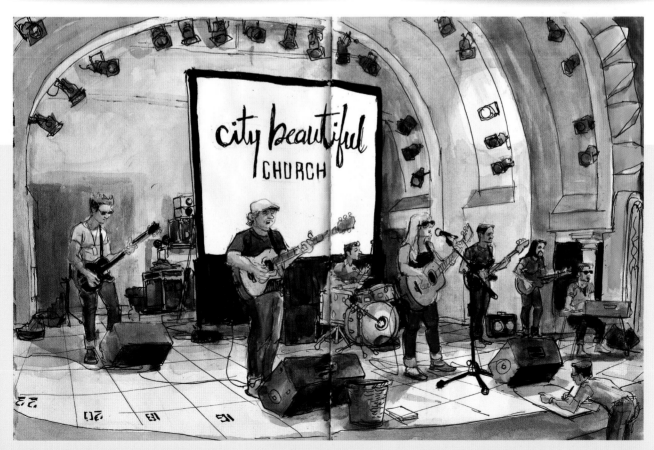

Detailed Studies

There is a tendency when you first start sketching on location to feel hurried by all the activity around you. It is important to slow down and savour the sumptuous details in the scene as it unfolds before you.

When you start a sketch, you always have a feeling that time is limited, and it is. The more you sketch, you get a better feeling of how long it will take you to capture a scene. I break my sketching time into different stages. In the first stage, a pencil is used to block in the overall composition. Things can change often at this stage and there is no stigma to using the eraser. The point is to work fast and furious.

The second phase is done in ink. Sinuous lines are put down with loving grace. If you sketched a person in the scene, then finalise them first, paying close attention to the details of their face. If the person is still in the scene, then go ahead and add colour to them as well. If they have moved off, then you can decide for yourself what colours work later.

Let's say there is an ornate tapestry or painting in the scene – this is a golden opportunity to slow down and study its detail. Take a sheet of blank paper and cut a 25-mm (1-in) square in the centre of it. Position the open square over the detailed area you want to capture on the sketchbook page. With slow, deliberate line work, sketch the intricate, detailed area. If you get to the edge of the square, then move the mask and continue drawing. The mask allows you to ignore all the other aspects of the sketch while focusing your attention on a single detailed area. In time, you will not need the mask to focus your attention. Each sketch should have passages of loving detail and large areas of open space.

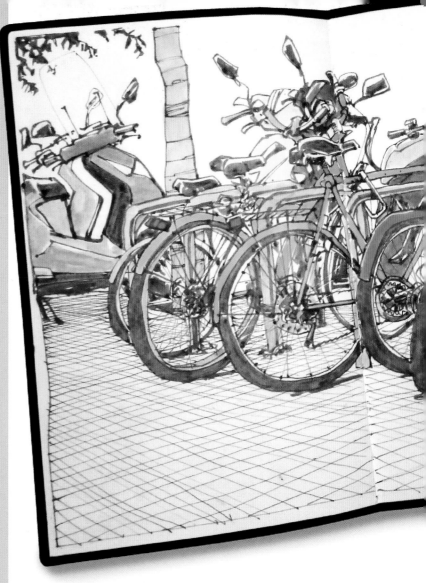

Miguel Herranz

Detailed Study in Ink and Watercolour: Bicycles

When we write, we begin on the upper far left (or right) of the page, and start adding lines until we have finished. It's possible to take the same approach with drawing: start from one point, then let the rest of the drawing grow around it. Feel the flow of the drawing, and follow it until you finish the 'story', whether the page is full or not.

In this example, I drew a collection of bicycles and scooters parked near my house. I walked around the parked bicycles a few times to decide which side would give the best viewpoint for my drawing, and it was then that I noticed the detail that I would use as the starting point for the whole picture – the bicycle lock that you can see right in the centre of the photo.

I like the calligraphic quality of this approach. Look closely at parts of the finished sketch, and it's an unreadable jumble of lines and curves, a bit like ancient manuscripts, where you may not be able to read what's going on, but it sure does look good!

◄ Find a Focus
Take a sheet of sketch paper and cut a small section out of it. This mask opening is just 25 by 38mm (1 by 1½ in). Keep this sheet in your sketchbook and use it next time you are faced with a complex pattern.

A brush pen with watercolour helps to achieve accurate colours.

1 Decide on the key point of your image and start your drawing from here. Put it more or less in the centre of the page.

2 Work your way out and around from your key point, growing your drawing in concentric circles. Remember that when creating a multi-layered picture, the objects in the foreground will interrupt the lines of objects in the background.

3 Don't worry too much about getting the proportions exactly as they are in reality. Instead, use the parts of the picture that you've already drawn as reference to work out if other objects should be bigger or smaller.

4 Continue to build up your sketch. Add some shading and darker detail work in some areas (such as the saddles and tires in this case) to give definition.

5 Add colour to separate the different layers within the picture and to give a sensation of depth to the sketch.

I used the bicycle lock as the starting point, and worked on the sketch from the centre outwards.

◀ **Tools** This drawing was created with a Sailor Calligraphy pen, which gives you a much less precise line than a traditional drawing pen. I wanted to portray the abstract texture of the material much more than the exact, mechanical appearance.

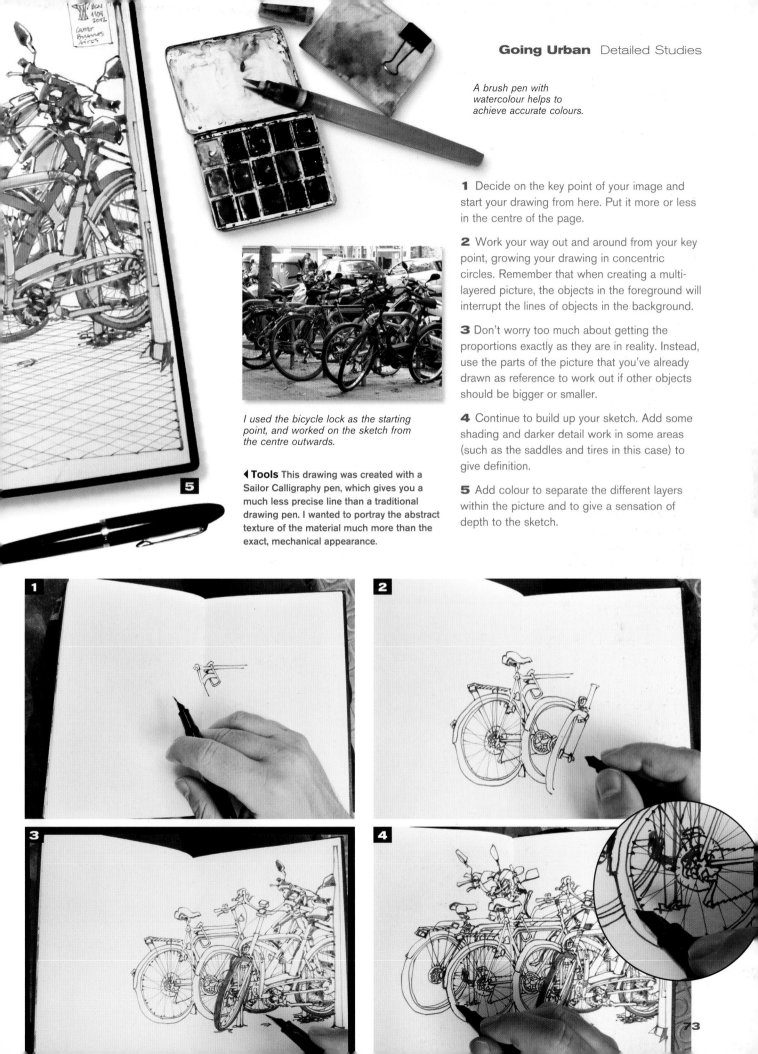

Nature in the City

Every urban setting has its parks and tree-lined boulevards. As an urban artist you can often incorporate these natural elements into your work. Working outdoors offers its own challenges and rewards. Bold sunlight or a cloudy day will affect every aspect of the sketch.

Take a photo reference so you can complete your sketch when at home.

Landscapes are a dime a dozen. It is only when you add the human element that a natural setting will convey a story we all can relate to. It is how urban planners mould nature or let it break free that is fascinating. You will have to consider the weather if you know you plan to sketch outside. Gloves with the fingers cut off are good for a cold day, or shade may be needed to escape the hot sun. As an artist, you need to be a good judge of the sun's path in the sky. If you misjudge, then you might find you have lost precious shade halfway into the sketch. Wind can cause your pages to flutter, so a clamp or elastic band might be needed to keep the sketchbook stable.

Trees are often the first challenge for an artist. Consider sketching them in very much the same way that you sketch the

▲ **Rendering Roots** When you see a tree's roots struggling to grasp the ground, it is easy to imaging human fingers as they grab at the soil. The bark of the tree flows in a way that describes the form. That natural flow is more important than defining every crevasse in the bark.

human figure: draw from the base of the trunk upwards, being sure the tree is firmly rooted to the ground plane. Let the limbs flow outwards, paying attention to where they connect to the main trunk. Watch the negative shapes between branches as you add more of them. Then, consider the overall shape of the tree's canopy. Large washes of colour can quickly add foliage while letting the sky peek through where needed. Use atmospheric perspective by painting distant foliage blue.

▼ **Find the People** Go to a public park and sketch people as they play and relax, as Kumi Matsukawa has done here. Outdoor concerts and sports activities also offer plenty of sketching opportunities, as people interact with nature. If you hear loud partying or music, walk towards it rather than away from it.

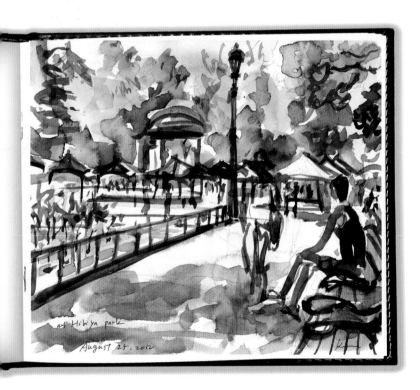

Always look for any opportunity to add the human element. If only one person walks through the scene, be sure to add them. Any urban sketch will feel desolate and lonely if you don't include people – that is at the heart of what will bring the scene to life. If you are sketching a park, then there will be plenty of opportunities to include people. Refocus your attention every time a person walks into the scene.

▲ **Stepping Back** Bold washes define the foliage in this sketch by Cristina Curto. Line work helps define tree trunks and the colour washes become blue and less saturated deeper into the scene. The only warm colours are those found in the manmade elements.

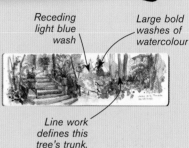

Receding light blue wash

Large bold washes of watercolour

Line work defines this tree's trunk.

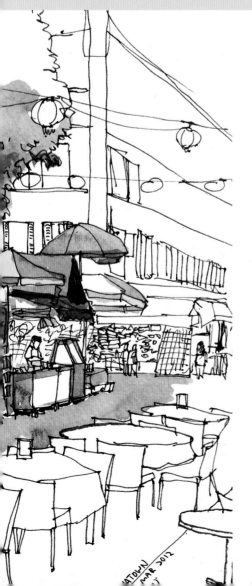

◀ **Canopies** In this sketch, Teoh Yi Chie painted part of a tree's canopy using a light green wash and then a darker green wash. The similarity between the tree's canopy and the umbrella canopies becomes a visual metaphor.

▲ **Between Cracks** Tin Salamunic sketched the green foliage that crops up between buildings like weeds growing from a crack in the pavement. No matter how urban the setting, nature always finds a way to grow towards the sun.

2

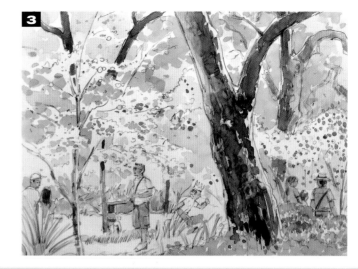

3

1

Aquabee pad for thumbnails and bamboo brush holder

Most of my watercolours are Winsor & Newton, but I like to experiment with other brands.

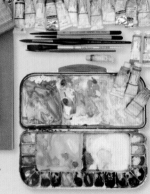

Stonehenge spiral pad, 230 by 305mm (9 by 12 in) – my current favourite sketchbook for the fine-quality heavyweight paper that takes all kinds of media well.

My palette is a Mijello Leak-Proof Palette. I have a basic palette but often like to add extra favourite colours.

Virginia Hein

Sketching Nature: Descanso Gardens

A few years ago, my drawing and painting left the confines of a studio, as I discovered a real joy in working on location, especially in the city. My urban sketching began as personal study, and then took on a life of its own, and I discovered a worldwide community of sketchers. For urban sketching in a natural setting, I chose a public garden, Descanso Gardens in La Cañada, California. My favourite spot is the Japanese Garden and, in March, everything is blooming! I chose this view for the contrast of those solid oaks and the delicate flowering cherry trees.

1 I start with some quick thumbnails, then move on to a preliminary pencil drawing. I begin with the large oak tree, my main focal point. I draw in other trees and bushes lightly and leave room to draw people passing by. These particular people aren't all on that path at the same time – I draw them as they walk by.

2 For me, the best way to organise the composition is to define the overall pattern of light and shade. I see bits of a light, cool blue sky, and use that colour throughout for the shade areas. Next, I establish a pattern of warm tones – mainly where sun is hitting the foliage. I leave the lightest areas white.

3 Generally, I like to work from largest areas to smaller details, but here I decided to paint in the pink camellias and bushes on the right, as well as a bit of violet shadow in the white cherry blossoms, and then paint the green foliage around them. To establish a stronger pattern of light and dark, I add darker tones to the tree trunks. I paint the large oak with several tones of cool grey, letting the paint mottle a bit to suggest its wonderful gnarled texture.

4 I add foliage using a range of mixed greens. I leave a lot of light patches in the camellias to suggest their shiny leaves, and balance the white cherry blossoms. I add colour to the figures. I feel I need to add some more warmth and depth to the foliage and tree trunks, and a bit more pencil detail. I want to keep a light touch on the cherry tree branches.

5 I paint more depth and detail in the foliage and the figures, and add darker pencil detail with a softer Cretacolor Monolith 4B pencil. I feel I'm close to finished at this point, but I'm concerned that I need to unify the composition more.

6 When the wind blows, I see some cherry blossoms overlap the oak tree, and I want to add that to balance and unify the composition – I use semi-opaque white. I notice some camellias peeking through the cherry tree, and that will also add balance.

7 Is it finished? Yes, for today. Working back and forth between drawing and painting helps me keep the attitude of a sketch – striving to observe fully in the moment. There's a timeless quality to this garden and the renewal of the season, and yet I want to catch the feeling of experiencing a specific moment in time – and hope I've done that today!

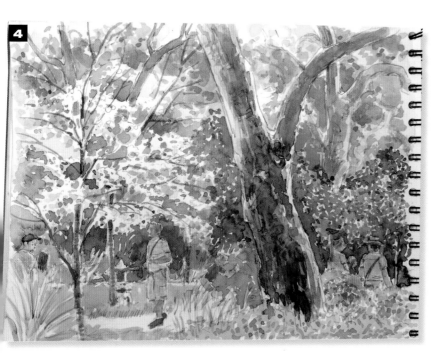

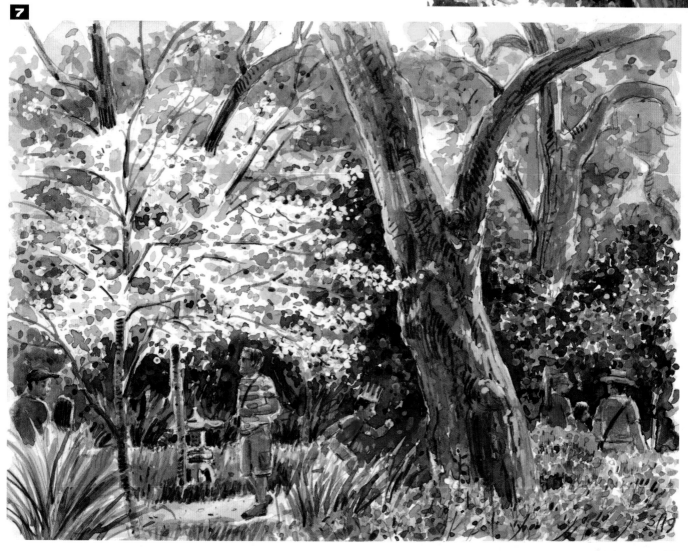

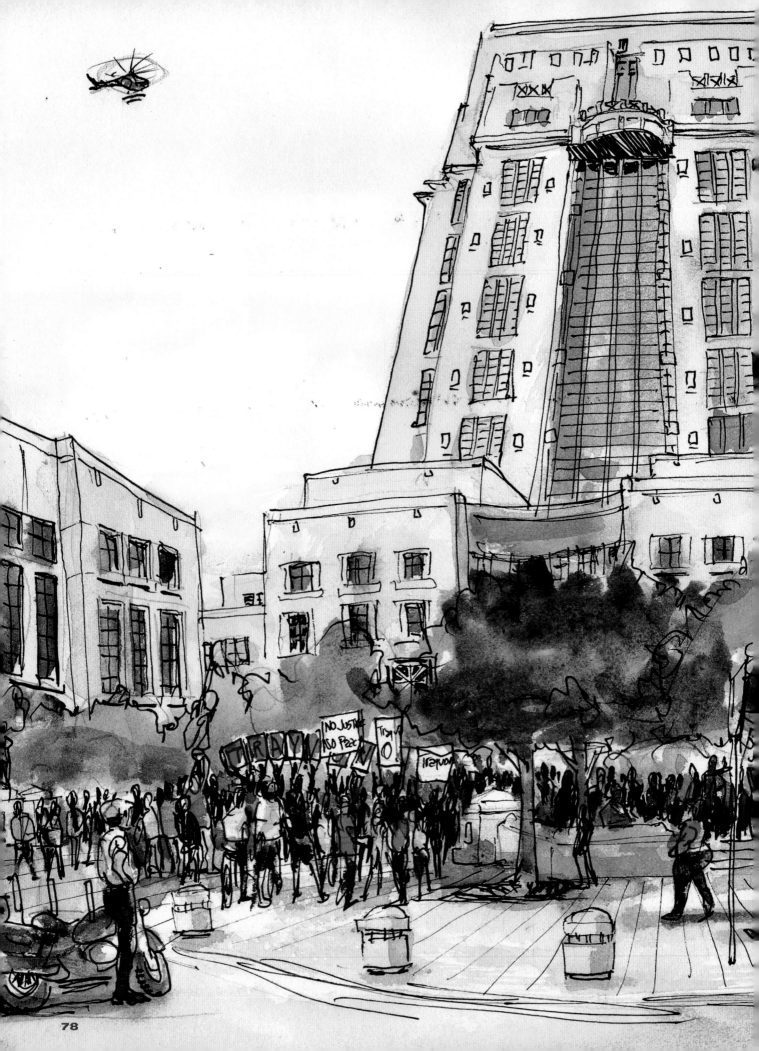

Chapter 3

Populating your World

Whether they're shapes in the distance or part of a detailed portrait study, figures will play a crucial part in your urban sketching, as they add the all-important human element, and inject life and drama into your work. This chapter builds on the figure-drawing basics you learnt in Chapter 1 and focuses on how to add characters to your sketches in a believable way, so that they fit naturally with each other, with their surroundings and within the story of your sketch. Urban animals, expression and action and movement are also covered to help you to really bring your sketches to life.

Trayvon Martin
Demonstration

Sketch by the author

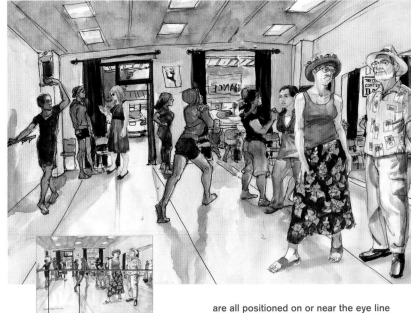

Kathy 170cm

Lori 157cm

Chere 168cm

Rory 175cm

The models' heights are noted to help keep track of how they might relate to one another in the same scene.

▲ **Individual Studies** These figure studies were done for a mural. Every sketch was done as I sat on my artist's stool. My eye line was roughly level with each model's hips. The models' heights are noted to help keep track of how they might relate to one another if they were placed together in the same scene. These studies took perhaps an hour each to do. When drawing on location, an hour is a luxury.

Eye line Dynamic action line

▲ **Crowding the Scene** The figures from above left are added to another sketch, above. Imagine these people walked into this dance studio. Knowing your eye line, it would be possible to sketch them into the scene. By making sure their waists/hips

are all positioned on or near the eye line (indicated by the red line) and that their feet are anchored to the floor plane that you have already drawn (and using their heights as a reference), you can ensure they're all drawn in proportion to their surroundings and to each other, and that the sketch will work as a whole. One dancer just left of centre has a dynamic action line as she leans forwards in motion.

People in Context

Over years of figure-drawing classes, you will fill hundreds of pads with two or three figures floating on each page. The key to creating dynamic sketches of people on location is to pay attention to how they relate to one another in space. Much of your attention will be focused on size comparisons.

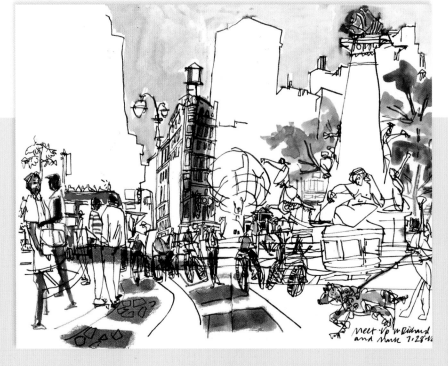

As you sketch at an event, people will move around. You usually have at most five minutes to catch any single pose. It is always a good idea to block in the scene that will not be moving, and get a firm grasp of the perspective of the scene before adding people to the sketch. Placing figures into the sketch is like doing a jigsaw puzzle – where all the pieces are floating in three-dimensional space and are in motion. Once one figure is locked down, the other figures can be drawn larger or smaller depending

▲ **Busy City** The horizon or eye line becomes very obvious in this sketch of a busy NYC street corner by Melanie Reim. Figures both large and small feel grounded, and get smaller as they recede into the scene.

80

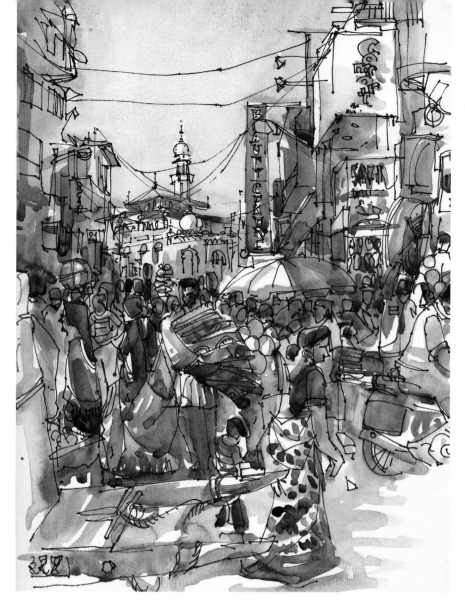

◀ **Crossing Chaos** Suhita Shirodkar sketched a vibrant, crowded crossing in India. A few large figures in the foreground have identifiable details and then detail is lost as the figures get smaller. Bold, vibrant colour appears everywhere. The smaller crowd is unified with a dark wash.

▼ **Lilliputians of NYC** In this sketch by Veronica Lawlor, the crowd watching the Macy's Thanksgiving Day Parade balloons being inflated in NYC, are drawn with fluid ink lines. A solitary figure in the foreground adds depth to the scene. People become an overall façade or wall below the huge balloon.

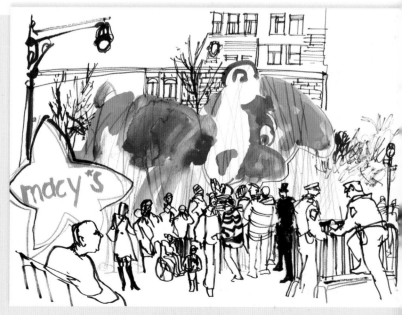

on where they are in space. A person standing right in front of you could dominate the sketch, while a person against a far wall might be incredibly small.

When drawing crowds of people, only a few key figures need to be recognisable, the rest can be quickly sketched in as a mass. Sketching figures into each scene can be the most challenging aspect of urban sketching, but when you catch just the right pose, it can be the most rewarding. It helps to block the figures into the sketch using pencil first; having the option to change your mind and revise a pose or erase it entirely is a big help when everything is constantly changing.

An action line runs through every figure's spine, helping to define the pose. Figures become more dynamic if the action line leans from vertical towards horizontal; the more horizontal the action line, the more active the figure's pose will seem. A dynamic action line implies the force flowing through the figure. When sketching on location, you will often only have enough time to estimate the figure's size in the scene. It takes patience and perseverance and experience to add a strong gesture. Once the gesture is established, then detail can be added by following the person with your gaze, or even borrowing costume details from other people. I firmly believe that adding convincing figures to any scene is the most important aspect of any urban sketch.

Continued on page 82

A solitary figure in the foreground adds depth to the scene.

Note the dynamic action line.

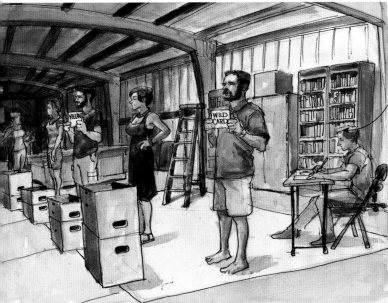

Figures draw the eye back into scene.

Main focus

Overlapping figures

Boxes overlap, giving an added clue to the deep space.

▲ **Improvisation** This is a pretty obvious study of figures in perspective. The boxes in the scene overlap, giving an added clue to the depth of space. In this improv show, the actors held signs that defined their character throughout the performance. Knowing who the villain was would affect how I drew them.

▶ **Body Painter** Here, the artist is in front of, and overlaps, the model. This adds some space to the scene. The figures behind the railing push the eye further back into the scene. The halo of light around the model's head and shoulders make her the undeniable centre of interest. The brush in the artist's hand completes the story point.

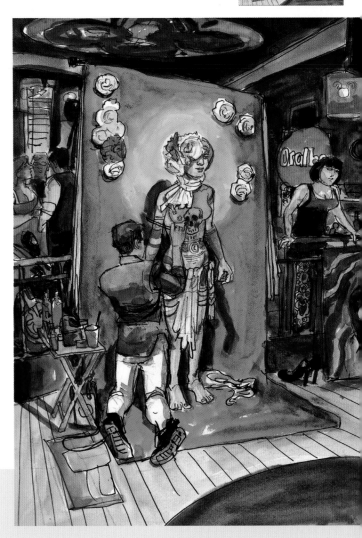

The key to incorporating figures into an urban sketch is to catch a quick gesture, loosely in pencil, and then add detail later. You have to decide as you go what details of the scene are most important. If a small detail on a far wall is important, then don't block it with a foreground figure.

Every time you place a figure in a scene, you must compare sizes and proportions. It is important to always try and incorporate a foreground, middle ground and background. The easiest way to imply deep space when sketching two figures is to have them overlap, with one figure partially blocking the other. Two people will seldom stand next to each other long enough for you to capture both, so you sometimes have to move people together in your mind and overlap them for the sketch.

By drawing nude figures for many years, you will get a feeling for the overall flow of the figure, along with where muscles swell and fold into each other. This anatomical muscle memory will help you when you are sketching clothed figures on location; by knowing what lies underneath the clothing, you can better understand the forms implied under fabric. It is easy to get lost in the details of folds, but if you know the underlying forms and structure, you can add the flourishes of a few folds to accentuate the form.

Although an understanding of some anatomy is important, your job is to catch each person's individual character with as few lines as possible. Constant observation and plenty of sketching practice will help you hit your mark. Facial features are only the icing on the cake. You need to pay attention to how people hold themselves – a person's slumped shoulders or proud stance will say much more about them than their facial features. It is possible to see if a person is exhausted or exuberant at a glance, and that is what needs to be caught when you sketch them.

Staging

Just like a stage or film director, an artist must consider the best placement of the actors on the stage. An actor will seldom stand facing the audience straight on, but instead actors will face each other, giving the audience a three-quarter view. In animation, this three-quarter view is even more important since it offers the most visual clues to the character's appearance.

When placing a figure in your sketch, it is important first to decide if they are in profile or facing three-quarters towards or away from the viewer. With that initial staging decision made, the person can move and you are still able to sketch them by picking details as they move around. You can also borrow details from other people in the area. No one will notice these Frankenstein sketch tactics; as long as the sketch is believable, you can mix and match people's details at will.

What you should be considering as you sketch figures into the scene is whether their position and gesture clearly tells the story. Storytelling is what any sketch should be about. Your goal shouldn't be to just draw things, but to convey and imply the underlying story.

Anytime two characters are interacting, they will become the focal point, whether they are large in the sketch or small. The key, as you search for an angle to sketch from, is to consider what personal interactions might happen between

people. Of course, the unexpected can also work its way into any sketch, so stay receptive and open to new possibilities. You might catch a person doing something just outside the confines of the sketch – feel free to move them anywhere that makes sense and helps tell the story. How you compose the scene affects how the viewer will feel about the sketch. It helps to have a clear idea as to what you are trying to convey each time you sketch.

▲ **Stage Left** The grid of the stage sets the scene of this backstage sketch. The most important figures are placed ⅔ to the left. The horizon line is just about ⅓ up from the bottom of the sketch.

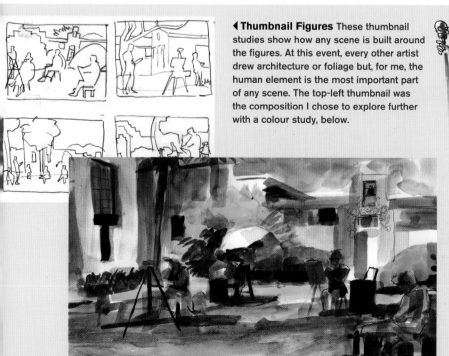

◀ **Thumbnail Figures** These thumbnail studies show how any scene is built around the figures. At this event, every other artist drew architecture or foliage but, for me, the human element is the most important part of any scene. The top-left thumbnail was the composition I chose to explore further with a colour study, below.

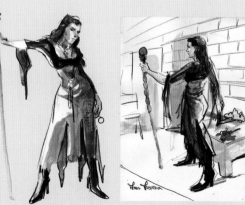

▲ **Quick Figure Studies** These two figure drawings of a model in costume could be set into any scene. The sketch on the right depicts the stage and background with a few simple lines. Seldom will there be a good reason to fill the scene with just the figure study. People are usually part of a much bigger picture.

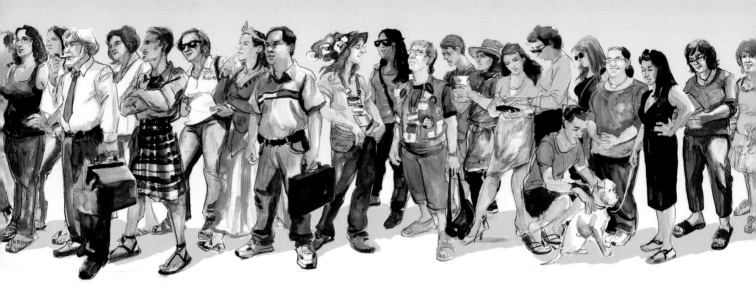

The Populated Sketch

No matter what location or event is being sketched, capturing people and their stories is usually the prime objective. If you are working on an urban scene, always change your focus and catch people who wander onto the stage of your sketch.

▲ **Whose Line Is It?** I sketched individuals for an hour each, as if they were standing in line. Later, these studies were compiled so that everyone looked as if they were standing together in line. The key was to be sure they all looked like they were standing on the same ground plane.

Whereas the focus in most figure-drawing classes is to accurately sketch a single figure on the page, it is important, as an artist documenting events, to capture people interacting in a venue. Not every person drawn has to be academically accurate. Sometimes it is enough to catch their gesture or to use several figures to help define the space.

A great place to start sketching people is with your friends, family and even colleagues. I prefer to sketch people who are doing something they love to do, so, rather than having people pose, I tend to sketch them at work or play. Working on a mural for a local museum, I put out a call on Facebook asking people to come to the museum, where I would sketch them as if they were standing in a long line. I was delighted to discover that people do actually enjoy posing when asked. I had always assumed that people in today's fast-paced

society would never have time to pose for an hour-long drawing. I was thankfully wrong.

If you run across someone who is unique, it isn't rude to simply ask them if they could pose for a sketch. There is a magical collaboration that happens when the artist and model are at work. People universally understand that posing for an artist is a rare privilege and are often honored and pleased, even if you question the quality of your sketch. As long as it isn't the worst sketch you have ever done, you need to accept it and move on. As a critical artist with good taste, you may never be completely satisfied with a sketch. It is only by repeatedly doing the work that you will one day be surprised to find you are producing acceptable sketches. It is when we sketch other people that we tend to most question our work, but by working on location you will be surprised to discover that other people aren't as critical as you.

▼ **Flash Mob** This is typical of the type of challenge that attracts me to a scene. Men, women and children were lined up in a huge function room rehearsing a dance sequence. People's heights and proportions were worked out in pencil and then detail was added using ink. Close attention was needed to capture the diminishing sizes as people receded into the distance.

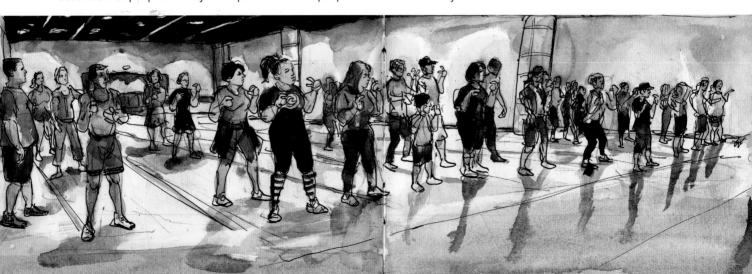

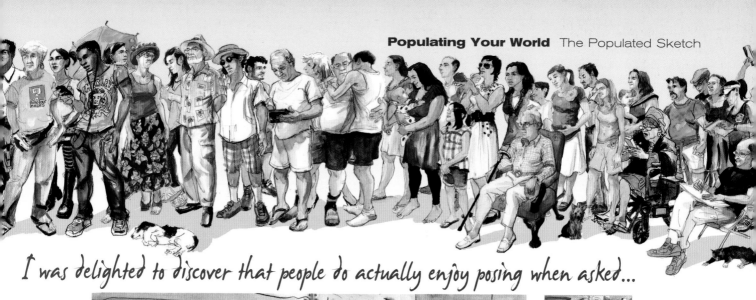

I was delighted to discover that people do actually enjoy posing when asked...

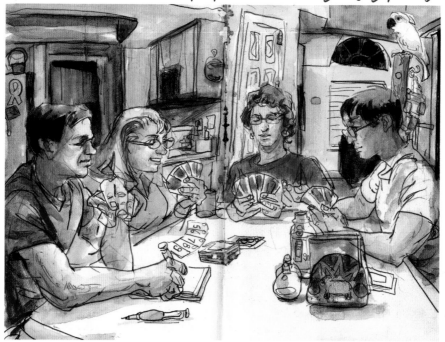

◀ **Phase 10** In this sketch of my family playing cards, the table became the ground plane that ties the scene together. Lines flow and warp on the sketch, which adds interest. Keeping perspective 100% accurate isn't as important as keeping the sketch expressive.

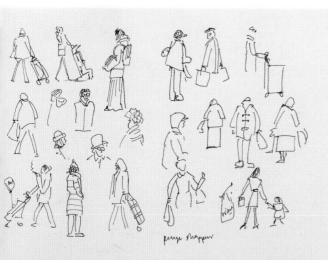

▲ **Figure Study Sheet** Doing quick thumbnail studies of people in a crowded public space, like these sketches by Lis Watkins, is great practice. The simple shorthand of scissoring the legs apart gives an instant hint that people are walking. Were these sketches drawn at various sizes and positioned on a floor plane, they would create a unified scene.

▼ **Studies in Space** Now I'll take Lis Watkins' sketches and place them on a floor plane grid, like chess pieces. Figures in the foreground are larger and figures in the background are smaller. You get to decide as you go whether figures work best large or small. For me, this is the exciting challenge of working on location. As you group figures together, you are creating your own story. The two red dots are the vanishing points of the ground plane. By building from the ground plane up, you can always create a reasonably populated sketch.

Vanishing point

Vanishing point

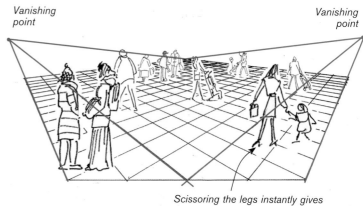

Scissoring the legs instantly gives the appearance of walking.

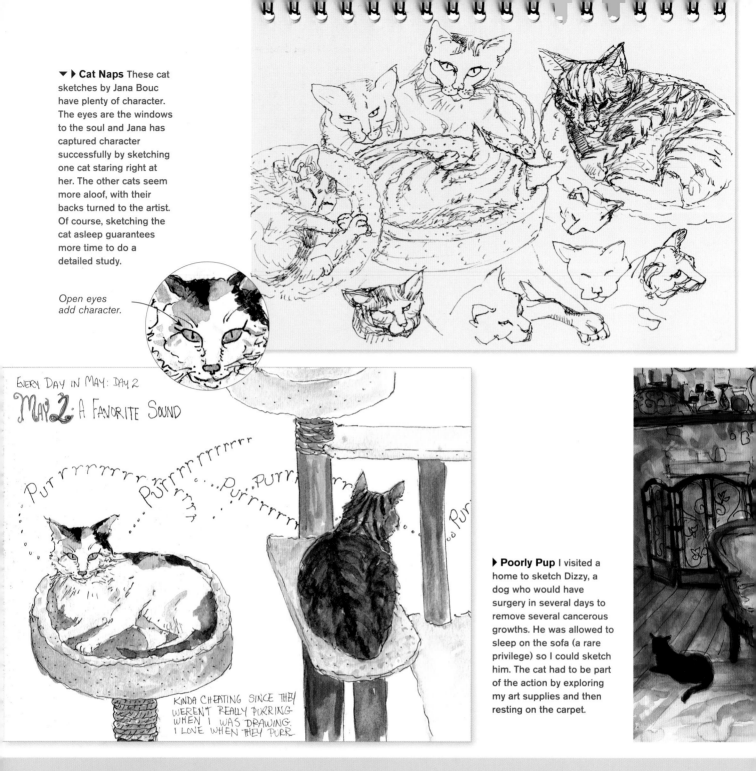

▼ ▶ **Cat Naps** These cat sketches by Jana Bouc have plenty of character. The eyes are the windows to the soul and Jana has captured character successfully by sketching one cat staring right at her. The other cats seem more aloof, with their backs turned to the artist. Of course, sketching the cat asleep guarantees more time to do a detailed study.

Open eyes add character.

EVERY DAY IN MAY: DAY 2
MAY 2: A FAVORITE SOUND

Purrrrrrrrrr...Purrrrrrrrr...Purr...Purrr...Purrrrrrr...Purr

KINDA CHEATING SINCE THEY WEREN'T REALLY PURRING WHEN I WAS DRAWING. I LOVE WHEN THEY PURR.

▶ **Poorly Pup** I visited a home to sketch Dizzy, a dog who would have surgery in several days to remove several cancerous growths. He was allowed to sleep on the sofa (a rare privilege) so I could sketch him. The cat had to be part of the action by exploring my art supplies and then resting on the carpet.

Urban Animals

Of course, the animals you will most often encounter when you are out sketching will be people's pets. The good thing is that pet owners can be quite fanatical and there are public events staged specifically for pets.

When I worked for Disney Feature Animation, the training department specifically had trainers come in with animals such as lions, bear cubs, possums or llamas so that the artists could sketch the animals from life. There were also field trips to the local zoo and horse stables that also offered sketching opportunities.

Though most events I sketch at are for people, there are plenty of opportunities to sketch animals if you look for them.

For a while I went to the stables where the police horses were kept in my city. Volunteers would ride the horses to be sure that they were trim and fit. There are plenty of sketch opportunities as the horses are washed, saddled and fed. My wife took riding lessons and I would join her with a sketchbook in hand. Once you have drawn an animal a number of times, you can add character and personality to each sketch. People who ride horses know each individual horse's personality; as an artist it is your goal to also catch what is unique to each animal you sketch.

Dog owners are often almost obsessive about their pets and there are a number of dog-related events: dog shows, dog-related festivals and fundraisers. I have even been to a pet shop when

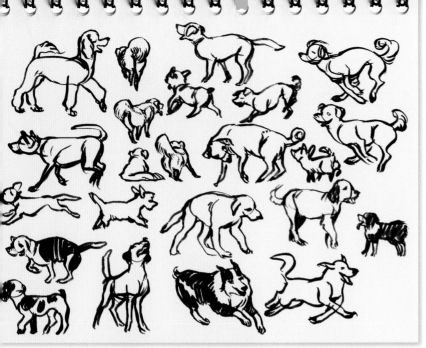

◀ **Dog Days** This fabulous page of dog sketches by Charlotte Belland depicts plenty of character and spontaneous doggy gestures.

▼ **How Much is that Doggy?** What better place to sketch dogs than at a pet shop? At this shop owners of a particular breed got together for a fundraiser and social hour. Dogs, especially small ones like these, are always on the move. Keep an eye open for the dog's general proportions and then add detail wherever it can be found. Each of these sketched dogs are composites of several actual dogs in the room.

owners of one breed all brought their dogs in on the same day. If you are doing an outdoor city scene, you are likely to see a dog owner taking their pet for a walk. If you ask a dog owner if you can sketch their pooch, they will be more than pleased.

A big challenge when drawing animals is that they seldom sit still. Just like drawing people, it is good to start off with loose gestural studies to catch quick poses. If the animal is in constant motion, you can do several sketches at once and return to each drawing once the animal returns to a similar position. I usually sketch three-quarters to one side or the other. There should be one line that flows through an animal's pose from snout to tail. Getting that first gestural mark on the page is necessary before you focus on details of the head, ears, legs and tail.

Continued on page 88

▶ **Doberman**
This Doberman, by Charlotte Belland, is structurally sound. The three masses, skull, ribcage and hips, show a solid understanding of quadruped anatomy.

Note the three body masses.

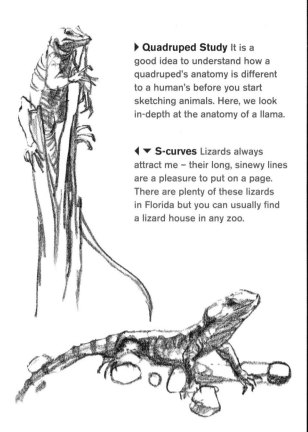

▶ **Quadruped Study** It is a good idea to understand how a quadruped's anatomy is different to a human's before you start sketching animals. Here, we look in-depth at the anatomy of a llama.

◀ ▼ **S-curves** Lizards always attract me – their long, sinewy lines are a pleasure to put on a page. There are plenty of these lizards in Florida but you can usually find a lizard house in any zoo.

▼ **Flow Fur and Flesh** Thin, fluid S-curved lines beautifully capture fur and flesh in this sketch by Benedetta Dossi. Being stuffed, the animals made perfect models; the challenge of capturing an animal on location is that they will always be moving. Catching small children in a sketch is about as challenging. With patience and perseverance anything is possible.

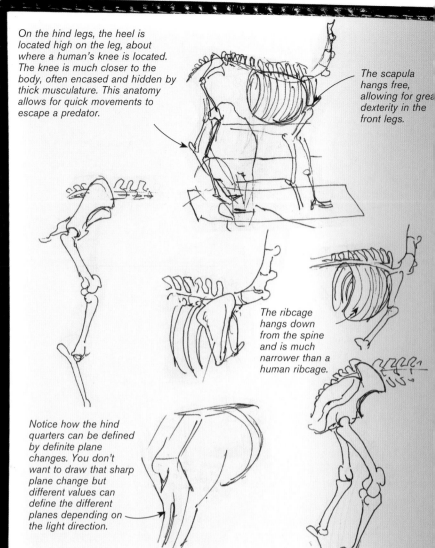

On the hind legs, the heel is located high on the leg, about where a human's knee is located. The knee is much closer to the body, often encased and hidden by thick musculature. This anatomy allows for quick movements to escape a predator.

The scapula hangs free, allowing for grea dexterity in the front legs.

The ribcage hangs down from the spine and is much narrower than a human ribcage.

Notice how the hind quarters can be defined by definite plane changes. You don't want to draw that sharp plane change but different values can define the different planes depending on the light direction.

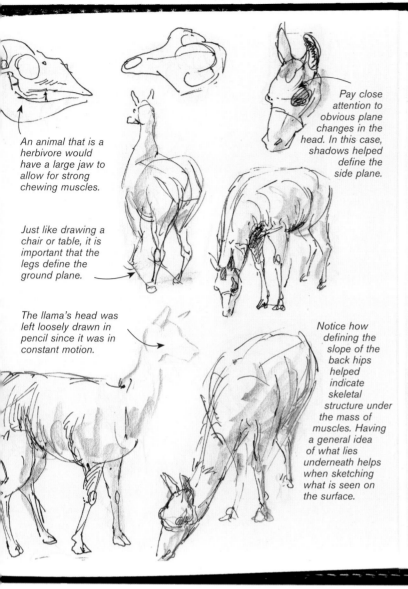

An animal that is a herbivore would have a large jaw to allow for strong chewing muscles.

Just like drawing a chair or table, it is important that the legs define the ground plane.

The llama's head was left loosely drawn in pencil since it was in constant motion.

Pay close attention to obvious plane changes in the head. In this case, shadows helped define the side plane.

Notice how defining the slope of the back hips helped indicate skeletal structure under the mass of muscles. Having a general idea of what lies underneath helps when sketching what is seen on the surface.

We're Going to The Zoo

When Disney Feature Animation was looking at my portfolio of sketches, they asked me to do a new series of sketches by going to the zoo. When you've taken multiple trips to the zoo, you start to discover which animals you enjoy sketching the most. Like every other aspect of sketching, the more you do it, the better you get at it.

▼ **Inner Structure** Lapin's magnificent sketches of dinosaur skeletons retain a sense of scale, while hinting at what the creatures would look like if they were walking the earth today. The scapula hangs along the sides of the ribcage like any modern-day quadruped. Simple grey washes silhouette the skeletons from the background.

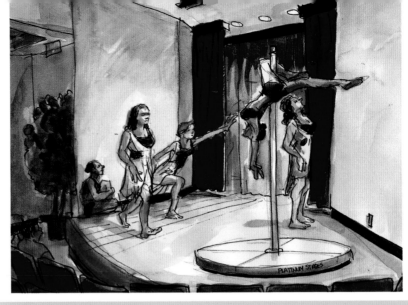

▶ **Single Action Line** The dancer walking is adopting what is known as the 'contact pose'. Her right foot is about to take her weight as the other foot rolls off the ground. This is the pose I fall back on when sketching someone walking. The dancer lunging forwards and the dancer on the pole were caught while moves were rehearsed multiple times. Accident, intuition and serendipity allow action lines to flow through one figure into another.

Action and Movement

Sometimes it isn't enough to place static figures into a scene. When sketching a city street scene, I will usually incorporate a person walking. Since the person is in constant motion, it is important to pick a portion of the action and recreate it from memory.

Animators learn how to recreate any motion through a series of poses. With a walk there are four basic poses: a contact pose, which shows the stride of the walker, a down pose in which one foot is taking all the weight, a passing pose where the free foot passes on its way to the next step and a high pose in which the figure springs up right before coming down to the next contact pose. I almost always recreate a contact pose when drawing someone walking since this pose shows the full stride.

When sketching at sports or dance events, I will focus on an action which happens repeatedly and try and recreate that action. The more the figure's action line leans forwards, the more dynamic the pose will be. When trying to catch action poses, it is important to find a single action line and build the figure around it. With practice and a little knowledge, you can sketch any action pose.

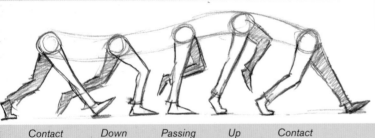

Contact Down Passing Up Contact

◀ **Walking the Walk** From the contact pose, one foot takes all the weight and the other foot passes through in preparation for the next step. The contact pose shows the full stride and is therefore the most useful pose in a still drawing.

Continued on page 92

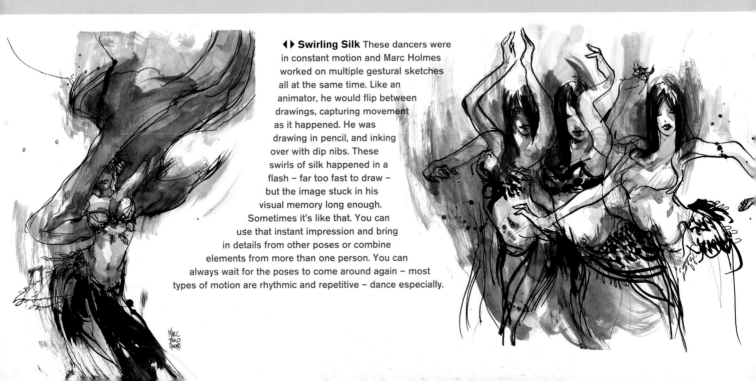

◀▶ **Swirling Silk** These dancers were in constant motion and Marc Holmes worked on multiple gestural sketches all at the same time. Like an animator, he would flip between drawings, capturing movement as it happened. He was drawing in pencil, and inking over with dip nibs. These swirls of silk happened in a flash – far too fast to draw – but the image stuck in his visual memory long enough. Sometimes it's like that. You can use that instant impression and bring in details from other poses or combine elements from more than one person. You can always wait for the poses to come around again – most types of motion are rhythmic and repetitive – dance especially.

▶ **Blind Gesture** You can do quick gestural studies without ever looking at the sketch page. Keep the pen on the page and keep drawing without pausing. This way you can put down far more line mileage and all your attention will be on the action, much like this sketch of commuters by Chris Fraser.

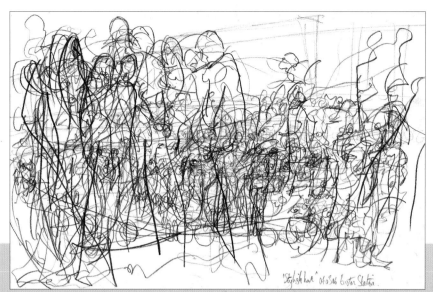

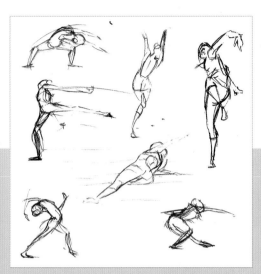

▲ **Dancers' Gestures** Christopher Campbell did a great job of quickly catching dancers' gestures. The more you sketch dancers, the better you will catch their movements. Each pose is built around a fluid action line. The sketches aren't about identifying the dancer, but about understanding how they move.

▶ **American Football** In this sketch, Darwin Borason tackled the challenging task of sketching an American football player at full stride from above. Understanding how the human form is foreshortened is critical to this sketch. The lighter gestural studies show how each sketch began.

The extra leg implies a quick action.

▲ ▶ **Flapping Wings** Robin Berry kept the gestural studies of birds preparing for flight loose and spontaneous. The more finished painting (right) retains that loose flow with bold washes. Lines were put down without lifting the pen from the page.

▲ **Full Gallop** This horse wasn't running, but the model's pose suggested a high-speed chase. This pose might not be accurate, but the drawing implies fast movement. Lines are put down fast and even the extra leg helps imply a quick action.

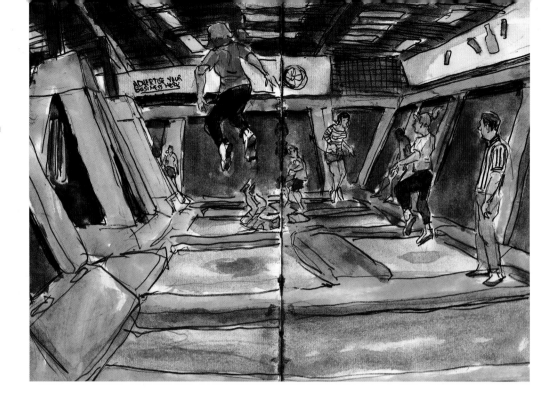

▶ **Mid-air Bounce** Most actions are repetitive, giving you multiple chances to catch a pose. The person in the red top bounced on the trampoline many times, giving me a chance to catch them at the height of the bounce. Each bouncing figure has a unique gesture that happened multiple times. The referee in the striped shirt has the most static pose.

You just have to abandon the notion of catching every detail of that individual's clothing or facial detail.

Even if you do not fully understand each of the poses involved in an action like a run, if you have the figure in mid air with both legs splayed, it will look like a run. Basically, every drawing you do of figures on location is training your eye and hand to catch motion because no one is posing for you. Since everyone is always in motion, you are always recreating action poses as you sketch. The action might be subtle, like a head turn or a hand gesture, or it might be as extreme as a jump. Either way, you have to decide what works for your sketch.

If you ask any child to draw a bird in flight, they will not hesitate as they put two simple arcs on the page. Drawing people and

animals in motion simply requires you to go back to that childhood confidence. You just have to put down a quick gesture and add details as you find them. Understanding what makes a pose dynamic will help you to push your figures to look more active. Most figures you will sketch will be people standing straight up and down. The second you lean that person forwards, you have created a dynamic action line. The reason I often sketch rehearsals is that actions are repeated over and over until the scene is set in everyone's mind – including mine. This gives me a chance to study active poses repeatedly.

As an artist, it is best to focus on movements that have a reasonable chance of being caught in a sketch. I seldom sketch runners, simply because they exit a scene so quickly. If I were

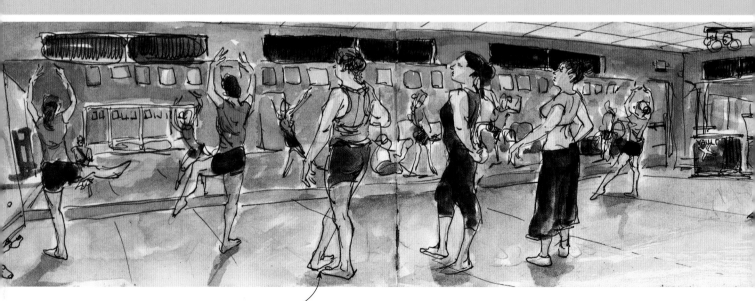

With some dancers, I watched the unique way in which they stand while others are mid-motion.

▲ **Dance Poses** Sketching dancers rehearsing is a real challenge. The advantage of a rehearsal is that dancers might repeat a dance move again and again, giving you time to catch a motion.

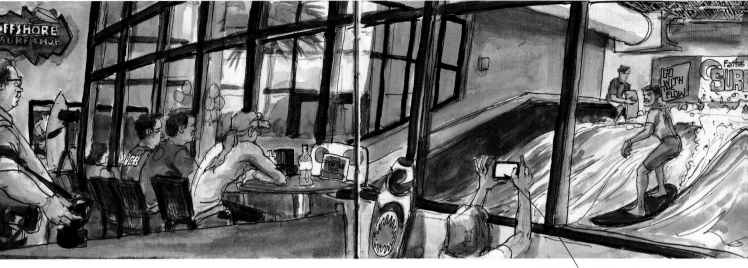

▲ **Go With the Flow** The surfer was caught by watching repeated attempts at riding the wave. The pose is actually a composite pieced together from different surfers. The person shooting video on their phone adds to the moment in time.

This person filming the moment adds to the sense of spontaneity.

sketching a running event, then I would focus my attention on runners warming up and stretching before the race. There are certain actions that are best caught by a camera and it's best to leave catching those moments to photographers. When writing about what transpired at such an event, it is possible to also link photos or even videos taken at the event to go alongside your sketch. Such images are instantly available online, so you can browse through them to show any action that wasn't caught in the sketch.

When I was starting out as an artist, I felt the need to rush, trying to catch things that happened in the blink of an eye. The key is to slow down and take in the whole scene in a way that a camera cannot. As you sketch one thing, you might notice

something else that interests you. You are able to layer in people and actions as they happen, and the sketch becomes a sort of composite that will feel complete when all the elements balance out. The multiple active gestures you catch can become part of the overall scene. Memory and a general knowledge of anatomy, gained from the time you put in at figure-drawing class, should help complete poses that change before you are finished. The key is to pick the poses that tell the story best and be willing to erase a pose if it just doesn't work. You are constantly going to have to evaluate the scene as it progresses. Once you finalise a pose to ink, then you need to live with that pose and work others around it. It is a constant game of give and take.

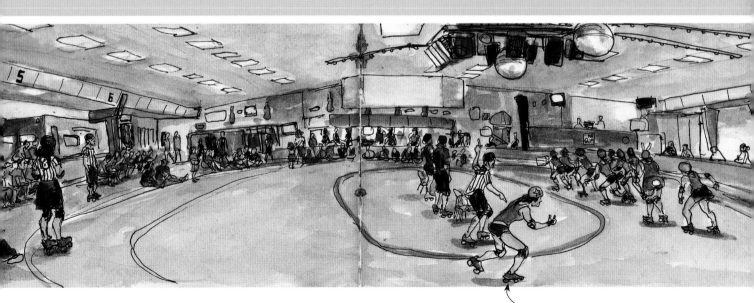

▲ **Roller Derby** With roller derby, the skaters keep going around the track, so you need to decide where to put the pack and sketch the skating poses one at a time, looking up when the skaters are in position. The forwards lean implies the speed of the skaters. I placed one skater in the foreground and her pose implies every other skater's pose. 100% accuracy isn't as important as believability.

This pose implies every other pose and helped me to establish a believable scene.

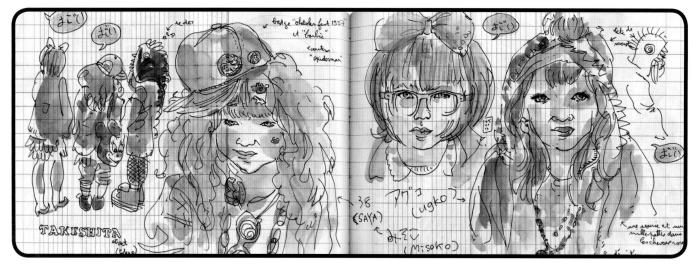

▲ **Anime** In this study, Lapin focused on the bold and gaudy anime-inspired fashions of these young girls, along with their bright pink hair. The artist sits close to his models, catching their eyes first before focusing on the details of their costuming.

◀ **Intense Stare** The direct gaze, the at-home setting and the relaxed pose that Tin Salamunic has captured, make this portrait of his fiancée an incredibly intense and intimate sketch.

▲ **Direct Gaze** These are basically contour drawing where each feature was drawn while looking at the person. I would only glance at the sketch briefly to reposition the pencil. There is an intimate energy that comes from sitting so close to the model.

Urban Portraits

Although working clandestinely has its rewards, the collaboration involved when you ask someone to pose for you is also rewarding. Life flows by at a breakneck pace, yet people are almost always willing to pose when asked. You might get the occasional joker, 'Do I have to take my clothes off?' but most people understand that what will be created transcends any photograph.

When I first started drawing on location in New York City, I would approach people waiting for trains in Grand Central Station or go to soup kitchens and sketch people waiting in basement hallways for a meal. The great thing about asking someone to pose is that the sketching experience is very intimate and, after the sketch is done, people are more willing than ever to share their life's story. Everyone has a story and as long as you are receptive, you'll find that the stories people tell you often directly impact aspects of your own life. Sketching and listening often results in unexpected self-discovery. It is as if certain people cross your path for a reason and you as an artist are open to life's lessons.

The best way to begin sketching portraits is to look at yourself in a mirror. You will always be your own best model, since you understand the importance of being still. The basic proportions of the eyes being half way down the face and the nose line being half way between the eyes and jaw might get you started, but I prefer to focus on the eyes first as the gaze is the most important aspect of a portrait. With the eyes complete, I then work down the nose and build the face around those details. It is best to look at the person's face more than you look at the page. It is better to let some details get exaggerated and off kilter rather than get super accurate and concerned with proportions.

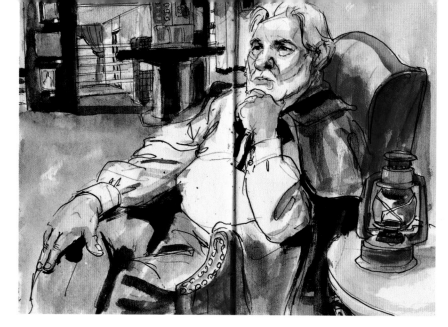

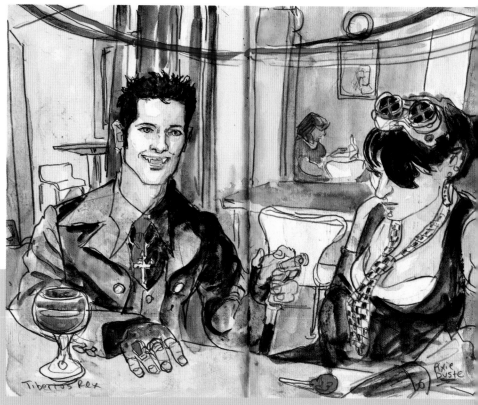

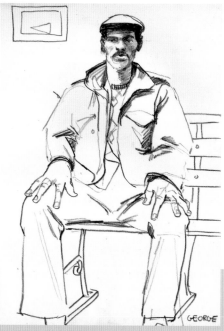

▲ Storyteller 'Country Joe' posed for me in a lounge chair in the Shakespeare Theatre. The triangle formed by his face, hand and the oil lamp holds the composition in place. Taking the time to look at the detail in the background adds a sense of place.

▼ The Vampire Tiberious Rex stared at me the whole time, smiling with his fangs exposed. Pixie Duste was more shy, so I asked her to pose without looking at me.

▲ All In the Hands This was sketched in a tight basement hallway as I sat on the floor. It is always a good idea to include hands in a portrait sketch. A person's hands can sometimes tell you more about a person than their face.

▼ Fill The Page Miguel Herranz filled the page when he sketched fellow sketcher James Richards. A cluttered table made for an unexpected foreground element on the next page.

It is always good to incorporate some of the background setting into the sketch. As the person is posing, find several background landmarks and then let the person relax as you sketch them. When you start adding colour, ask the person to pose again. Work in the flesh-coloured washes quickly and when it feels good, let your model rest again. Be sure to utilise every spare moment that you have with the person to add detail. I tend to work faster when sketching a person posing because I realise that any pose will be difficult to hold for long, but you will often be surprised at how patient people are. No portrait is ever easy but, like anything, the more you do, the better you will get at it.

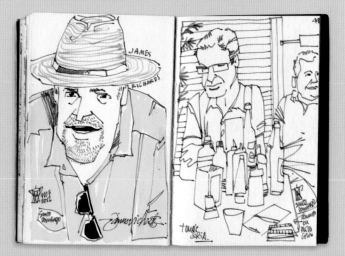

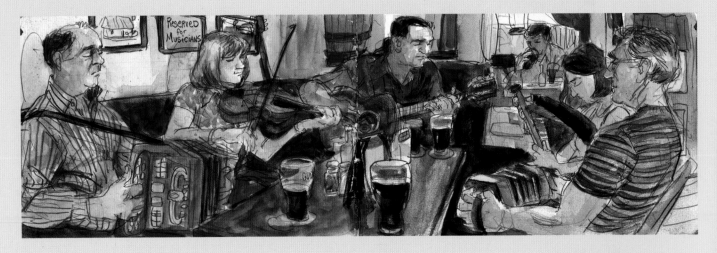

Expression

Every sketch that incorporates people at an event has an element of portraiture to it. A portrait needn't be a head filling a page. Anytime you sketch someone doing what they love to do, you will discover more about that person than what could be seen in a static, posed portrait.

Capturing a person's gesture, the way they hold themselves, is as important, if not more so, than capturing the features of their face. People are more at ease and open when they are actively pursuing their chosen goals. A question I am frequently asked is, 'Do you do faces?' It is an odd question. Every time I place a person in a sketch, I draw their face but the face is usually considered after trying to find the person's signature pose. The signature pose is a pose the person returns to time and again. That pose is usually worked out roughly in pencil, allowing for change at any time.

Quite often, I will block in a whole composition and then slow down to add the features of a face. If that facial expression is caught just right, then it is possible to relax knowing that the 10% of the sketch that people will first look at is done. The other 90% of the sketch can be rough and messy. Even when sketching

distant figures no bigger than a thumbnail, it is important to try and capture an essence of the person's gesture and expression. A portrait usually captures a neutral expression or an attempt at a 'Facebook smile', but a good sketch will capture the person's honest expression as they are living their life. What they are doing helps to tell the story of who they are and their expression hints at their personality. If you focus your attention on events, then you will always be focusing on the people who participate and those who attend.

Of course, working on location with no one posing means that you have to work quickly and with economy. An expression might be caught in a face smaller than a dime. The point being, you need to focus your attention no matter how small the person might be in the sketch. Big or small, every face you draw will be a challenge that has its rewards. Even as you question your marks, others will delight in them. The more quirky and sincere your sketch is, the more people will appreciate it. People can see photos of themselves every day, but a sketch always has an ancient magic to it. It will have your personal stamp that comes from unique observation. An artist's style isn't something that you seek out as if shopping; style is something an artist cannot avoid, it is like their handwriting, a definite pattern of mark making that they discover every time they sketch.

213

◀ **The Driver** Sitting close to his subject, Lapin catches the expression in the face and then lets the body grow small, as if seen through a fish-eye lens. The lines have a natural ebb and flow.

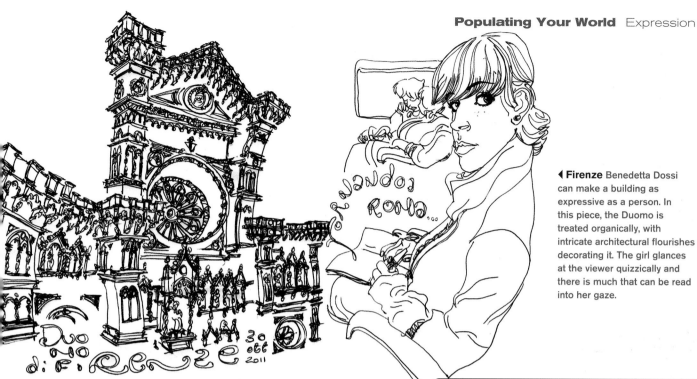

◀ **Firenze** Benedetta Dossi can make a building as expressive as a person. In this piece, the Duomo is treated organically, with intricate architectural flourishes decorating it. The girl glances at the viewer quizzically and there is much that can be read into her gaze.

▶ **Fellow Artists** Tin Salamunic has a wonderful way of capturing every tendon and muscle. He caught a friend taking her pen to her journal – the poses are relaxed and intimate. Pattern is added in loving detail.

▲ **Barrel** Miguel Herranz placed his two friends in the shade using a simple grey wash. By doing so, they become a bold foreground element. Small cups, bottles and the mid-ground barrel hint at the festivities surrounding the sketch.

◀▶ **Small Expressions** In this sketch by Moira Clinch, the small figure, shown enlarged on the left, is the size of a thumbnail on the sketch, yet it is just as much a portrait as a larger-scale sketch or a painting of someone's face. The boredom of the sales girl on the glitzy make-up counter is apparent.

Chapter 4

Choosing a Subject

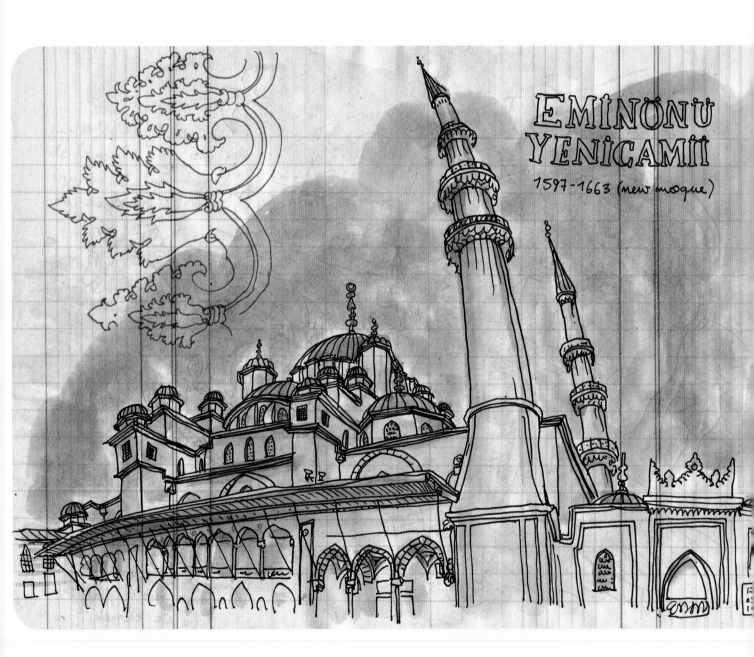

EMİNÖNÜ YENİCAMİİ
1597-1663 (new mosque)

There are sketchworthy scenes and moments all around you — all you have to do is open your eyes and you'll start seeing everyday moments as chances to get out your sketchbook. This chapter puts together all the practical things you've learnt so far in the book, and explores a variety of different subjects and sketching opportunities not to be missed. From your local neighbourhood and your daily commute to once-in-a-lifetime celebrations and newsworthy events, we look at the points you will need to consider in each scenario, as well as how other artists have captured and interpreted that slice of life.

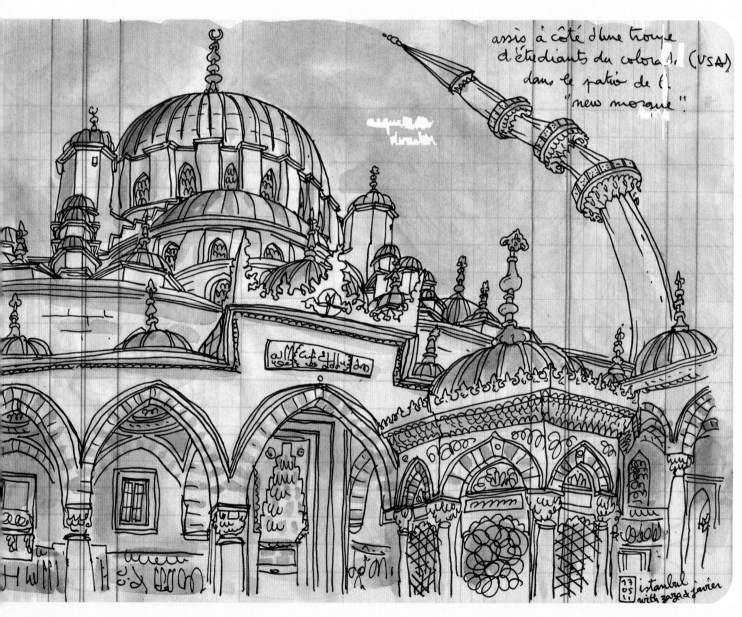

Istanbul

Lapin

Street Life

Sketching on the streets is a good exercise in getting accustomed to being out in public working. At first, the locations aren't as important as the process – it is just important to get used to having people around you as you sketch.

Many sketchers are concerned that people will judge their work if they sketch on location. If you get out every day to sketch, you will soon realise that this is simply not the case. Most people are too preoccupied to notice you, and the few that do stop to look will probably have good things to say.

Seek out places to draw where people gather on the streets. A farmers' market or bus station can be a great place to start. In university, I first sketched at Grand Central Station in New York City. I then narrowed my gaze and returned again and again to sketch a newsstand in the station. By narrowing the field, I didn't have to worry about catching the constant stream of people who flowed in a flocking mass through the terminal. I knew more about that tiny newsstand than any other New Yorker. The sketches weren't great, but the process of returning every day is what mattered and, by persevering I began to build confidence. When I worked at Disney Feature Animation, the theme parks became my sketching hunting ground. Whenever there was a break, I would return to the themed streets and sketch.

Cities of all sizes have street festivals, outdoor concerts and events of all kinds. The key is to research what is happening in your city and get out with a sketchbook to record what you find. From your figure drawing, you will realise that it takes at least five to ten minutes to sketch a person, so don't start sketching someone who seems impatient and constantly on the move. If your subject does leave, return to the details of the street itself. The streets of any urban setting offer limitless sketch opportunities. Get out and simply observe!

Key Points to Remember

- Focus on stationary people.
- A few active gestures will enliven any street scene. Find a person's line of action and build a pose around it.
- Pull ideas from multiple people (a FrankenSketch).

Audabon Market

▲ **Adding Life** This sketch of a farmers' market at night is, in its basic form, a cube of space defined by the tents, with people gathered around it. Only a few gestures were needed to add life; I chose a woman with a child on her hip and another woman leaning over to look at produce. The rest of the figures are just quick indications. People walking down the aisle between the tents were ignored.

▼ **Catch the Walkers** In this sketch, Kumi Matsukawa depicted walking figures with a simple, scissored-legs gesture. Adding these walking figures to the crossing helps to bring the street scene to life. Other people are waiting for the light to change and could be captured with a bit more deliberation.

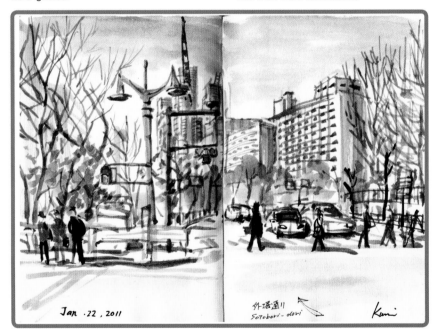

Jan .22 , 2011

外濠通り
Sotobori-dori

Kumi

▶ **Choose Your Focus** At this outdoor Art Festival, I ignored the crowds of people rushing around the fountain and instead focused on the people who chose to sit and relax in the sun-dappled shade. A few active figures are added in the far distance to give the feeling of activity.

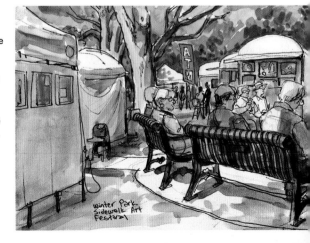

Winter Park Sidewalk Art Festival

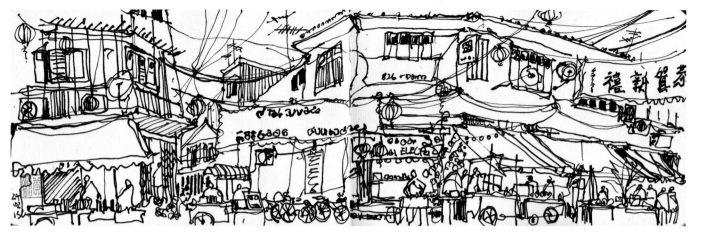

▲ **Panoramic View** The thin strip at the bottom of Paul Wang's sketch shows all the human activity on the street. The buildings could be sketched at leisure, but sketching the people required fast work. The riot of bicycles, wagons and carts further stress the activity.

▼ **Observe Angles** Melanie Reim catches magnificent and simple gestures. The man with the hat has a bold, diagonal stance while another person leans over in a question-mark-shaped gesture. The distant fence and a glimpse of brownstone buildings give just enough of a hint of location.

▲ **Let Shapes Flow** Margaret Hurst lets the people walking down the street billow and flow like balloons. The figures have an incredible amount of character, observed at a quick glance. The people dominate the setting.

This figure has been drawn with a diagonal stance.

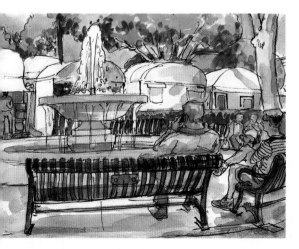

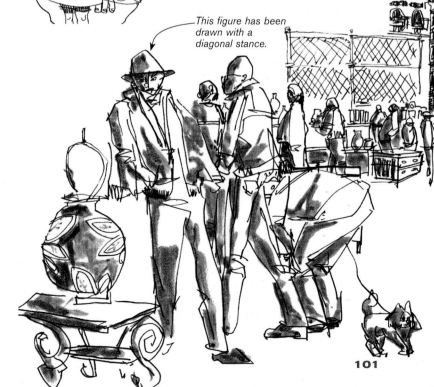

101

Park Life

Sketching in a public park is often a great way to start as an urban artist. When I host sketch outings with fellow artists, we usually meet at a public park. As always, I am attracted to the activity of groups of people. If there is music or shouting, then walk towards it.

Being a creature of habit, I always park in the same place, near a public park, whenever I sketch in my city. For me, there are practical reasons (the advantage of public toilets and the avoidance of parking metres and the hassle of driving into town) but, even without such considerations, I would say to anyone: if you can, begin near a park. You will find it is really relaxing to stroll through the park; sometimes I have to stop just to sketch the view.

Once, at the Metropolitan Museum in New York City, I saw a guard standing and gazing out a window into Central Park. The trees were in full springtime bloom with a riot of rich colour.

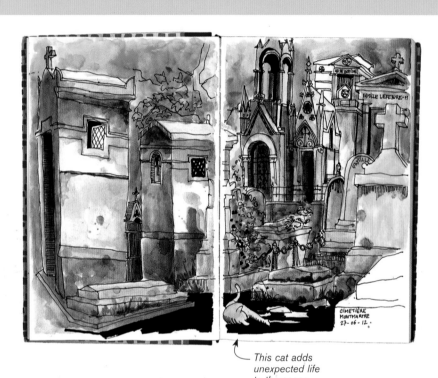

This cat adds unexpected life to the scene.

▲ **In the Cemetary** There is no more peaceful place to sketch than a cemetary. You can be pretty sure that no one will look over your shoulder (and if you do sense something behind you, it's best not to look!). A cat adds unexpected life to this structured tombstone scene by Cristina Curto.

◀ **Micro Versus Macro** I tend to focus on wide-angle sketches, capturing the expanse of events. It is just as important, however, to focus on the smallest of details like Cristina Curto does in these studies of cacti.

Key Points to Remember
- If there is life and activity, walk towards it.
- Find pleasure in depicting small details and large expanses.
- People can be an important part of a scene or a small part of the larger picture.

The museum seemed dark and gloomy in comparison, so the best thing to do was to go out and try and catch some of that colour.

Public parks are always bursting with life. People relax on the grass, feed the pigeons, skateboard, rollerskate, jog, stroll. It is usually best to find a fixed landmark in order to ground the composition and then place figures quickly. As well as capturing the stories and activities of everyday park life, check bulletin boards to find out what events are scheduled to happen in a park near you. Concerts, cultural events and dances could very well be your next subject. Look for life and you will find it.

Sunday in the Park

At the turn of the 20th century, George Seurat returned to a Paris park doing repeated studies of people relaxing on the weekends. His studies were quick, black-and-white tonal sketches done from life. In his studio he then

painted the immense 'A Sunday Afternoon on the Isle Grand Jatte'. The final painting was done with an infinite number of dots of colour, a technique known as Pointillism. The studies, however, were undeniable urban sketches. If you ever doubt that a park might offer enough drama for a sketch, then be sure to see Seurat's painting at the Art Institute of Chicago.

◀ **Blue Grass** Outdoor concerts are always a great sketch opportunity. In this sketch, the trees' shadows were put down with blues and purples over the base colour of green grass. The woman in the lawn chair anchors the sketch, while the distant performers push the eye deep into the scene. You don't need a front row seat to get a decent sketch.

This woman anchors the sketch.

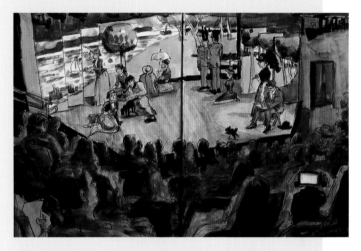

▲ **Art Mirrors Life** The play 'Sunday in the Park with George' is all about George Seurat sketching in a Parisian park. The artist had an eye for finding life in the park.

▼ **The Lone Couple** The couple seated on a park bench in this sketch by Matthew Brehm add a touch of romance to a panoramic tree-lined boulevard. Deep purple shadows anchor the trees, and a warm wash draws your eye to the couple.

Although they are tiny, it is almost impossible to miss the couple on the bench.

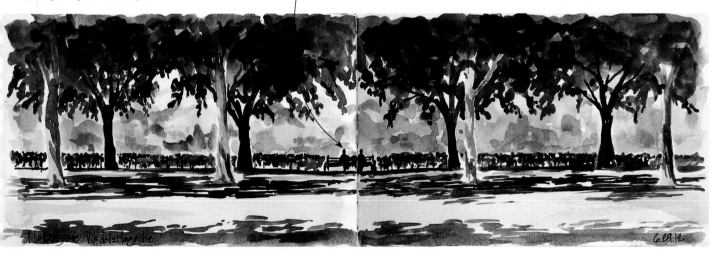

◀▶ Profiling Passengers
Public transport is always bustling with activity. Ana Rojo captured an elderly couple reading the same paper (left), their heads silhouetted in the darkness of the window.

▲ A crowd of school children seem cheerfully engrossed in Teoh Yi Chie's sketch. The large foreground businessman crowds the scene, upraised arms hinting at a shaking train.

◀ Tube Focus The tube offers free models seated right opposite you. If you are clandestine, people will never know that they are being drawn. Most people are so busy with their own concerns that they don't have time to notice you sketching.

Transport

When you begin to carry a sketchbook every day, you will find that being a passenger in a car or on a plane, train, bus or the tube is no longer wasted time, but rather a great time to sketch. People seated across from you can become models if you are clandestine as you sketch.

As a student, I could never resist sketching fellow passengers on the tube. Every trip became a sketching excursion. A baseball cap can help avoid catching your subjects gaze. By focusing your attention first on the feet and working upwards, you will have most of the sketch done before quickly adding facial features. Another advantage is that you will know roughly how much time you have to finish the sketch and you can adjust your speed accordingly.

Continued on page 106

The artist's knees and feet make it clear that he is in the driving seat.

▲ A row of bus seats creates a rather lonely scene in Ana Rojo's bus sketch.

▲ Passengers nod off in Cristina Curto's tube sketch, yet keep the sketch alive by wearing bright primary colours.

◀ **Planes Perspective** The two-point perspective inside a plane gives Miguel Herranz's sketch a cavernous yet cosy feel. One vanishing point is directly in front of his seat at the nose of the plane. The other vanishing point is down the row he is seated in when he turns his head to the right.

▶ **Terminal Sketching** A bus or plane terminal is a great place to people-watch and sketch. Artists are probably the most patient travellers – a delayed flight can be viewed as an excuse to get one more sketch done. Andrew Tan seems to be evesdropping as he sketches the intricate details of two men sitting in front of him.

It's a real challenge to sketch someone who is sitting right beside you.

◀▶ **Inside Cars** Tin Salamunic captured in loving detail the intricate forms of a car's dashboard (left). The sketch was later digitally tinted. When you are a passenger in someone else's car, then there is often time to sketch. The movement of the car will cause your lines to shake, which might detract from accuracy but will also add energy to the sketch. Joao Catarino used bold, black brushwork to sketch a driver and passenger from his back-seat vantage point (right).

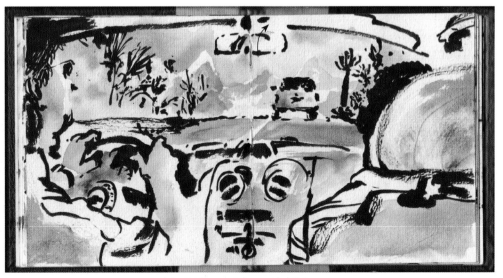

▲ ▶ **Your Ride** Whether your ride is a Nissan Xterra like mine (above), or more like Tin Salamunic's Harley Davidson (right), sketching your own vehicle is a great way to start. Vehicles are usually part of any cityscape. Pay close attention, they add character to any sketch. Then again, they tend to date your work. So, if you are sketching historical architecture, it is sometimes better to leave vehicles out.

When seated on a plane, you will have to focus much of your attention on the one-point perspective as you look down the length of the cabin. If you use a fish-eye distortion, you might be able to catch the passengers next to you. When you are a passenger in a car, it is a fun challenge to sketch the driver. If the road is bumpy, then the lines in your sketch will reflect that. Being able to accept the added roughness in the lines brings you closer to realising that sketching conditions can prompt unexpected results.

I know that artist Edward Hopper worked from inside his car when weather conditions were bad. In this way, the car can become a mobile studio. He used to lean his sketchbook against the steering wheel, using it like an easel. In the winter, having the heat on in the car can be a blessing, whereas the summer heat can be avoided with the AC. I have seldom tried sketching from my car because I mostly sketch at events which are staged indoors anyway.

Waiting at an airport or train station will never be wasted time if you have a sketchbook on hand. Holidays are often packed full of such sketch opportunities. As the saying goes, 'It's not where the road leads, but the journey that counts'. Having a sketchbook means being able to catch every moment of the journey.

Key Points to Remember

- Just like sketching a room, you need to understand perspective to see the general shape of a vehicle.
- Be sure the vehicle's tires are well planted on the ground plane.
- Spend some time on the details.
- Make use of transport delays to sketch other commuters who are similarly forced to sit still.

▶ **The Station** In this sketch, Miguel Herranz does a good job of capturing the flowing curve of a tube station. Once the setting was established, waiting passengers could be added to the platforms. Just three values are used in the composition, with red added to pop out some signage.

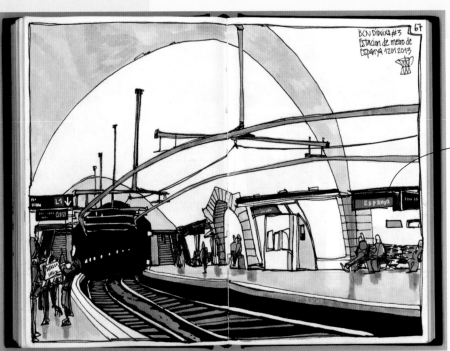

Red signs add a splash of colour to an otherwise black-and-white sketch.

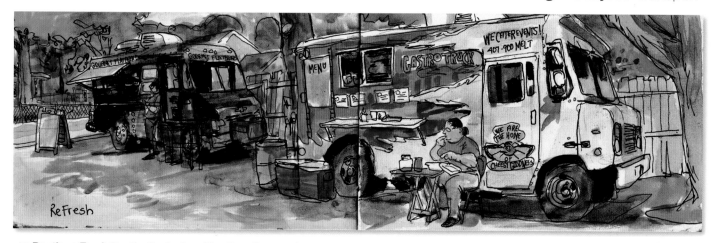

ReFresh

▼ **Boutique Truck** My attention is piqued by alternative uses for modes of transport, like this fashion boutique truck. Markings on the pavement are strong indicators of the ground plane. The basic composition is of a square inside a rectangle. Strong shadows define the basic forms.

▲ **Food Trucks** A similar use of vehicles, food trucks are becoming more common. In their simplest form, the trucks can be thought of as elongated cubes on a ground plane. Tree shadows are applied as blues and purples.

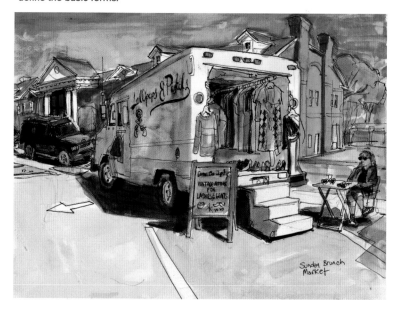

Seeing the Shapes

The trucks can be thought of as elongated cubes.

Strong shadows define the basic forms.

The basic composition is of a square inside a rectangle.

▼ **Fish-Eye Distortion** Lapin's sketch of a Bel Air car has been done with a fish-eye distortion. The artist sits close to his subject (so close that his reflection can be seen in the bumper) to get the effect and capture incredible amounts of detail.

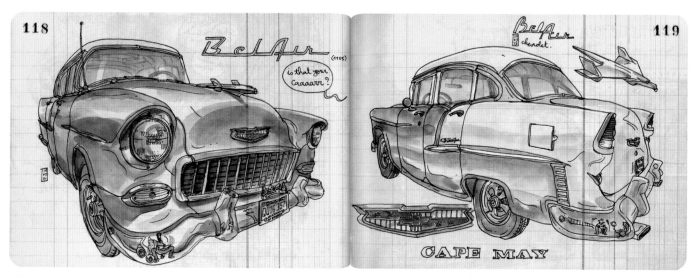

It's not where the road leads, but the journey that counts.

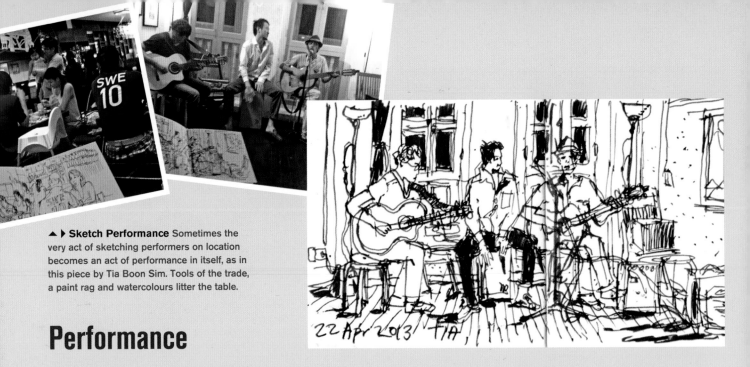

▲ ▶ Sketch Performance Sometimes the very act of sketching performers on location becomes an act of performance in itself, as in this piece by Tia Boon Sim. Tools of the trade, a paint rag and watercolours litter the table.

Performance

All of the arts speak the same language. As an artist, it helps to surround yourself with inspiring people. There is much to be learnt from sketching actors, dancers, musicians and performers of all kinds. Besides being great subjects, performers are fun people to be around. By sharing your experiences, you contribute to the community you live in.

When I began doing one drawing a day and posting it online, I was soon drawn to performers. What intrigues me is sketching others who are lost in the creative process. That first year, I followed a play from the first reading all the way through to the final stage production. So many pieces had to fall in place, and artists from different backgrounds collaborated to realise the production. When I listened to the director talking to the actors, her comments often sounded like she was referring to a sketch as it is created: the beginning stages have uncertainty and some trepidation, but one by one decisions and commitments are made that help shape decisions to come.

Sketching in a theatre can be problematic. House lights often go off when a play is performed; a small book light is helpful but be mindful of audience members around you. I prefer to sketch rehearsals, because the actors will repeat a scene again and again until they get it right. These multiple takes give multiple chances to stage the characters in your sketch. This is true of dance rehearsals as well, as repeated moves give you multiple chances to catch loose, flowing gestures while locking them into an overall composition.

One advantage of sketching live performances is that it forces you to complete the sketch by the time the show is over. It is important to utilise every moment, so if there is a break, keep working. The interval is a great time to switch gears and start throwing colour on the sketch. If the performer isn't on stage anymore, then paint what you remember. Stage lighting can be inspiring to paint, a strong red stage light might make the figure appear completely red even if he is wearing clothes of a different colour (see page 33). Painting in very low lighting forces you to only paint bold values and to guess what colours you are using based on where they are in the palette. It is often a pleasant surprise to see what was painted once you find a light.

Sketching staged productions also trains you to find clear staging in every other sketch you do. It is possible to find at least one performance to sketch each day. Follow your instincts and curiosity, learn something new and share it with others online.

Key Points to Remember

- Set the stage and then add the performers.
- Lightly block the figures in and then add details in ink.
- Rehearsals give you multiple chances to sketch a given gesture.
- Stage lighting can change a performer's colour.

◀ Get Close Ted Michatowski uses bold ink lines, sometimes putting ink on the page with an eye dropper. He works large with bold splashes of colour.

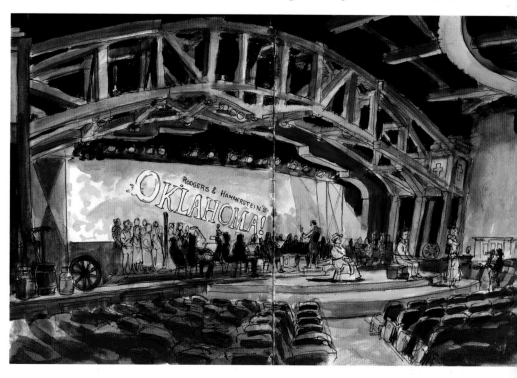

▲ **Local Gigs** Small coffee shops and late night bars offer many free concerts featuring local performers. The more you get out and sketch, the more familiar you will become with the local arts and culture scene.

▲ **The Venue** Sometimes what is astonishing isn't a close-up view of the performers. Sometimes the massive scope of the space and stage is what is inspiring. Here, there is barely room for a hint of the faces among the chorus and the sixty piece orchestra is treated as a simple silhouette.

◀ **Floor Level** This sketch by Ana Rojo has the eye level directly at or slightly below the stage level. This makes the orchestra appear like a Parthenon frieze, moving flat and horizontal. Note the limited palette of Burnt Sienna and grey.

▶ **Closer than the Audience** Ted Michatowski (right) has musicians play and artists surround the performers, in essence on stage themselves, bringing the action up-close and personal. A sketch artist doesn't have a zoom lens, but you can draw close, detailed studies like Miguel Herranz has done of these performers (far right).

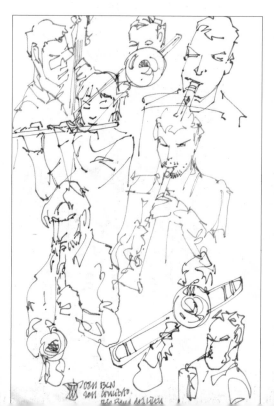

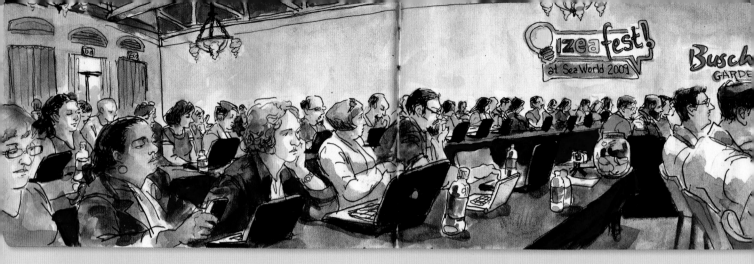

Working Life

Everyone has to work to make a living. Some people define themselves by their job, yet people seldom document their work life. As an artist, it is important to expand your horizons, so sketching people at work makes a rewarding subject — you can learn a lot about someone if you sketch them at work.

It is, of course, a good idea to start sketching colleagues at your own job. When I worked at Disney Feature Animation, I would sketch colleagues at their desks during breaks and the lunch hour. Doing a sketch at work is like exercise; it can help invigorate you, making you more productive. I find myself drawn to people who

have creative jobs. When someone is truly lost in their work, there is an energy that helps to fuel the sketch in progress. You will learn something from every person you sketch, so remain open and always listen. Often a person will relate something that is directly pertinent in your own creative journey.

I've sketched my wife at her office and I usually seek out people that have interesting jobs to sketch. Curiosity about everyone around you is essential as you branch out to find interesting sketch opportunities. Most people consider their job to be an uninteresting subject for a sketch. You just have to assure them that you will be the final judge of what is intriguing to draw.

There have to be businesses that you frequent and yet just haven't thought to sketch. I'm often surprised to find that few artists have ever sketched in the art shop where they get their supplies. Every artist will have their own favourite spots to

Using Soft Cubes to Find the Human Form

The simplest way to block figures into a sketch is to think of the general shape of the pose as being made of soft-edged cubes. I tend to do this in pencil and then go back with a pen to add more organic flow to the pose. It is possible to sketch the cube forms just using the outside contours. The inner changing of planes is usually implied when shadows are added with watercolours.

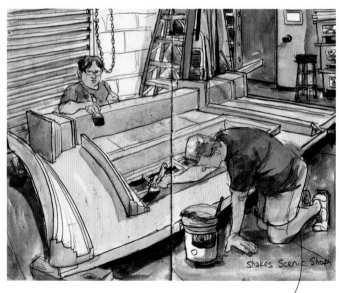

The head, torso and hips are three distinct cubed forms that can twist relative to each other.

▲ **Facing Opposition** While sketching in a department store, I was asked to put the sketchbook away or leave. You may encounter such things but it always makes for an interesting article when I write about the event.

▲ **Set the Scene** With the centrefold of my sketchbook, the challenge with this sketch of a set design assembly was to try and fit one figure on each page. It is important to patiently wait for the right gesture and work quickly to get it in position. Sometimes, moving a figure where you want it is the best option.

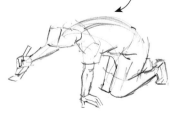

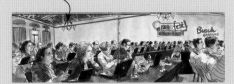

This triangle-shaped section of ceiling defines the far corner of the room.

Triangle section of ceiling structures the room.

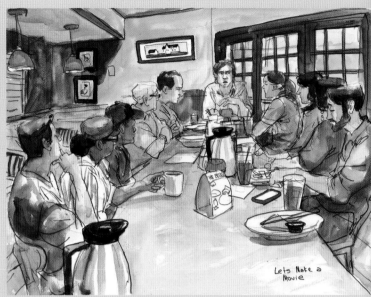

◀ **Captive Models** At a high-tech-blogging conference, everyone's faces are illuminated by computer and mobile-phone screens. It was rewarding to capture this scene in the old-fashioned way with pen and paper. In our digital age, people are often distracted by electronics, turning them into perfect, motionless models.

▶ **Meeting Notes** Next time you are at a meeting, pull out your sketchbook. Most people will think you are just taking notes.

frequent and the possibilities are endless. If you sketch outside, then you can sketch police, security guards or builders without having to ask permission. If you have to sit in a doctor's waiting room or you are waiting for a car repair, these are great sketch opportunities. Restaurants, pubs and other venues are also wonderful places to stop and sketch. Moments that might be wasted flipping through mobile-phone applications can become creative and fulfilling moments of observation.

 I tend to sketch businesses in the creative field or charities. It is rewarding to see volunteers working to improve their communities. Most local papers have such volunteer events listed. As you progress as an urban sketcher, your interests will become obvious as you follow your curiosity and instincts. You might be fascinated by politics; if so, follow a campaign. There are plenty of inspiring stories that can be sketched in any community.

Key Points to Remember

■ People at work often take signature poses. Take note of them.
■ Use soft cubes to add structure to a pose.
■ A person's workplace can say much about their character.

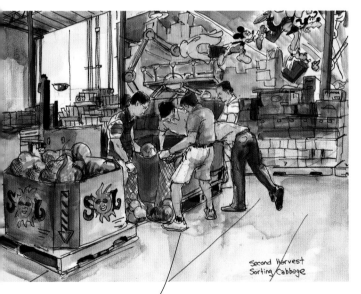

Second Harvest Sorting Cabbage

▼▲ **Look Around** The working world is the world around you. From markets to courtrooms, the opportunities are endless. Moira Clinch drew the fish market on site, the courtroom sketch was drawn from written notes and memory. Tia Boon Sim added touches of colour to the market sketch below to bring it to life.

Treating the skull as a cube form helps you look down on the shape.

▲ **Capturing Gesture** Volunteers sort cabbages, placing them in red knitted bags. The key to this scene was to establish the whole composition of the immense warehouse and then focus on each individual's unique gesture. Gestures were captured loosely in pencil, so I could reposition poses as needed, and then I committed to ink.

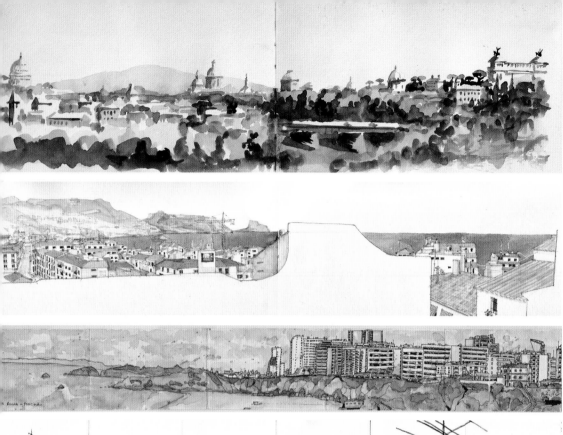

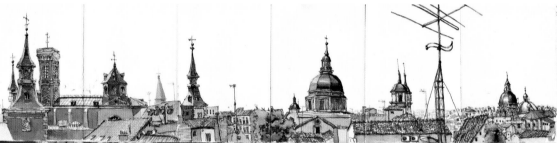

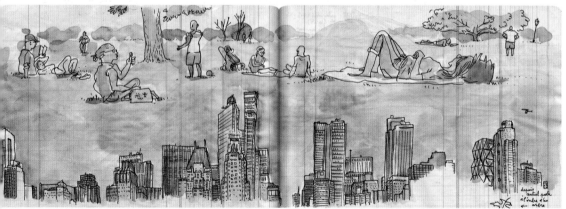

Holiday Sketching

Most people go on holiday to relax and get away from work. However, a holiday is the perfect place to get out the sketchbook and document a new city or culture. Sketching is a universal language and you might interact with locals in a way most tourists don't.

By taking the time to sketch while on holiday, you really get to know a place. Everything will feel new and fresh, waiting to be documented in your sketchbook. The architecture and culture might seem mundane to the people that live in your holiday destination, but with your sketches you will be excitedly seeing everything from your unique perspective. You might realise that the everyday aspects of your hometown are just as unique if you would take the time to sketch them.

Honestly, sketching a beautiful holiday spot is a great way to relax, as long as you surrender to the idea that no sketch is perfect. Of course, you probably have travel companions, so you might not be able to stop long enough to complete a sketch

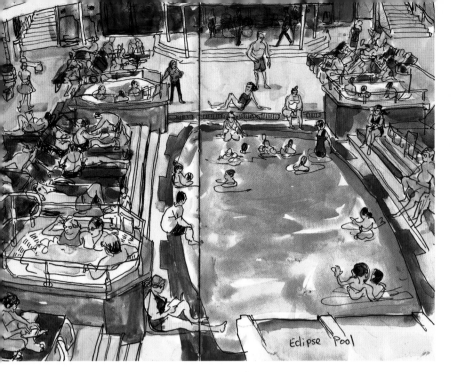

◀ Cruise Ship Pools
A cruise ship can offer the same sketching opportunities that are available in a small city. While most people soak up the sun, you could be flexing your sketching muscles.

▼ Poolside Sketching
Simple, pure ink lines capture the gestures of children just about to get in the water in this poolside sketch by Carol Hsiung.

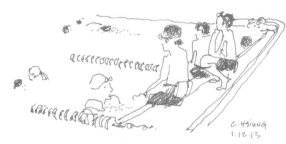

▶ Florence Benedetta Dossi sketched this girl on the river embankment. The lamp post flows with organic grace and the crowds grow thick, as they approach the Ponte Vecchio.

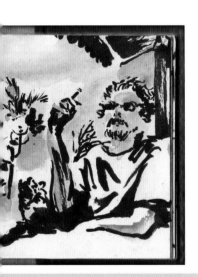

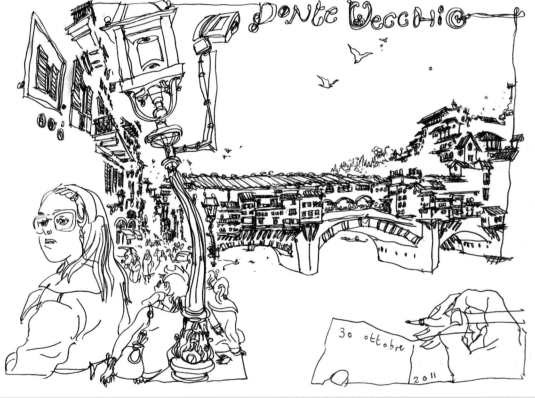

everywhere you go. Just like when you aren't on holiday, try to schedule enough time to complete one sketch each day. Many holiday sketches might be done when waiting for a plane or train, but it is also important to experience the local culture while sketching. Your sketchbook journals may be your most treasured, since returning to a sketch will bring you back to that moment on holiday in a way that photos just can't. As a matter of fact, I no longer carry a camera on holiday. I much prefer savouring and capturing the moment with a sketch.

Cruise ships and large hotels offer scheduled cultural events, just like a small city, so you can sketch any events that catch your eye. However, once you arrive at any new city, it is a good idea to get a local paper to see what events the locals favour. Don't rely only on touristy pamphlets in hotel lobbies. Orlando, the city I live in, is a huge tourist destination, but what I sketch each day is seldom to never visited by tourists. Having said that, kitschy tourist traps can be fun sketch opportunities as well. It's all about variety.

Key Points to Remember

- Stay open to new experiences and sketch new settings and cultures.
- Find out where the locals go for entertainment and follow them.
- Even if you don't know the language, you might find yourself interacting with locals who are curious.
- Keep your travel sketch kit light.

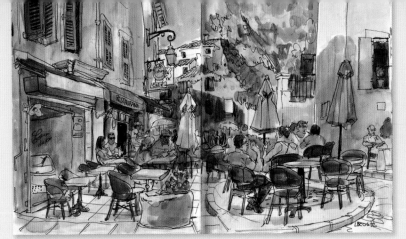

◀ French Café When travelling, I am much more likely to sit outside to take in the architecture. The buildings are used to frame the human activity.

Find the cube shape.

Layer on architectural detail.

Buildings

In a movie, many sequences begin with an establishing shot, which is taken from a distance to show where the action is happening. When drawing buildings, I am usually thinking of the sketch as an establishing shot for the sketches that follow.

When I began doing a sketch every day, it was January and most of my sketches were of buildings. When summer came around it was too hot to be sitting outside in the sun, so it made sense to begin sketching events inside. When I am travelling, many of my sketches are of buildings and architecture because they are the most accessible subjects when you are new to the city or culture. It takes time to learn what the locals do for entertainment in the evenings.

Among urban sketchers there are essentially two camps. One camp is the illustrators and fine artists who spent years doing figure drawings from models. They tend to think of buildings much like the figure, trying to imply

Continued on page 116 ▷

▼ Modelling Mansions My wife likes to go on guided tours inside mansions. While she is with the tour group, I take the time to study the architecture. Always look for such hidden moments to sketch.

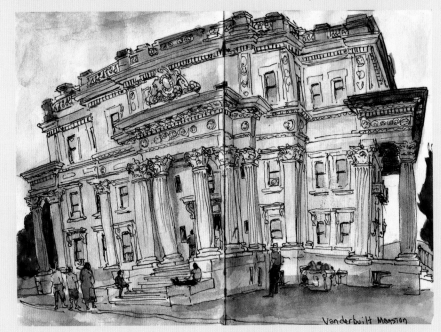

Vanderbuilt Mansion

▼ Exotic Destinations This light and airy sketch by Kiah Kiean keeps the whole surface active with loose washes. Birds on a wire and a tight crowd of people make this street scene breathe. What is exotic for the artist might seem mundane to the people who pass by every day.

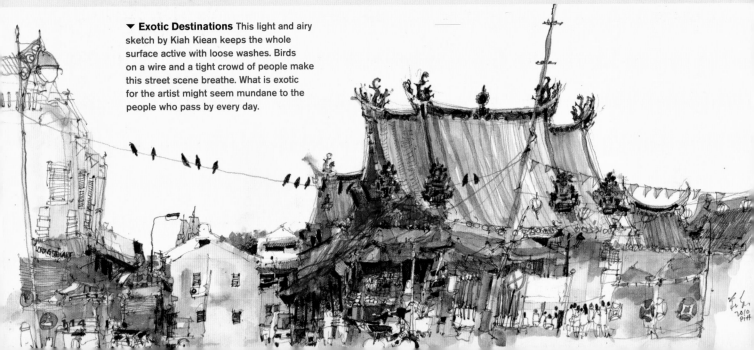

114

▶ **Curved Lines** Notice how the lines fall away from the edge of the page as the building rises up. This warps the scene as you look up.

▲ **Complex Interior** Miguel Herranz took this complex interior of the Palau de la Musica and used the simple shape of the oval above a ground plane to construct the scene. There are basically two grey values used here. The whites of the window are the lightest values in the sketch.

gesture and mood in loose sketches. The second camp of sketchers are architects who want to get out and directly observe architecture on location. Their drawings tend to be more precise and accurate. Both approaches are exciting and valid in their own right. Variety is what makes sketches unique. With the next generation of artists and architects growing up using computer programs to create images, they all benefit when they step away from the screen and walk out into the sunlight to sketch directly from life.

Buildings are large, so your first step is to try and fit it on the page. If you begin by drawing small details, you can become lost. Find the top of the building, then find the base in your sketch. Once the large forms are blocked in, you can break down the larger shape into smaller shapes. The process is very much like drawing a large rectangle and then putting smaller rectangles inside it. Everything doesn't need to be fully defined – you don't need to draw every brick. A small pattern of bricks and a loose colour wash can imply a whole brick wall. Keeping it simple and knowing when to stop is always the biggest challenge.

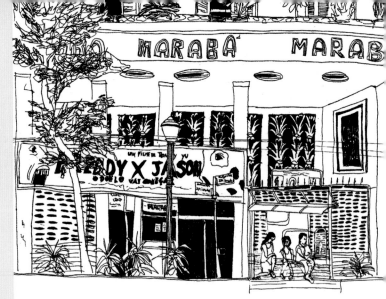

▲ **Maraba** This sketch of a building entrance by Juliana Russo makes use of one-point perspective and pays careful attention to patterns. The people at the bus stop help to populate the scene.

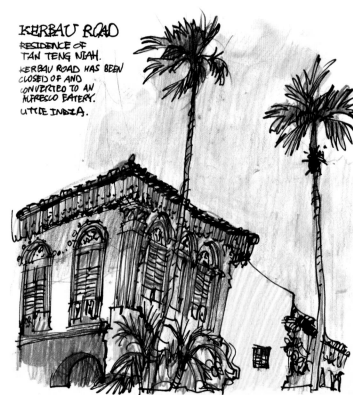

▶ **Kerbau Road** In this sketch, Don Low focused his attention on the corner of this building and used coloured pencils to apply bright, direct colour. Using coloured pencils for large areas is a challenge, but he established just enough blue sky in order to silhouette the building.

▼ **Light Washes** Tia Boon Sim's sketch has large, splashy areas of colour, with ink lines defining architectural detail. I love the tree treated as a wild, loose scribble. When you apply marks quickly, they are sometimes more expressive than descriptive.

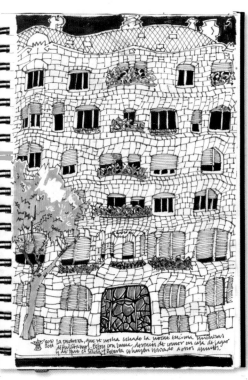

▲ **Façade** This building façade by Miguel Herranz makes good use of rectangles inside rectangles, inside rectangles. Black is used to darken empty windows, while brickwork is carefully explored. This is an example of flat space which explores the two-dimensional quality of the façade.

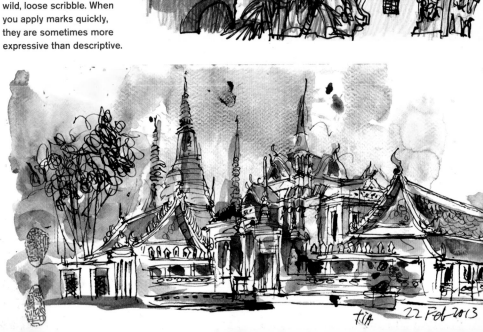

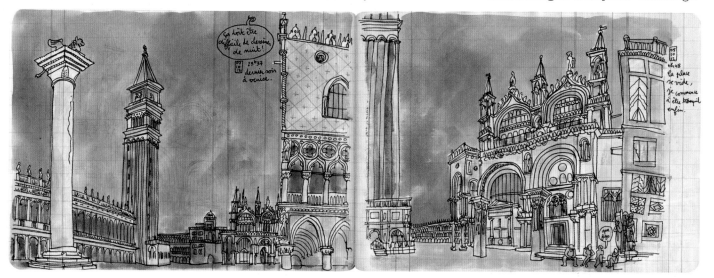

▲ **Venice** In his sketch of Venice, Lapin pays close attention to the delicate filigree and details of the buildings. The bold, blue wash used for the sky accentuates the warm buildings. The two separate sketches almost read as a panorama because of the consistency of technique.

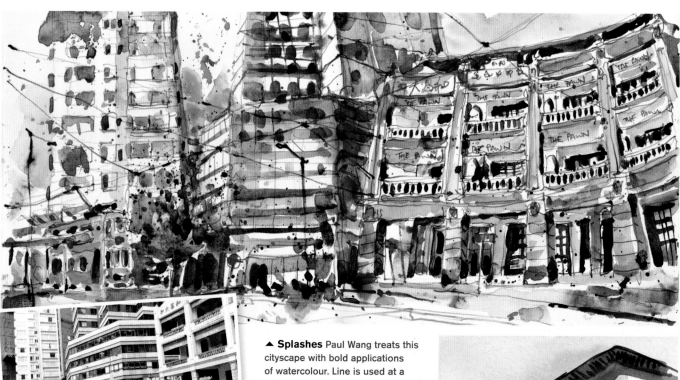

▲ **Splashes** Paul Wang treats this cityscape with bold applications of watercolour. Line is used at a minimum, in favour of drips and splashes of colour. A building feels concave and it rises upwards to a third vanishing point in the sky.

Key Points to Remember

- Establish big shapes first and slowly work towards the details.
- The sun will create warm surfaces and cool shadows.
- If possible, add the human element.
- Neat or sloppy, every sketch should balance detail with expression.

▶ **Classic Architecture** Minimal line work is also used in this sketch by Matthew Brehm. A sky-blue wash outlines the building, the façade of which has warm surfaces and cool shadows. A bold, dark wash sets back the building across the road. Minimal details allow the viewers to complete the scene in their minds.

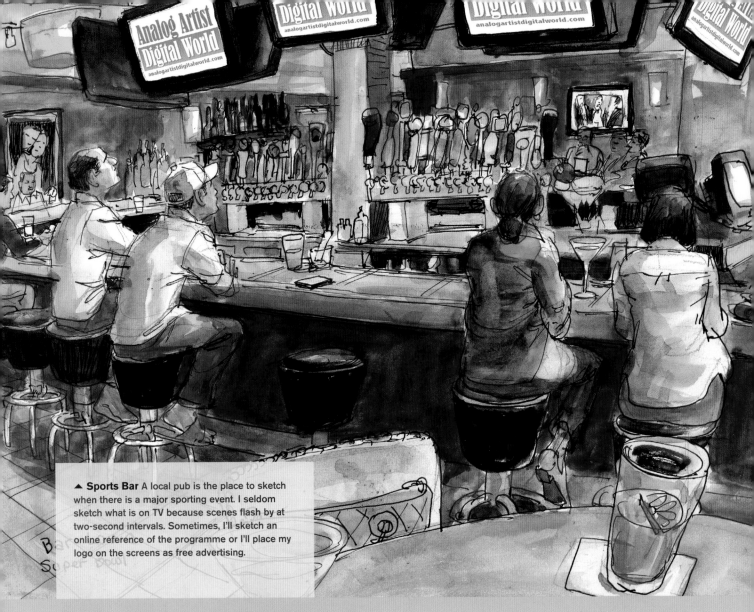

▲ **Sports Bar** A local pub is the place to sketch when there is a major sporting event. I seldom sketch what is on TV because scenes flash by at two-second intervals. Sometimes, I'll sketch an online reference of the programme or I'll place my logo on the screens as free advertising.

Cafés, Bars and Restaurants

Cafés, bars and restaurants are some of the first places you might sketch when you venture out of the studio. I like to joke that just because I've posted online 67 sketches done in pubs doesn't mean I have a drinking problem. The fact is I have a sketching problem.

Going out to sketch at a bar or restaurant guarantees you will find a room full of people, many of them seated, which gives you ample time to sketch. You have an added bonus in that you get to order delicious food and drink which you can report on. Sometimes, if the establishment owner finds out you are sketching as part of a review of the food, you may get perks. I just discovered a quote by author Mary Oliver that rings so true for sketching, 'Instructions for living a life. Pay attention. Be astonished. Tell about it.'

If you follow those simple instructions when you sketch, your life will change. It will become an adventure of tastes, sights, sounds and people whom you might never have met otherwise. As you become comfortable in the hustle and bustle of pubs and restaurants, you will begin to want to branch out and find other places where people get together. Your interests might lead you

to sporting events, literary events or any number of places where people meet and share ideas, as well as food and drink.

The thing about being an urban sketcher is that you will need to learn how to be comfortable being alone as you sketch. It is impossible to be actively engaged in a dinner conversation and sketch at the same time. Observation requires a bit of distance. I once asked friends which restaurants they would be the most uncomfortable going to alone and then I visited and sketched each of the places to get used to the feeling. As you sketch, you will become aware of conversations going on around you. They all become part of the story of the sketch. A few people might approach you to see what you are doing, and you might tense up because your sketch isn't finished, but no one will judge you.

Key Points to Remember

- People seated in a restaurant or bar will still be active. Find their signature pose.
- Pay attention to light sources and accentuate the most obvious ones.
- Shadows and plane breaks help define shape.
- Try and catch gestures, such as a sip or the cutting of food.

▲ A Tea Crawl Liz Steel likes to sketch the tea and food she samples. Any restauranteur will respect your taste, if you sketch their food presentation. Good food properly presented is like a stage production.

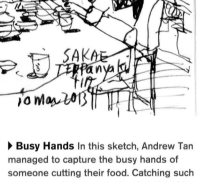

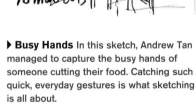

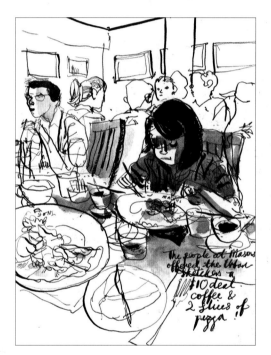

▲ Teppanyaki Tia Boon Sim caught a chef who worked the grill at the table at this restaurant. Such table-side chefs can be quite flamboyant. Wonderfuly spontaneous lines go right through dishes and the chef's hat, giving the impression that dishes are moving repeatedly.

▶ Busy Hands In this sketch, Andrew Tan managed to capture the busy hands of someone cutting their food. Catching such quick, everyday gestures is what sketching is all about.

▼ Mixing Media The atmosphere of this bakery and coffee shop in Barcelona is wonderfully conveyed by Victor Martínez Escámez (aka 'Swasky'). You can see how he has used brushwork for some of the characters, watercolours for much of the bakery produce, and pen and ink to complete other elements, including café furniture and the humble air conditioning unit.

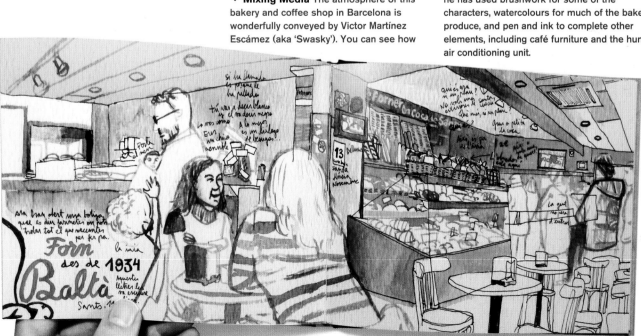

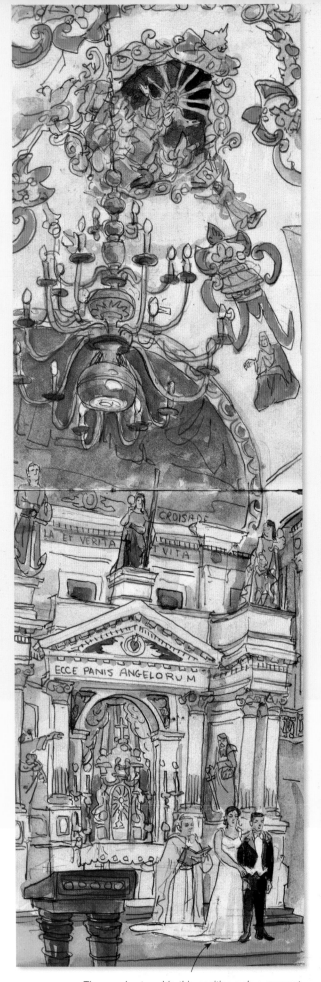

The couple stayed in this position only a moment, but they are a small part of a much bigger scene.

Celebrations

A sketch artist seeks to document all of life's celebrations and challenges. On multiple occasions I have been asked to sketch at weddings and parties. I've also documented life-changing events such as divorces and funerals. No event is too small or too large to be captured with a sketch.

At most parties and celebrations I am unable to focus on conversations of people around me. I tend to hear the overall noise generated by the crowd as a whole. But, the second I begin to sketch, the background noise fades away. The focus required to sketch brings with it a sense of peace and well-being. Of course, there is the constant struggle to bring the composition to life, but nothing can distract an artist who is lost in the process.

A wedding seems like an incredibly fast-paced affair when you try and catch it with a sketch. Unlike a photographer, you have to find one great vantage point, stick with it, and calmly accept how the scene unfolds. Since time is limited, it is a good idea to start the sketch before the ceremony begins. Keep areas where people are likely to congregate in pencil. If you believe the couple might leave, be sure to add watercolour washes to complete the look of light and shadow on people. If they do leave, continue working on the background setting. Every sketch is a game of locking in what is ephemeral and then going back to finish the rest.

Every town and city has its share of street festivals and celebrations of all kinds. It might be difficult to catch all the details of a parade as people march by, but you can certainly capture the crowd of spectators. You might just need to catch a few specific gestures in the crowd and then treat the rest as one large mass.

News stations report on tragedy. As artists sharing our work on the Internet, we get to report on things that should be celebrated. Every festival, concert, party or wedding celebration is an opportunity for artists to learn something about themselves as they sketch and report. Getting out of the isolation of an artist's studio to sketch every day helps an artist better understand the world. You begin to realise that most of life is a celebration and you just need to be there to capture it with a sketch.

Key Points to Remember

■ Find a position and stick with it until the sketch is finished.

■ If somebody seems like they might leave the scene, add colour and final line work to them before they are gone.

■ Even when the event is over, you can keep working on the sketch.

◀ **Wedding Illustrations** Capturing this wedding required finding a pew where my view would be unobstructed. I focused on the grand cathedral architecture when the couple's backs were to me. The people are small in the huge space. A photographer could capture any close-ups needed. Colour was added to the couple and the priest before the ceremony was over. The architecture was sketched and painted as everyone left for the reception. Every spare moment was used.

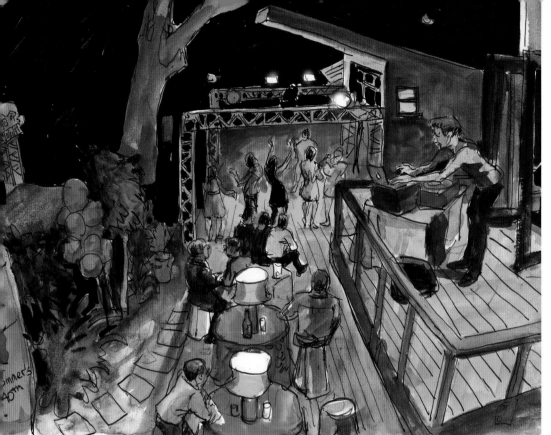

◀ Party Party The Catch 22 of sketching celebrations is that you have to step back to do a sketch. This sketch was done from a second-floor window and, once it was done, I made my way down to the dance floor to celebrate a friend's 40th birthday.

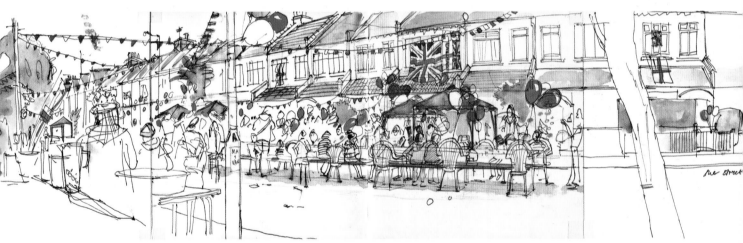

▲ Street Festivals Every city has its share of street festivals and parties. Lis Watkins caught a wide expanse in her panoramic view of a street festival. Red and blue add spots of vibrant colour.

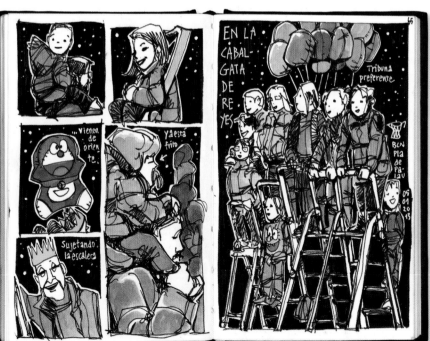

◀ Vignettes Miguel Herranz broke up this sketchbook spread into panels like a graphic novel in order to sketch individual vignettes of a crowd. These small sketches tell me more about the event than one large sketch of the crowd would.

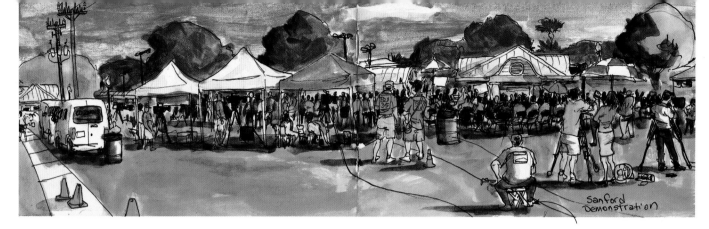

▲ **Protests** A large crowd gathered to demonstrate after the fatal shooting of American teenager Trayvon Martin by neighbourhood-watch coordinator George Zimmerman on the night of 26th February, 2012. Zimmerman claimed he shot the unarmed youth in self-defence and, at first, he wasn't charged by police. Questions about Florida's 'Stand Your Ground' law received international attention. Allegations of racist motivation for both the shooting and police conduct contributed to public demands for Zimmerman's arrest.

This journalist is seated very much like an artist sketching the scene.

Social Issues

Every city has some civil unrest. As an artist documenting modern society, it is important to pay attention to people's needs. Unmet expectations are the seed of almost every drama. Whenever I hear of a protest, march or rally, I grab my sketchbook.

You might be drawn to social issues that specifically affect your everyday life. Some artists will do daily sketches documenting an ongoing siege or battle, and some truly amazing art comes from artists who become war correspondents. I have never been a courtroom artist but have sketched in courtrooms on occasion to document personal stories of people I know. Since TV cameras are being allowed in many courtrooms now, the courtroom artist is a dying breed.

If you remain curious and follow your instincts, you will be able to document many civil debates and protests. By reading your local paper or following online news feeds, you can always stay connected to the issues in your community. For example, whenever the circus comes to town, I know that protesters will be there to demonstrate against the harsh treatment of the animals.

Homelessness is a pervasive and never-resolved issue. On one occasion, I documented an act of charity being treated as a criminal offence when people feeding the hungry were arrested because of a city ordinance involving food-sharing permits. When I lived in New York City, I used to sketch people waiting for food at the Cathedral of Saint John the Divine. I don't document homelessness as much these days, preferring to focus on the people who help through charity work. Find the social issues that interest you.

People who try and help the disadvantaged in any community deserve to have their efforts documented. By sketching and reporting on the selfless services performed, you can help raise awareness and inspire others to volunteer. In this humble way your sketches can bring about positive change.

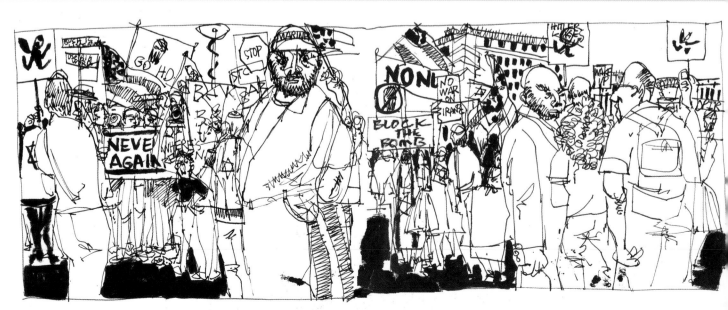

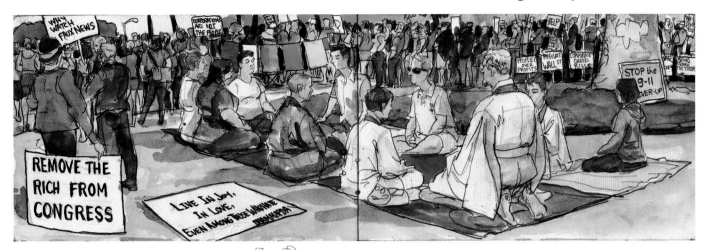

▲ **The 99%** In solidarity with the Occupy Wall Street demonstrators in New York City, demonstrators camped out at the Orlando Chamber of Commerce, starting on 15th October, 2011. Protestors stayed on the property for many months and I would stop back on occasion to sketch. People were arrested and property was confiscated. In time the protest dissipated.

▶ **Two Colours** The crowd of protesters with banners is drawn in black ink while the building is drawn in red. Cristina Curto treated the crowd with loose, fluid line work. Raised arms immediately add some motion to the scene.

Key Points to Remember

- Establish a horizon.
- Use people in the scene to create the feeling of deep space.
- Banners and flag outlines can be quickly sketched with details added later.
- You can sit in the midst of a protest and still go largely unnoticed.

▼ **Personal Protests** Some battles are fought on a smaller, more personal, scale but are still worth reporting. In this sketch, I documented the story of a homeowner in my neighbourhood who was fighting a city ordinance that would require him to replace this gorgeous vegetable garden with grass. The homeowner is still fighting the ordinance and the case is ongoing.

◀ **In the Crowd** In this sketch, Melanie Reim captured the impression of being in the midst of a large protest. Small, medium and large figures and banners fill the page with a sense of busy commotion.

Let it be

News Circus

Newsworthy Events

When you begin sketching events every day in your city or town, you will become a journalist, reporting on the activity in your community. You don't always have to document the negative aspects with your sketch journalism, TV news does that already. Document the creative and inspiring stories of the people in your city, too.

▲ **News Circus** In this sequence of sketches, I documented an event that really rocked my community, when local Orlando, Florida mum, Casey Anthony, was accused of killing her daughter, Caylee Anthony. I saw helicopters hovering over the courthouse, so I walked towards them. I encountered a media circus when Anthony was found not guilty of murdering her daughter. She was found guilty of providing false information. She was later released on 17th July, 2011.

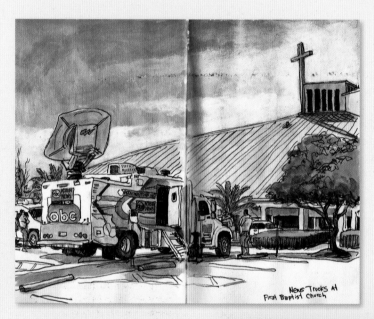

News Trucks At First Baptist Church

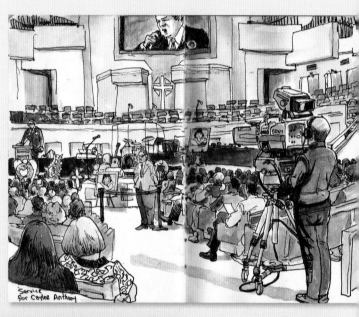

Service for Caylee Anthony

▲ **Community Rocked by Murder** In this sketch, I focused on a memorial service that was held for the young girl. Casey was in prison and didn't attend.

▶ **Makeshift Memorial** The site where the young Caylee Anthony's body was found became an important site for mourners and well-wishers, with people bringing cuddly toys to leave behind.

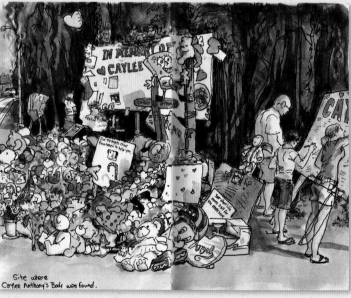

Site where Caylee Anthony's Body was found.

▲ **Sketchbooks Allowed** No cameras or mobile phones were allowed in the memorial service for two-year-old Caylee but I brought my sketchbook in to report on the event. No one noticed me sketching.

When you mention journalism, most people assume that means reporting on crime, accidents, murder and war. Although this is undeniabley a part of it, there are just as many creative and inspiring human-interest stories that can be found. If you are out in the community sketching every day, then you will meet people who will point you towards stories that are worth sketching. Remain open-minded, always curious and you will find yourself sketching events that you never knew about before. Finding interesting stories and events involves some work: scour newspapers and social media for potential sketch opportunities. Follow your instincts and sketch what interests you most.

When I was an illustrator in New York City, I felt that I needed to convince art directors and editors that drawings done on location are a great way to document events. With the rise of the Internet, I now realise that I don't have to wait for art directors and editors to send me on assignments. I can pick my own assignments and share them with people every day via a blog. Anytime there is an event where cameras aren't allowed, bring a sketchbook. Printed newspapers are struggling, yet there is a sea of information that goes online every day. It is a bold new frontier and I'm convinced that people see the value of sketches done on location. Everyone is sharing photos taken with mobile phones, there are millions on Facebook, but a sketch is more human, imperfect, intimate, and by writing as well, you can paint a bigger picture, adding details that didn't make it into the sketch. If you quietly sketch an event for an hour and a half to two hours, then you will witness some sort of drama. There will always be some

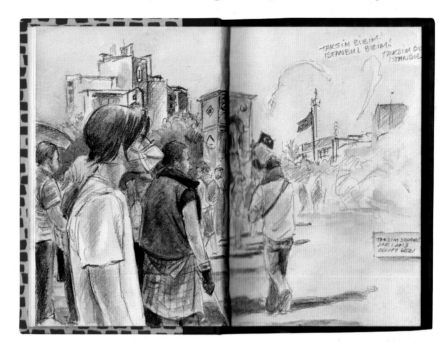

surprise because you are surrounded by people and anything can happen. I actually find that I can quiet my mind and get into a productive 'zone' much more easily now when I am in a crowded setting. No one will judge you. Most people will not even notice what you are doing. Focus on finishing the sketch.

By sketching out in the community every day, you become part of the community. People can look at your collection of sketches and writing and get to know more about what is happening around them. Different groups get to learn about others who are pursuing similar goals. Your goal isn't to just draw things but to sketch incredible stories. Your art can inform, enlighten and help bring people together.

▲ **Smoke and Breeze** One profile of a protestor wearing a medical mask tells the whole story in Samantha Zaza's atmospheric sketch. The distant architecture adds stability, while loose smoke and flags show motion. Distant figures beyond the smoke are drawn with vague, grey values.

Key Points to Remember

- Even if cameras aren't allowed, you can always sketch.
- Keep track of local news via newspapers and social media. You are the media.
- As the media, you can expect access to newsworthy events.

◀ **Finding Subjects** News doesn't need to be depressing. I report on creative projects in my city, like Paul Joachim, who does life-size sculptures using chocolate. If you focus on creative and inspiring people, you will always find interesting and profound subjects to sketch.

Index

Credits

Quarto would like to thank the following artists for kindly supplying images for inclusion in the book. All artists are credited in the caption to their sketches. Unless otherwise stated, all other artwork was produced by the author. While every effort has been made to credit contributors, Quarto would like to apologise should there have been any omissions or errors – and would be pleased to make the appropriate correction for future editions of the book.

A. Rmyth, www.metaspherique.blogspot.fr

Ana Rojo, http://aidibus.blogspot.com.es/

Andrew Tan, www.drewscape.blogspot.sg

Anthony Zierhut, http://anthonyzierhut.com/blog

Benedetta Dossi, http://365onroad.blogspot.co.uk/

Carol Hsiung, http://www.flickr.com/photos/48097026@N02/

Chakarida Nukoolkit (Ai), www.facebook.com/AiArtBarn, p.11b

Charlotte Belland, www.bellandpixel.com

Chris Fraser, http://chrisfraseronline.wordpress.com

Christopher Campbell, http://www.stosart.blogspot.co.uk/

Cristina Curto, http://www.stosart.blogspot.co.uk/

Darwin Borason, artbydar.blogspot.com

Don Low, http://www.flickr.com/photos/thedesignlanguage/

Felipe Gaudalix, http://www.flickr.com/photos/fguadalix

Florian Afflerbach, www.flaf.de

Guno Park, http://gunopark.com/

Hélio Boto, http://rua-dos-riscos.blogspot.pt

Jana Bouc, http://janabouc.wordpress.com/

Joao Catarino, http://desenhosdodia.blogspot.co.uk

Juan M. Josa, http://dibujandoydivagando.blogspot.com.es/

Juliana Russo, http://jurusso.tumblr.com/

Kiah Kien, http://kiahkiean.com/artblog/

Kumi Matsukawa, http://www.flickr.com/photos/macchann/

Lapin, http://les-calepins-de-lapin.blogspot.co.uk/

Lis Watkins, http://www.lineandwash.blogspot.co.uk/

Liz Steel, http://www.lizsteel.com

Marc Holmes, http://tarosan.wordpress.com/

Matthew Brehm, http://brehmsketch.blogspot.co.uk/

Melanie Reim, sketchbookseduction.blogspot.com

Miguel Herranz, http://www.miguel-herranz.com/

Moira Clinch, http://www.londonart.co.uk/

Orling Dominguez, http://www.drawingbythepound.com/

Patrizia Torres, http://www.flickr.com/photos/patxarantorres/

Paul Heaston, http://www.flickr.com/photos/paul_heaston/

Paul Wang, http://fireflyworkshop.blogspot.co.uk/

Pete Scully, http://petescully.com/

Robin Berry, http://www.natureartists.com/

Sylvie Bargain, http://bigoudene46.over-blog.com

Suhita Shirodkar, sketchaway.wordpress.com

Ted Michalowski, www.tedmichalowski.com

Teoh Yi Chie, www.parkablogs.com

Tia Boon Sim, http://tiastudio.blogspot.co.uk/

Tin Salamunic, http://www.salamunicart.com/

Veronica Lawlor, http://www.veronicalawlor.com/

Víctor Martínez Escámez "Swasky", www.swasky.es

Virginia Hein, http://www.worksinprogress-location.blogspot.co.uk/